Print Culture

With the advent of new digital communication technologies, the end of print culture once again appears to be as inevitable to some recent commentators as it did to Marshall McLuhan. And just as print culture has so often been linked with the rise of modern industrial society, so the alleged demise of print under the onslaught of new media is often also correlated with the demise of modernity.

This book charts the elements involved in such claims – print, culture, technology, history – through a method that examines the iconography of materials, marks and processes of print, and in this sense acknowledges McLuhan's notion of the medium as the bearer of meaning. Even in the digital age, many diverse forms of print continue to circulate and gain meaning from their material expression and their history. However, Frances Robertson argues that print culture can only be understood as a constellation of diverse practices and therefore discusses a range of print cultures from 1800 to the present 'post-print' culture.

The book will be of interest to undergraduate and postgraduate students within the areas of cultural history, art and design history, book and print history, media studies, literary studies, and the history of technology.

Frances Robertson is a lecturer in the department of Historical and Critical Studies at Glasgow School of Art.

Directions in Cultural History
Series Editors: Ben Highmore and Gillian Swanson

The *Directions in Cultural History* series directs history towards the study of feelings, experiences and everyday habits. By attending to the world of sensation, imagination, and desire at moments of change, and by coupling this to the materials and technologies of culture, it promotes cultural history as a lively and vivid arena for research. The series will present innovative cultural history in an accessible form to both scholars and upper level students.

Print Culture
by Frances Robertson

Forthcoming titles:

Dreams and Modernity: A Cultural History
by Helen Groth and Natalya Lusty

Design at Home: Domestic Advice Books in Britain and the USA since 1945
by Grace Lees-Maffei

Cultural History: Detail and Intimacy
by Gillian Swanson

Practicing Cultural History
by Ben Highmore

Home Discontents
by David Ellison

Print Culture

From Steam Press to Ebook

Frances Robertson

Routledge
Taylor & Francis Group

LONDON AND NEW YORK

First published 2013
by Routledge
2 Park Square, Milton Park, Abingdon, Oxon OX14 4RN

Simultaneously published in the USA and Canada
by Routledge
711 Third Avenue, New York, NY 10017

*Routledge is an imprint of the Taylor & Francis Group,
an informa business*

British Library Cataloguing in Publication Data
A catalogue record for this book is available from the British Library

Library of Congress Cataloging in Publication Data
Robertson, Frances, 1952–
Print culture / by Frances Robertson.
pages cm
Includes bibliographical references and index.
1. Printing–History. 2. Printing–Social aspects–History.
3. Graphic design (Typography)–History. 4. Communication and
technology. 5. Digital media. I. Title.
Z124.R63 2013
686.209–dc23 2012020068

ISBN: 978-0-415-57416-7 (hbk)
ISBN: 978-0-415-57417-4 (pbk)
ISBN: 978-0-203-14420-6 (ebk)

Typeset in Sabon
by Taylor & Francis Books

Printed and bound in Great Britain by the MPG Books Group

Contents

Figures

1 Introduction

This book addresses the meanings that have become attached to print mediums in the industrial West since 1800. Even in the digital era, the styles and appearance of letterpress, lithography or silk screen continue to resonate in the graphic design languages we come up against in public space and in our private encounters with the page. We still engage with print culture by thinking about print, using print and producing printed artefacts. Looking at print as a designed object or 'marked surface', the approach taken in this book, is a good way of getting into the thick social and cultural contexts that have created current attitudes, and it also challenges the common assumption that we are now bombarded by texts and images that have somehow become dematerialised by new media developments. In fact, it is quite the opposite; digital equipment at home and in the office invites us to compose and print out more new documents on a daily basis. In considering print as a made object, the book will contextualise and integrate narratives of production and reception at a time when both these roles are becoming available to non-specialist writers and authors.

The poster in Figure 1.1 is a home-printed agitational gesture; 'print' in this book is not limited to a discrete specialist area, but will be considered in relation to many social and material transactions. Although print culture is often celebrated as a medium of information transfer, promoting knowledge, print is also about litter, bus tickets and propaganda. In fact, before knowledge exchange, print functions more to record how we work to establish trust amongst strangers. We see this when we use and print banknotes, cheques and receipts as material tokens that underwrite a social agreement. Postal services replicate similar print transactions in miniature, for example in Figure 1.2 where the residues of many separate lives in 1905 were suddenly brought together and fixed through print at a quarter past five one September afternoon. This book aims to bring to account such overlooked elements of print in culture, while also considering various incarnations of print culture as broader and deliberative discourses about print. Everyday and localised examples of printing from the past two centuries are open to almost every researcher, wherever they may be based, and are useful for testing their research against broader narratives of print culture. Local examples can

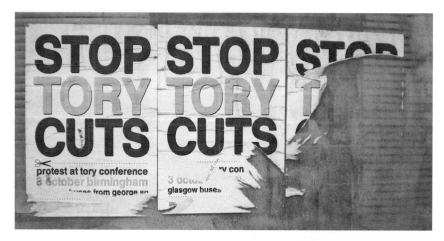

Figure 1.1 Digital desktop prints, flyposted to vacant shop window, author photograph.

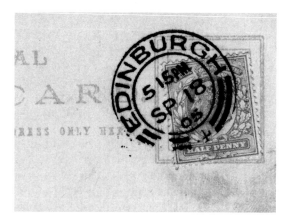

Figure 1.2 Printed postcard, 1905, steel-engraved halfpenny stamp, overstamped with cancellation mark showing time and place of posting, author collection.

suggest that apparently universal statements about the workings of print culture actually come from particular circumstances. For example, Western academics writing for peer-reviewed publications are more ready to characterise printed matter as the vehicle of reliable and lasting information, while the *samizdat* readers we meet in Chapter 6 would bristle with suspicion when confronted with similar texts. In giving an open acknowledgement of the fact that this book reflects the circumstances of its writing, the book seeks to recognise the contradictions and tensions of trying to describe a medium that is at the same time collective, individual and contested. Singular examples of print open up connections to the material and social circumstances of production. The business of print is populated with competing

groups of publishers, print entrepreneurs and workers, all primed to forge and disseminate information. Different groups might construct and nurture their own version of print history for decades until forced into confrontation, as we see in the bloody strikes in Wapping associated with the move from hot metal to digital newspaper production in the 1980s. Self-conscious celebrations of print and its benefits have surfaced at various times, from Victorian promoters of progress to the media-conscious 1960s (when the term 'print culture' first came into circulation), and again more mournfully in the 1990s. Just as print culture was often linked with the rise of modern industrial society, so the alleged demise of print under the onslaught of new media is often correlated with the demise of modernity. This book charts the constellation of elements involved in such claims – print, culture, technology, history – through a method that examines the iconography of materials, marks and processes of print. We see how the notion of print culture, first promoted in the work of scholars such as Marshall McLuhan (1962; 2001 [1964]) and Elizabeth Eisenstein (1979; 1983), was connected with the particular cultural moment and the anxieties of these authors who were writing in a period when the expansion of new electronic communications after World War II appeared to threaten older media, and made the qualities of established printed communication more apparent, rather than just as the stuff of everyday life. Now, with the advent of more recent digital communication technologies since the 1990s, the end of print culture once again appears to be inevitable (Birkerts 1994; Finkelstein and McCleery 2005: 26; Gomez 2008). In considering print as a made object, this book in one sense acknowledges McLuhan's characterisation of print culture – that the medium, as much as the message, is the bearer of meaning – but beyond this it will also question the term by arguing that print culture can only makes sense in the plural, as a diversity of differing practices.

In summing up and saying what now seems to be a premature farewell to the 'Gutenberg galaxy' in the 1960s, McLuhan took a distinctive approach. He stressed the importance of the medium of communication, rather than content, in shaping human perception and knowledge. In a similar vein, other scholars of this period such as Elizabeth Eisenstein and William Ivins celebrated the cultural and intellectual benefits of print. Noting that printing can reproduce and spread identical copies of words and images to places far apart in space or time, texts such as *Prints and visual communication* (Ivins 1992 [1953]) claimed that the invention of printing encouraged scholars to argue about the accuracy of texts, interpretations and data, and hastened the scientific and technological ascendancy of natural philosophers in the West. But descriptions of the workings of print culture in this period often transplanted contemporary values back in time in an anachronistic way. In *The printing press as an agent of change* (1979) and *The printing revolution in early modern Europe* (1983) Eisenstein conjured a 'communications revolution' during the Renaissance, to which she applied contemporary concepts such as 'data collection', 'storage and retrieval systems' or 'communications

networks', suggesting strongly that the development of contemporary secular and industrial society was the result of new kinds of consciousness fostered by the invention of printing. Such ideas are still influential, but they have attracted strong criticism, for example, that the notion of 'print culture' is a form of reification (Maynard 1997), that it is a misleadingly over-simplified generalisation (Johns 1998; Dane 2003), or that the term proclaims a naïve technological determinism (Nye 2006). Nevertheless, the term 'print culture' is still used and with increasing frequency in many new contexts of study. The term is often used to indicate specific networks of writers, readers and publishers, for example those involved in the expression of radical politics in the nineteenth century (Wood 1994; Gilmartin 1996; Haywood 2004), or in the formation of scientific communities (Latour 1987). Print culture also implies a level of reflexivity – a self-conscious proclamation that print is part of a group's identity. For example when Eisenstein cited Francis Bacon's description of printing (in the *Novum organum* of 1620) as one of three world-changing modern inventions (along with gunpowder and the compass) she implied that the print culture of her existing community of scholars in humanities was also part of a long tradition of print commentary (Eisenstein 1983: 12). William McGregor, an art historian, has argued equally that print was so ubiquitous a medium for visual education that even by the seventeenth century it had become the commonplace guiding metaphor for the workings of the mind and perception, as evidenced in the development of words such as 'imprint' or 'impress' to denote states of mind (MacGregor 1999: 389–421).

Beginning in nineteenth century, this book gives examples of the ways in which different print mediums and visual languages have accumulated meaning in contemporary visual culture and graphic design and in the study of humanities. Each chapter addresses different kinds of print medium, but in addition the book also follows a chronological progression through to the present. So, for example, Chapter 3 on letterpress printing is connected to cultural and historical debates associated with the mid-nineteenth century, while offset lithography is discussed in relation to mid-twentieth century developments in Chapter 6. The book does not present a comprehensive history of the notion of print culture, but asks how cultural history and theory might mesh with specific print cultures. For example, lithography – a protean medium that gave rise to fears of unbridled piracy in the early nineteenth century – will be explored in relation to the development of ideas of grades of authenticity in the reading of images. The nineteenth century is a good place to start for several reasons, in part because, as we will see, many current assumptions and myths about the nature of print were formulated during this time. With this in mind, it is not surprising that writers such as Elizabeth Eisenstein have described this period as the 'zenith of print culture' (Eisenstein 2011: 153–97), or that Ivins now appears to be less of a twentieth-century modernist and more a born-again Victorian. Print gained huge cultural significance as a metaphor for industrial production in general during the

first half of the nineteenth century, always tinctured with the ink, oil and metal of the presses and their machine actions. The development of mechanised paper production and the invention of steam printing machinery supported a rapid expansion of the printing and publishing industries. For readers, prices fell; levels of literacy increased and many kinds of texts both factual and fictional were produced (Altick 1957; Eliot 1995: 19; Finkelstein and McCleery 2005: 113–15). Although by definition print is a medium for producing multiples, the expansion of the market through industrial means of production also meant significant fragmentation and conflict at this time. Mass markets are made up of competing groups, all vying for status. In considering the different audiences addressed by different techniques, we can see the limitations of those seductive phrases 'print culture' and 'mass market' when they are used without qualification.

Print culture is fermented in many different academic disciplines, but also in daily life and in workplaces. Academic research into book history is one notable stronghold of print culture, in both senses, as this is a community caught up in print technologies that is also constantly engaged in self-reflexive and critical debate about its own assumptions and methods. In addition to a large and expanding body of research and literature from individual scholars, book history is also promoted through various national and international initiatives, such as the Centre for the History of the Book at the University of Edinburgh, the Society for the History of Authorship, Reading, and Publishing (SHARP), or the Program in the History of the Book in American Culture that set in motion the five volume collaborative project of *A history of the book in America* (2007–10). Book history is a fairly recent field of study, emerging from older disciplines such as bibliography, literary studies, and social or economic history. Because books come together through a totality of different activities book history favours a synthetic approach. For example, literary criticism alone could not address the task of examining the conditions of production, or why printers or designers have chosen certain styles of typography and layout in different editions. Equally, while bibliographers used to concentrate on the physical materiality of books and their internal evidence, for example, by comparing and contrasting the evidence of wear on metal types and printing plates in order to ascertain when and where a certain volume was produced, these observations began to feel thin without some explanation of the social field in which the book was produced, disseminated and read. With these newer sociological approaches printers, readers, publishers and distributors have all come to be considered as the makers of texts. French scholars such as Chartier, Febvre and Martin (1997 [1976]) influenced English speaking historians, for example Robert Darnton with his concept of the 'communication circuit' or D.F. McKenzie's expansion of the 'sociology of texts' (Finkelstein and McCleery 2002; 2005; Howsam 2006). The 'sociology of texts' approach embraces many groups of people beyond the world of books and scholars, showing many more diverse fields of production and use, the 'full range of social realities which the medium of print had to serve, from

receipt blanks to bibles' (McKenzie 1986: 6). Looking at the social and cultural construction of texts in this way has pricked critical awareness about the very notion of print culture itself. Writers such as David McKitterick or Adrian Johns attacked earlier claims in the work of Eisenstein or Ivins that printing produced identical texts, or 'exactly repeatable visual statements'. Whereas Elizabeth Eisenstein argued that standardisation, dissemination and 'fixity of texts' created a reliable resource for scholars in the early modern period, Johns disputed this claim. Instead, many texts were regarded with suspicion due to piracy or malicious parody, for as the enemies of print argued; what could be worse than multiplying a dangerous lie? Even with the best and most scholarly intentions, many printed texts were simply not the same even within one edition (Johns 1998: 28–33; McKittcrick 2003: 151–64). Trust in print and in 'fixity' was a later development, and came about through the machinations of people, not because there is some inherent quality in print as a medium.

The idea that print is a medium of and for social formation is the starting point in many histories of media and communications, in cultural theories of media, and in the very broad field of 'visual studies' (Elkins 2003; Barnhurst, Vari and Rodriguez 2004). Cultural theory in part derived from the critical projects of writers and thinkers associated with the 'Frankfurt school' from the 1920s onwards, who sought to examine society and the formation of cultural assumptions in order to prompt a questioning attitude in the reader and hasten public action for change. Mass media, and the role of representations in the formation of individual consciousness and social hierarchies, was an important focus of study for these theorists such as Walter Benjamin, Theodor Adorno and Jurgen Habermas. Habermas, for example developed an account of the so-called 'public sphere', created through late eighteenth-century print forms of newspapers and novels. The 'public sphere' is now a term that has been applied to many contexts, but originally denoted an imaginary realm in bourgeois market-oriented culture where educated free citizens engaged in rational debate about public and social policy (Habermas 1989 [1960]; Briggs and Burke 2009: 79–90). In a similar style, print has been described as the medium that developed 'imagined communities' (Burke 2004: 62–64). In Europe, vernacular languages such as modern French, German or English eventually displaced Latin as the language of officialdom through prestigious projects such as translating and printing the Bible, for example in the English Authorized Version of 1611 (Briggs and Burke 2009: 29). Separate vernacular languages that were regimented and stabilised by print then began to form the imagined communities of nations and ethnic groups (Finkelstein and McCleery 2005: 18–19; Anderson 2006 [1983]).

Historians of science are now also important contributors to the study of print culture. In the late twentieth century science and technology studies adopted cultural and sociological approaches in order to understand the construction of systems of knowledge and practice through publications such as *The social construction of technological systems* (Bijker, Hughes and

Pinch 1987). For example in the period since the foundation of the Royal Society in Britain in 1660s, men of science worked to establish trust in their knowledge through establishing belief in their printed communications. In an influential text, *Leviathan and the air pump*, Shapin and Schaffer examined how trust in print was built up. Men of science used 'three technologies' (that is, material, literary and social technologies) to recruit supporters and gain allies for the new methods and theories of empirical science (Shapin and Schaffer 1985: 18–25). In *The nature of the book: print and knowledge in the making* Adrian Johns continued this theme of the interlocking relationship of print and the history of scientific practices through further case studies that demonstrate how knowledge was made and defended in the context of warring research allegiances through to the late eighteenth century (Johns 1998: 6). In *Victorian sensation*, James Secord (2000) synthesised approaches from printing and publishing history, history of reading and history of science in a detailed and exciting account of the making and reception of the publishing outrage of the 1840s, the anonymous *Vestiges of the natural history of creation*, a work that carried ideas of natural science and evolution into the cultural context of nineteenth-century Britain. In histories of technology and industry, less critical attention has been given to the print culture of manufacturing until fairly recently, even though, as this book will demonstrate, the prophets and promoters of the 'machine dreams' of industrialisation (Sussman 2000) in the nineteenth century used printing as an extended metonym for the virtues of the entire factory system. Recently, however, in *The arts of industry in the age of enlightenment* (2009) Celina Fox developed an account of the formation of technical styles of representation by asking how skills in the 'useful arts' in Britain were built up and communicated in the period before 1850. She considered the practices of drawing, model-making, and the convivial technologies of clubs and societies, alongside prints and print communications such as encyclopaedias and self-help magazines (Fox 2009: 8, 251–87), following from the work of earlier Victorianists and social historians such as Klingender (1972) or Briggs (1979).

Evidently, print is a medium of images as well as texts, and the study of visual print culture extends into art history and cultural history – from worlds of fine art connoisseurship to folk art and ephemeral satire, or to the workings of the print trade (Lambert 1987; Anderson 1991; Ivins 1992 [1953]; Griffiths 1996; Hallett 1999; Briggs and Burke 2009: 45–50). Print culture, as a business of design and graphic communication, is also part of design history (Margolin 1988; Drucker 2009) and architectural history (Carpo 2001), just as the study of visual representations and their circulation in print is now also a key aspect of the history of science. There is also a vast literature on print culture from graphic designers and working practitioners of all kinds. Many publications are examples of enthusiastic 'trade' literature, documenting for example the triumphs of an advertising campaign; works like these are excellent resources for research. More recently, however, design professionals have developed more distanced and critical registers of analysis directed at

their own history and practices, particularly from those who are also involved in teaching or academic research. One constant theme amongst concerned professional designers since at least the 1960s has been to draw attention to the power of their own specialism, either when used to dominate the civic realm or, in the service of advertising, to persuade, dazzle and indoctrinate. Ken Garland's witty manifesto *First things first* of 1964 for example lamented a system that applauded designers and new students for applying their skill and imagination to sell such things as: 'cat food, stomach powders, detergent, hair restorer, striped toothpaste, aftershave lotion, beforeshave lotion, slimming diets, fattening diets, deodorants, fizzy water, roll-ons, pull-ons, and slip-ons', rather than in more worthy outlets and lasting expressions such as 'street signs, books and periodicals, catalogues, instructional manuals, industrial photography, educational aids, films, television features' (Garland 1999: 154–59). Although such 'reformist' positions appear at first glance critical, nevertheless they still serve to bolster the power of the professional designer in society. In the second half of the twentieth century the development of university departments of graphic design has prompted a further expansion of academic and critical writing amongst teachers and researchers who are also professional designers (Margolin 1988; Bierut et al. 1994; 1999; Heller and Ballance 2001; Lavin 2001: 121–23). Although this book is indebted to this extensive literature, it will not present a guide or history of typography and graphic design practice as this area is very well served by many design professionals and practitioners who bring deep expertise and knowledge to their publications, from specialist guides to student introductory texts on graphic design languages, history, typography and other aspects of visual communication (Heller and Pomeroy 1997; Meggs 1998; Baines and Haslam 2005). Instead this book recognises this powerful group of practitioners as one element in contemporary attitudes to print culture.

The history of printing and print culture is not just about books and fine art images, but also embraces more fragile, ephemeral, everyday and throwaway items. These range from newspapers and journals (King and Plunkett 2004), to timetables, seed packets and restaurant menus. Some of this vast flood of paper has been archived variously by museums, enthusiasts or academic research institutions such as the Centre for Ephemera Studies, University of Reading (Rickards and Twyman 2001) but by definition most of this material evades the historian or archivist. Many everyday and humble items of ephemera have often not been near a graphic designer, but have been made by jobbing or amateur printers. In terms of volume and paper consumption, contemporary production by those with access to office printing technology represents one area of print culture that is increasing in the digital era. The study of ephemera opens a wider view to 'printer culture', embracing artisan trade printers, non-specialist printers, designers and graphic artists, and consumers. Furthermore, the ephemeral and the everyday aspects of print connect to ideas of materiality that run through this book. The design historian Victor Margolin, quoting Fernand Braudel, evokes the mysterious pleasure of

accessing through the study of everyday objects and practices the 'shadowy zone' of 'elementary basic activity which went on everywhere' (Margolin 2009: 99). Bill Brown, in discussing the 'material turn' in cultural history in the last decade of the twentieth century, noted the paradox of trying to get at 'things' that 'lie beyond the grid of intelligibility' (Brown 2001: 5). Writers, historians and artists look to the humble material objects of everyday life in part because they are inspired by the 'practical' or 'rhetorical' materialism of Marx (Frow 2010: 25–37). The development of industrial capitalist economies in the nineteenth century created a 'mechanisation' of many aspects of daily life, from the standardisation of time and working rhythms, even down to the most basic of foodstuffs such as factory-baked bread, while workers were alienated from their productive work. Left-wing political action aimed to disrupt these patterns that were so familiar they had become invisible, and to seize control of daily life (Highmore 2002: 5–10). To avant-garde artists print is full of possibilities for such disruption as it produces ubiquitous and overlooked artefacts that are both humble objects and bearers of content. The flimsy qualities of ephemeral printed materials invite disruptive interventions into this information soup, for while paper is the carrier of words and representations its material nature displays the contradictions of written language and representation; a smear of carbon, an impress of an arbitrary sign. As Peter Stalleybrass reminds us, printers print pages not texts (Stalleybrass 2007: 315–40). The artificiality of print is more apparent when it is seen not simply as content, but as a manufactured object. Nevertheless there is something slippery in attending to the material qualities of print mediums, for there is a ceaseless temptation to act like a consumer not a critic. Observing fine differences for example in the appearance of notations such as typefaces may be, as John Frow suggests, simple-minded or trivial (Frow 2010: 26) and indeed some current writers on the materiality of print deliberately appeal to sentiment rather than reason. For example, in the battle against digital texts, defenders of books often call up the smell of old libraries, or the steamy indulgence of reading in the bath; arguments that are only too easy to contradict.

Nevertheless, and despite these objections, considering the material qualities of different kinds of print need not be trivial or sentimental, for these differences speak in a unique way about the many social negotiations that are congealed within printed objects. Recognising materiality is a method of interpretation that seeks to respect the signification of both the flow of disembodied meaning in cultural production and its specific physical expression. This approach is clearly relevant to the study of all inscriptions, whether in written manuscript, print or in new media. More playfully, and in homage to the preoccupations of the period, the material quality of print seems especially apposite to the nineteenth century when we recognise the imaginative appeal of the 'immense ponderosity' of the whole business of mechanised printing. We can see this heavy, realist, materialism for example in the novel *Clayhanger*, where the author Arnold Bennett piles on descriptive details to evoke

the solidity and complexity of the machines and contrivances crammed into a provincial printing house of the 1870s: 'you moved about in narrow alleys among upstanding, unyielding metallic enormities, and you felt fragile and perilously soft' (Bennett 1970 [1910]: 102–3).

Printing is a technique for creating multiple copies. The means used to craft printing equipment (such as making metal letters), and indeed, the methods used to get inky marks onto paper – the printing itself – shade into industrial and craft technologies used to make other objects in multiples, such as casting, moulding, stamping, branding and stencilling. Many of these processes are ancient, for example the manufacture of bronze axe heads, stamping out gold coins or impressing a private seal into clay or wax. In this sense many copying techniques are a habitual or tacit human skill. But in the industrial factory system as it developed in the late eighteenth century, certain aspects of copying gained value. Exact repeatability in the production of multiples came to be an ideal that was constantly to be sought after even when never fully achieved. The notion that printed copies are identical, a common belief in the nineteenth century and beyond, grew out of broader contemporary ambitions established in the previous century amongst modernising intellectuals and entrepreneurs of the Enlightenment for creating ordered systems to regulate habit and action (McKitterick 2003: 166). In turn the analogy between printing and industrial production in the nineteenth century became a well-used metaphor that turned endlessly back on itself. In *Tools for the job*, a history of machine tools, L.T.C. Rolt (1986) evoked print not merely as a partner to industrialisation but as its model, when he recalled Eli Whitney's aim in 1798 to establish a factory that would assemble guns made from multiple interchangeable parts: 'as much like each other as the successive impressions of a copper-plate engraving' (Eli Whitney, quoted in Rolt 1986: 150). The virtues of replication in industrial production were urged in popular works such as Charles Babbage's *On the economy of machinery and manufactures* (1835), where he claimed: 'nothing is more remarkable, and yet less unexpected, than the perfect identity of things manufactured by the same tool' (Babbage 1835: 66).

Copyright laws and agreements began with printing. According to William St Clair, we should understand the original invention of intellectual property not in terms of 'creativity' or author rights, but as an economic response to the difficulties of producing multiple copies of texts in one print run. Printers need two kinds of credit or economic support; first, they need to set up the equipment and manpower for printing and, second, they need to finance the period in which stock remains unsold. Copyright is effectively a price-fixing agreement and monopoly in the merchant's favour to allow him to fend off competition during the period when the product is out in the market and hence vulnerable to copying (St Clair 2004: 43–45). Copyright as a merchants' monopoly on titles was eventually suspended, but later replaced by an author-and-publisher copyright system in the nineteenth century that has since grown and ramified in response to the development of new mediums of

mechanical reproduction such as photography, music, film and now digital communications. Overall, copying is not a simple industrial virtue, but is a problematic activity, full of contradiction. In a world that puts a value on intellectual property and trademarks, and in the world of fine art or hand crafts, copies are seen as inferior shadows or worse; as fakes, forgeries and knock-offs, where the production of identical multiples threaten both the value that is given to the object and also the status of elite buyers. Unregulated copying is attacked as piracy and plagiarism (Schwarz 1996; Johns 2009). Copying also destroys significance and meaning, becoming 'noise' or redundant information, so although printing is so often characterised as a system for circulating information, printing multiples also takes away meaning through repetition and redundancy.

Books, and indeed, every medium of record, from writing to electronic storage, have often been accused of robbing the memory. In Plato's dialogue *Phaedrus*, Socrates tells a story about two Egyptian gods arguing about the invention of writing, 'an elixir not of memory, but of reminding' (Fowler 1925 Volume 9: 274–75). Nevertheless, printed objects often come to act as material sites for memory, and like relics may become objects of reverence. One of the many poignant documents encountered in writing this book was a tattered copy of a publication, *Fluxus etc., Addenda 1* (Hendricks 1983), from the anarchic Fluxus art group created in homage to the avant-garde artist and activist George Maciunas, active in alternative art practices from the 1960s onwards. In its time, this work was deliberately made to be ephemeral and of low quality, with a typewritten text printed through offset lithography onto standard newsprint, borrowing the appearance of standard contemporary low-cost publications of its period. It is a compilation of many kinds and registers of text and includes transcripts of videotape interviews, newsletters, and mock-serious plans of imaginary proposals, for example, the 'Caravan/Expedition to Circumvent the World' from 1975/76 (Hendricks 1983: 246). When newly printed this had a deliberately banal appearance, but now it is a withered crumbling item of art history (Hendricks 1983; Wood 2004: 297–310). Like all ephemera, this item is now rare (Rickards and Twyman 2001), but as a result its material testimony is more apparent to the 'forensic imagination'. Although this object set out as a homage to the banality of the multiple, it now has an 'aura'; the battered patina of its individual history. Printed objects like this carry sentiment but that does not limit their meaning for us as they also give access to non-textual historical evidence, they 'form records: analogous to living memory, storing information beyond individual experience' (Kwint 1999: 4).

Photography played an important part in the development of print culture discourses examined in this book, and will be treated in relation to mainstream print mediums first in relation to photographic half-tone images that were reproduced by standard printing techniques using carbon-based inks and second as an adjunct to established industrial printing mediums that used line and other solid graphic markings. In other words, although photographic

printing from transparent negatives using silver chemistry is clearly a method for multiplying images, this best-known aspect of photography falls outside the scope of this book, even though the book is indebted to the body of photographic history and theory that informs much discussion and research in the history of visual culture. Photographic techniques for image-making first emerged in the 1830s, culminating in the announcements in 1839 by Daguerre in France and Henry Talbot in Britain of two competing processes for making images of objects in the world through the capture of light; events with immediate and enormous cultural resonance. After public announcements of these inventions many photographic businesses were set up almost immediately; however, photographic printing was not easily compatible with other print mediums. The conditions of production were also different between the new photographic industries that employed unskilled female labourers (Jammes 1981: 45) and the established printing trades; part of the so-called 'aristocracy of labour' of unionised skilled workers who defended their closed printer culture against all outsiders (Zeitlin 1979: 263–74; Gray 1981). Nevertheless, photographic techniques were used in many printing experiments after 1850, using light-sensitive chemicals to transfer images to lithographic plates (photolithography) or to metal in the example of photogravure. Photographic images in print made up of continuous tonal gradations were a later development after the invention of half-tone screens in the 1880s. As we see in Chapters 5 and 6, photographic techniques of image transfer came to dominate standard carbon-based printing in the twentieth century, but these techniques were still part of the printing industries and largely separate from the enormous photographic enterprises that also emerged in the twentieth century.

Today, it has become commonplace to assert that we are living in a 'visual culture', composed of mass media images (Mirzoeff 1999: 1–31) but, even if this is true, this did not just happen willy-nilly. Experimentation and change to incorporate more visual content was complicated, unpredictable and often costly, as we see in the different hybrid combinations of photographic technologies with conventional print mediums. The introduction of different imaging mediums and techniques came about through many smaller shifts and contests amongst various groups within the print world. In the world of readers, the introduction of more images in print clashed with questions of popular education and access to elevated culture. Printing, along with a 'free press' is often considered to be the means of creating a democratic society made up of educated individuals. This is one of the virtues of print culture that appears in accounts such as those of Ivins, Eisenstein and many other commentators. Accounts of printing or publishing in the nineteenth century frequently include a chronology of legislation that supports this idea, where the Reform Act of 1832 is followed by such landmarks as the Public Libraries Act (1850), the abolition of Paper Duty (1861) and the Education Act of 1870. However, education and increasing access to political power are not straightforward projects of a benign government. Instead, they were and remain

contested issues. Working-class readers in the nineteenth century engaged with cheap magazines and books for entertainment and as a self-education resource because there was no free state schooling for children. In this publishing world, journalists and other writers often developed a self-congratulatory rhetoric linking print with progress (Secord 2000: 30; King and Plunkett 2004: 6). But in this industrial free market economy, education was often more about creating citizens who could work in factories and shops. Printed publications also educated citizens as consumers, advertising products for everyday subsistence or for entertainment in leisure time, with an increase in visual images. Indeed, from at least the time of the Great Exhibition onwards, the Victorians were aware of the pleasure and power of their 'visual culture' in print. An article in the *Illustrated London News* proclaimed: 'those whose office it is to dispense instruction are practising a new art. Our great authors are now artists. They speak to the eye and their language is fascinating and impressive ... the Great Exhibition itself, which is a representation to the eye, is a part of the same progress. It is performing the office of a large illustrated newspaper. It is the history of modern art and invention taught by their actual products [in] representations of the material world and of common life ... the common and the useful predominate' ('Speaking to the eye' *Illustrated London News* 24 May 1851: 451–52).

The free circulation of words and images offered by print did not just raise anxieties about access to knowledge and education, but also about access to culture in the most elevated sense. In *The printed image and the transformation of popular culture* (1991), Patricia Anderson contrasts two scenes from high and low life from Ackermann's *Microcosm of London* (1808); first a Royal Academy exhibition and second an image of the workhouse in the parish of St James that depicted two 'extremes of aesthetic abundance and visual deprivation' (Anderson 1991: 49). In the 1830s respectable and reforming cheap publications like the *Penny Magazine* began what Anderson described as an 'unprecedented and enlightened attempt to introduce the theories and images of art into everyday life' (Anderson 1991: 83). Later, from the nineteenth century onwards, we see that print as a medium of expression has often been annexed or appropriated by avant-garde artists seeking to break down the barriers between the arts, and to banish the spectre of social distinction. But the growth of print mediums and of image reproduction techniques expanded the types of art and artist competing for business and status. Fine artists have been supported in their claims to high status by a whole field of institutional practices and critical commentary that has generally worked to exclude commercial and populist visual practices made for print. When this high art position is combined with the revolutionary ambition of some avant-garde artists to break down social distinctions through appropriating mass media techniques, then a morass of competing claims for status is created, elite versus populist, high against low art (Elkins 2003: 44–53). Generally, according to Johanna Drucker, graphic design and commercial art is still treated as a 'dangerous interloper', not because it

is bad art, but on the contrary because it is too painful to admit that popular art could be creative or innovative (Drucker 1999: 36–47; Lupton 1994: 104–8).

Within working 'printer culture', on the other hand, the battle of 'who gets to say what to whom' (Lavin 2001: 2) often appears to be staged not between high and low art, but rather between amateurs and professionals, where claims of tradition, law, education or expertise are used to defend the right to speak, or the right to work, against incursions by newcomers. Philip Meggs for example defends typographers with craft and design school education against untrained contemporary digital desktop publishing 'morons' (Meggs 1994: 160). Professional graphic designers are of course in a strong position to defend fairly sweeping claims to authority, for example in design critic and founder of *Eye* magazine Rick Poynor's statement: 'it is no exaggeration to say that designers are engaged in nothing less than the manufacture of contemporary reality' (Poynor 1999b: 9). Print production, about dissemination and free circulation of ideas, knowledge and expertise is not a good forum in which to try to defend exclusivity; nevertheless workers, professions, entrepreneurs, copyright holders and many other agents all compete both against each other to defend their control of print production and to exclude outsiders. So for example we will see skilled craft printers in trade unions banding together against unskilled and female workers, wood engravers in conflict with professional illustrators, or defenders of copyright who rig the market so that lower social groups are shut out from contemporary knowledge or discourse (St Clair 2004: 355–56). In these battles, the protagonists used the capabilities of different mediums in various ways; for example, subversive or non-specialist groups have exploited lithography at different times and in different ways to create printed communications that were unconventional in relation to established letterpress conventions.

Amateur printers, however, cannot be kept down. Apart from the fact that many famous names in the history of print were self-taught or otherwise unconventional presences in established print worlds, many practitioners maintain a fluid identity and value the enthusiastic, playful and convivial atmosphere of part-time printing that is not primarily a business. Small nineteenth-century hand presses, that could operate almost anywhere so long as they had a 'sound floor, adequate natural light, and a source of clean water', were used in their time by amateurs and jobbing printers alike, and continue in use (Rummonds 2004: 9). The private press movement of the 1890s and the wood-engraving revival of the interwar period produced innovative, influential work from this atmosphere of enthusiastic experiment, and established a community of alternative print culture that runs in parallel to the commercial world (Cave 1971: Ashbrook 1991). Today, even in the era of digital print, many graphic design students worldwide still study letterpress, engage in hand setting and print on hand presses. In part this is because in the 1960s and 1970s the development of photosetting and litho offset printing pushed many traditional printing firms out of business, so that cases of type

and presses came into the market for enthusiastic amateurs and alternative printers. In Britain, the St Bride Library off Fleet Street in London is one contemporary stronghold that supports a fluid community of print enthusiasts moving between different working practices, paid and unpaid, in their research and creative lives. When the library was set up in 1895 this part of London had an immense concentration of printing businesses and was a centre for printers' vocational classes. Its original holdings of craft manuals and examples of design and typography are enhanced by the collection of William Blades (1824–90), a city printer and enthusiastic researcher of William Caxton. Blades collected material that was overlooked by more academic book lovers in his time, such as technical handbooks, manufacturers' catalogues, and type founders' specimens (Mosley 1978–79: 85–98). Now the St Bride Library is a centre for contemporary research and practice, both experimental and historical, and hosting a continuing world that is according to *Printing History News* by turn scholarly, convivial and nerdish. But, as we will see, many other forms of amateur print exist, less organised and less celebrated, often in more impromptu fashion, and sustained by office printing technologies, small local copy shops and home desktop printers.

The structure of the book

Each chapter in this book deals with different print mediums and different kinds of material production. Chapter 2 reflects on printing procedures that involve cutting, punching and inscribing metal, first in relation to type founding and the craft of typography and second with regard to the intaglio technique of engraving. This chapter also demonstrates the overall approach of the book in considering print as a made object. In this chapter, analysis of the 'marked surface' of print is connected with the value that has been given to classical monumental inscriptions in the West, a narrative of culture and invention that has been constantly revisited and reinvented. Steel engraving, with its direct echoes of the iron and steel industries of the nineteenth century, generated a distinctive visual style that was used to underwrite conventions of cultural and monetary value within the Victorian economy. Both these proce-dures, however, were supported by selective histories that emphasised the role of the skilled designer and craftsman – rooted in tradition, and in control of difficult techniques of material shaping – as the creator of the authoritative impress of value in engraving and letterpress.

Chapter 3, 'Steam intellects' introduces the 'default' print technology of the first part of the nineteenth century with clear links to Gutenberg's process of 1450: letterpress and run-in relief illustrations that in the period 1800–50 expanded tremendously due to industrial methods of papermaking and the adoption of steam-driven printing. Alongside this expansion, we can see the growth of a specific 'printer culture': wood engravers, print tradesmen and journalists. Meanwhile, self-help publications, aimed at improving and educating industrial workers, celebrated the very methods and machines

that had brought them into being, alongside a crash course in mainstream and official culture.

Chapter 4 addresses lithography; a planographic medium that allows a vast range of drawn marks to be reproduced at will almost infinitely. The ability of the medium to accept the slightest sketch and autographic writing allowed it to be used for 'improper printing' (Twyman 1990), reproducing marks and symbols outside conventional typesetting systems, while its facsimile functions created exaggerated fears of piracy. Lithography in this chapter will be considered as a subversive element, a perturbation in the 'Gutenberg galaxy' of print culture, eliding some clear distinctions that have been made between writing and printing, or between text and image, just as it destabilised clear distinctions between original and copy.

Chapter 5, 'Greyscale' is about the development of half-tone printing for photomechanical reproduction. The advent of photographic images in printed publications at the end of the nineteenth century destabilised previous evaluations given to existing print mediums. Equally, photographs presented new and highly contested forms of evidence, in the natural sciences, in law courts and in popular journals. The chapter also comments on the cultural after-effects of the critical theory of mass media first developed in the 1930s whose influence, for example the work of Walter Benjamin, still resonates in visual studies. Chapter 6 picks up those aspects of photomechanical reproduction not discussed in Chapter 5, equally important to the workings of print culture in the twentieth century and beyond. While the graded greys of half-tones were developed to convey the effects of photographs in print, other photomechanical image processes, that were generally simpler and cheaper to use, captured and reproduced emphatic blacks and harsh contrasts with no intermediate tones. From line block process prints to Xeroxing techniques, any clearly differentiated mark could register as 'camera-ready' copy, allowing many shifting assemblages of images and text. Original copy did not necessarily come from the printing house, but could come from home or office printing equipment. This chapter brings together a discussion of these effects, relating them to pop art and postmodern developments in art and graphic design theory and practice, art that self-consciously reflected the 'shift from nature to culture', and the era in which print became an object, rather than a text. In relation to the argument of this book, it also returns us to the period of McLuhan, his emphasis on the medium, and the development of the concept of 'print culture' in contemporary academic discourse.

The final chapter asks whether with digital technology we are now living in a post-print culture. Just as in the 1960s, the threat of new rival mediums has prompted a re-recognition that books and other printed materials are not natural objects, but are also a type of technology acting on consciousness, and, in some quarters, a similar technological determinism, for example, about the brain-rotting effects of cyberculture. Moreover, the ruling metaphor of virtuality in the digital world frequently masks the materiality behind the production, appearance and reception of interface texts. Nevertheless, and

despite the myth of the paperless office (Sellen and Harper 2002), digital technology has prompted an increase in the circulation of ephemeral printed documents. Print culture is not dead, but it is changing. This chapter describes some of these changes and some disputes and commentaries in the contested sphere of the 'late age of print' (Striphas 2011), from the products of everyday 'printer culture', to the alleged delights of 'post-digital' books, and the expanding print cultures of scholarship and media commentary.

2 'Marked surfaces'

Printing is about copying and multiplying images, motifs and texts on the 'marked surfaces' of designed objects through contact with the printing matrix, which is itself a further designed object. Techniques and materials of print reflect the manufacturing practices of their time, echoing the values of surrounding technologies, from woodcuts to digital dot matrix printing. At the beginning of the nineteenth century, printed images were crafted using wood, copper, steel and limestone plates. Text types were cast from metal alloys, but the relief images that accompanied them were cut into wood (see also Chapter 3). Images in metal, on copper and steel plates, were produced separately, in the 'intaglio' technique whereby the desired lines of the image were cut into the metal with an engraving tool, or etched with acid. In intaglio printing, very fine lines act as channels in the metal holding the ink, and the paper surface is literally squeezed into those lines under immense pressure to pick up the image. Finally, images from stone (lithography) were produced 'planographically', that is, from a flat surface, using a technique that was dependent not on the surface contours of the plate but on its chemistry, exploiting the antipathy of oil and water (see also Chapter 4). All these methods were derived from wider working practices and tacit knowledge of materials.

A print is a two-dimensional surface pattern that speaks as much to the eye as to the reading mind, creating meaning that is supplementary to any analysis of textual content and information. This surface pattern comes from the matrix; a woodcut image produces a different quality of mark from a digital printer. This chapter considers some basic and traditional print marking techniques that involve cutting, punching and inscribing metal, first in relation to type founding and the craft of typography and second with regard to the intaglio technique of engraving. Steel engraving, with its direct echoes of the iron and steel industries of the nineteenth century, generated a distinctive visual style that was used to underwrite conventions of cultural and monetary value within the Victorian economy. Typography also developed in these contexts that included the mechanisation of print production, the expansion of commercial forms of art for publicity, and the establishment of state-funded art and design education. Type designers, type founders and printers generated

many new experimental forms with greater frequency, and engaged in more wide-ranging historical research (Miller and Lupton 1994). Frequently experimentation was informed by a self-conscious manipulation of historical styles, and a growing historicism that sought to place cultural artefacts within a broad sweep of 'Western civilization' (Burke 2004; Thomas 2004). This expanded historical view was developed in discourses about the aesthetic, social and moral functions of design growing out of the arts and crafts movement in the late nineteenth century, and contributing to the formation of modernist philosophies of design in the first half of the twentieth century. We can see these factors at play in the professional self-fashioning of typographic designers William Morris and Stanley Morison who used historical research both to inform their own work as designers and as material for writing and lecturing. In their descriptions of the sources and methods of 'good design' they developed an imaginary world of letterforms as hewn or crafted architectural and sculptural objects existing in a metaphorical tension with the 'marked surface' of the printed page, emphasising an understanding of print culture as one of formal, aesthetic and rational calculation with firm roots in a long tradition of cultural practice.

The title of this chapter comes from a phrase in *The engine of visualization; thinking through photography* (Maynard 1997). Patrick Maynard, a philosopher and writer on concepts of vision and aesthetics, proposed a functional definition of photography as a technology that produced 'physical marking of surfaces through the agency of light' (Maynard 1997: 3). This description of photography as a means of producing 'marked surfaces' was a deliberate challenge to the influence of writers such as Roland Barthes (1980) or Susan Sontag (1978). Maynard criticised their interest in the so-called 'ontology of the photograph' (that is, asking 'what is the essential nature of the photograph?'). Instead, Maynard was more interested in understanding how meaning is made through action by examining the many diverse technologies and applications of photography. Maynard elides print and photography by considering for example the development of photogravure where the use of light-sensitive chemical coatings were used to mark and then etch a metal printing plate ready to receive ink. In short, he treats photography as just one print medium amongst many, and printing itself as a 'meaningless' process for multiplying marks with a diversity of applications from scientific illustration, fine art reproduction, banknote printing and transfer-printed ceramics to silk-screened T-shirts (Maynard 1997). Chasing after the meaning and essence of 'printing' or 'print culture' in the essence is in his opinion fruitless; instead, different contexts of action produce meaning.

Alphabet soup: typography and the crafting of language

Although at first glance it might appear perverse to view a whole printed surface as one designed object whose significance is separate from any words it might carry, this 'double vision', the tension between visual expression and

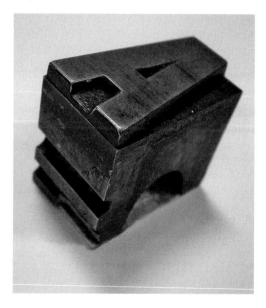

Figure 2.1 Grotesque 72 point A printing type, courtesy of Glasgow School of Art
 Department of Visual Typography, Letterpress Caseroom.

textual meaning, is at the heart of graphic design. In the design and prod-
uction of printed texts, meaning is fragmented. In the Western letterpress
tradition, printed texts are built from individual arbitrary characters. In *The
Gutenberg galaxy*, Marshall McLuhan argued that this 'meaningless sign
linked to the meaningless sound' created the consciousness of 'typographic
man' in the age of print (McLuhan 1962: 54). Typographers work to design
those 'meaningless signs', individual letterforms and families of types, but
what they do is filled with significance. Type designers and historians
have ascribed meaning to their craft through an appeal to philosophies of
knowledge, to various historical narratives, or by a more tacit appeal to craft
practices that change through time (Miller and Lupton 1994). In contemporary
working practice, for example, designers develop their craft through historical
research in material and digital archives, using computing skills for manip-
ulating and presenting text, data, and still or moving images. In the nineteenth
century, the relevant craft knowledges were characterised much more by
reference to laborious material shaping of metal or stone.

Typography, the craft of designing and producing families of letterforms
for use in printing, was first developed at the time of Gutenberg in the
fifteenth century as one aspect of the invention of movable type for so-called
'letterpress' production. Makers of type, type founders, have developed thou-
sands of different families of type for different purposes. Currently anyone
who is familiar with word processing on a home computer will be accustomed
to choosing different digital typefaces from the 'font' menu such as Times
New Roman, Arial, or Comic Sans. Each typeface has a certain character,

socially determined by group approval, and in the informal context of home publishing and e-mail communication the writer tries to choose the most appropriate face for their audience or genre. Depending on the context of reading, typefaces may be visible or invisible. Typography in standard published texts, such as this academic piece of writing, has been designed to deflect attention away from letterforms and page layouts with the intention of lulling the reader into inhabiting a symbolic abstract world of information flow, the result of conscious design decisions to make reading as natural and seamless as possible. Other texts, for example in advertising, use types that by contrast assert their presence. Readers learn these conventions while they learn to read, so they seem normal. But because reading and writing from printed texts is central to the construction and ordering of knowledge in our culture, the study of typography has now moved beyond circles of designers, printers and book collectors – from expected specialist areas of 'printer culture' to wider scrutiny in humanities and cultural theory. In the era of digital communication typographic designers work with information specialists, cognitive scientists and engineers to create 'mutable type' that can be processed by many different configurations of screens or printers, and legible to both human and non-human machine readers (Carter 1995: 132–33; Rider 1998: 39–54; Staples 2000).

But in the nineteenth century, the word 'typography' was most often used to denote the material craft operations of printing, described in one *Popular encyclopaedia* of the 1890s as: 'the art of printing in paper with movable metal types, wood blocks, or other surfaces engraved in relief' (Annandale c. 1890). Compositors invoked this meaning when they named their trade unions, such as the London-based Typographical Association (Musson 1954). At the end of the nineteenth century, notions of who might be involved in the art of typography expanded to include designers in other fields, as well as writers, researchers and historians. This alliance of interests brought typography into print culture as a subject for cultural commentary and debate beyond the print shop. Typographical history became variously a strand in wider narratives of Western cultural origins and, in the eyes of socialist visionary William Morris, stood as an example of dignified craft knowledge. In the first printing houses in the fifteenth century metal type was made on site, but this work soon became the separate business of type founders (Hanebutt-Benz 2002: 13). Thousands of the same letter would be needed at any time when setting pages of text, and type founders made these by casting them in small moulds. Punch cutters made the first individual letters, the master copies, in consultation with the printer or patron. This was exacting work, as letters were made to their actual size, peering through a magnifying glass, where craftsmen combined metalworking executed with jewellers' and engravers' tools with the knowledge and judgement appropriate to monumental sculptors or masons in designing letterforms. These crafted originals were used to punch out a negative form in a mould, and in turn these moulds were used to hold the molten metal that formed the individual types that were used in the press. Letter types were cast from a lethal mixture of metals, mostly lead and

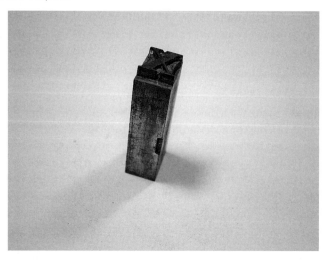

Figure 2.2 Times bold 24 point X printing type, courtesy of Glasgow School of Art Department of Visual Typography, Letterpress Caseroom.

antimony (giving off poisonous fumes when heated) that could run freely when molten into the finely detailed type matrices (Savage 1841; Tracy 1986). When the cast metal was cool, the letter types were taken out of the mould, rubbed down and arranged neatly in perfect alignment (a small notch in the type helped both eyes and fingers with this task) ready for shipping to the printer. These finishing tasks, handling the minute types by fingertip, were often performed by a chain of boys who would process thousands of individual types an hour. Finished metal types have a monumental sculptural form, albeit at miniature scale, as each piece of type stands up in the form of a vertical block or plinth, with the letter at the top in relief. These traditional methods of working were still universal at the start of the nineteenth century, as described in the monthly supplement of the *Penny Magazine* (26 October 1833: 422–24), or in *A dictionary of the art of printing* (Savage 1841).

However, mechanisation of many aspects of type founding, set in motion by business owners, led to a decline in the number of traditional skilled artisans and new definitions of the work of typographers. Punch-cutting machines, such as that patented by the American type founder Linn Boyd Benton in 1885 (Cost 2011), could copy existing types or new drawn designs, and scale these up and down in size. The machine did the cutting that previously was the work of a skilled artisan so that designers and commissioners made design decisions without reference to the kinds of tacit judgement formed in the craftsman through his experience of cutting and shaping metal. Mechanised punch cutting encouraged experimentation and the development of new forms as new letter types could be quickly drafted out on paper. It also meant that existing type forms, developed in other times or places, or by rival businesses, could be copied much more readily (Tracy 1986: 38–42;

Isaac 1990). In a commercial environment, with increased production of printed ephemera beyond the world of books and journals (Twyman 1970a; Meggs 1992; Rickards and Twyman 2001) many different type designs were made, sold to printers, and began to appear in printed materials of all kinds from the beginning of the nineteenth century. The invention of stereotyping also cut down the number of metal characters that were committed to a print job at any time, and encouraged printers to increase the variety of typefaces they bought in (Casper et al. 2007: 40–46). Posters and flyers, often with a different and arresting typeface on each separate line, filled the urban environment with variegated texts that transformed railroad schedules, notices of emigrant ship departures or circus tour dates into dramatic narratives. For such advertisements, jobbing printers bought in typefaces that were deliberately and outlandishly newfangled, such as the theatrical 'Egyptians' and fat faces, and often juxtaposed with other types that revived historical styles with romantic or nostalgic intent, so that the decorative pleasure of these assemblies of type vied with the textual content (Harris 1983).

This increasing range of typefaces encountered by the viewer in everyday life can be seen as one manifestation of the eclectic exploitation of historical or exotic styles in decorative and manufacturing 'high Victorian design' in the nineteenth century (Jervis 1974; Jobling and Crowley 1996: 246). In book design, Philip Meggs points to the heavily ornamented title page from W.H.F. Talbot's *The pencil of nature* (1844) as an example of the 'eclectic confusion of the Victorian Era' complete with Medieval script, Baroque plant forms, and geometric interlacing (Meggs 1992: 154). Such a distanced manipulation of style, treating the past and the present as a 'resource library' to be rifled at will, is one manifestation of changes to labour organisation in industrial production, and the development of new professions such as 'designer' in the decorative arts (Forty 1986; Brett 1992). Increasing demand for industrial and commercial design encouraged state funding for art and design education (Macdonald 1970; Bogart 1995: 26–31). Typography moved from its previous associations with skilled artisanal practices to its current alignments with commercial art, graphic design and academic scholarship, creating audiences for more ambitious cultural histories of typography.

Roman virtue

Commentaries on the history of so-called 'roman' typefaces (such as Times New Roman) engage with a range of imagined pasts in different ways. Although printing with movable type began in the Renaissance, a thousand years after the end of Roman empire, the adoption of Roman letterforms was intended to signal an allegiance with that lost classical world. Roman faces were developed in opposition to the first more 'gothic' typefaces that imitated manuscript writing hands. Subsequent generations of designers have frequently returned to Roman lettering, in particular to the stately inscribed capitals of monumental sculpture, for inspiration (Updike 1980 [1937]).

These leaps back to the past were an attempt to put on the perceived virtues of an almost mythical culture, and were already habitual at the beginning of the nineteenth century. But new perceptions of the ancient world, and of ancient languages and inscriptions, were aroused by archaeological explorations by Europeans in revered areas of the ancient world such as Italy, Greece and the Middle East from around 1800 onwards. European culture was perceived as the mingling of two streams, from the classical pagan world of the Greeks and Romans, and from the divine Judaeo-Christian world of the Holy Land. Excavations, and the development of archaeology as a discipline, created a revised view of ancient history and its relation to contemporary culture (Burke 2004; Thomas 2004). Histories of the development of printed letterforms often borrowed this vastly expanded timescale of cultural development that invited the reader to peer back far beyond the invention of printing or even beyond the days of classical Rome. Our alphabetic writing system, ABC, is derived from Middle Eastern forms of writing developed around 1500 BC. These gave rise to the letterforms of the Greek and Roman alphabets (Drucker 1995; Finkelstein and McCleery 2005). Up to the beginning of the nineteenth century Western European theories of the origins of writing and of the history of human culture incorporated supernatural and mythic elements such as the Creation or Noah's Flood. From then on the discovery of new archaeological materials and the development of new forms of Biblical scholarship began to undermine scriptural authority and familiar narratives of history. The excavation of artefacts covered with inscriptions and attempts to decipher unfamiliar ancient texts led to the development of new types of cultural history. Reports and pictures from expeditions, for example in the archaeological 'best-seller' *Nineveh and its remains* (1849) by Sir Austen Henry Layard, led to the flowering of a vast field of speculation and theory about the origins and meaning of written and inscribed alphabet letters, located within a vastly expanded time frame that reached back to some imagined dawn of culture (Malley 1996: 152–70).

In relation to the meaning of 'Roman' typefaces, different writers on typography have thus had a range of very different time frames and theoretical methods to interpret the cultural significance of printed Roman alphabets. In the mid-twentieth century, the typographic consultant and writer Stanley Morison gave historical gravitas to type forms he had developed (such as Times New Roman and Gill Sans) by comparing them directly with ancient classical inscriptions in stone from as far back as 600 BC. Although Morison's employer, the Monotype Corporation, made automated 'hot metal' typesetting and typecasting machines specifically for modern, high-volume, mass-market industrial printing applications (such as newspapers) with often-limited lifespans, Morison chose instead to accentuate the connection of modern types with ancient monumental inscriptions from the classical world; proof, he claimed, of an 'effective universal consensus' of the enduring value of the Graeco-Roman alphabet 'in all works addressed to the intelligence of mankind' (Morison 1972). Other typographic historians have been

more circumspect; Daniel Updike offered a more cautious and historically specific genealogy of 'Roman' letterforms from the 'humanistic writing' traditions of manuscript culture in the centuries immediately before the development of printing (Updike 1980 [1937]: 38–57) while Talbot Baines Reed kept his narrative even more modestly within the circumstances and experiments of a print history that was strictly post-Renaissance by attributing the 'classical Roman letter' to the Venetian type founder Nicholas Jenson in 1471 (Reed 2001 [1920]). But despite their differences of emphasis their histories all share a respect for the same classical tradition, and more fundamentally, a concentration on form, design and aesthetics as part of a new professional persona of typographers, separated from the everyday business of print work.

Designers, professional conscience and self-presentation

The research and publications of Updike, Reed and Morison at the beginning of the twentieth century are examples of new ways of thinking and writing about typography, book design and printing history that developed out of 'arts and crafts' and 'aesthetic' initiatives in the decorative arts of the late nineteenth century (Naylor 1971), which were indebted to the ideas of figures such John Ruskin (1819–1900) and William Morris (1834–96). Audiences for these design ideas were not necessarily print trade craftsmen, but were designers, businessmen, bibliophiles, working men and women, and students of decorative and industrial arts. John Ruskin, an influential writer on art and design, was also a social campaigner who rejected the stultifying effects of industrial division of labour and defended craft work as empowering (Haslam 1988: 65–70; Denis 1995: 276–305). William Morris shared this utopian philosophy, and as a working designer and social critic he acted out his belief in craft design as an expression of joy in everyday work. Morris designed in many areas and taught himself printing and typography (Briggs 1962). Celebrated as one of the 'pioneers of modern design' by the modernist critic Nikolaus Pevsner (1960), Morris's ideas on typography are still characterised as a source of new modernist attitudes towards graphic design, for example in the recent anthology of readings *Looking closer 3: classic writings of graphic design* (Bierut et al. 1999). Morris insisted that formal expression depended on functional honesty and simplicity of design with clear type set into well-designed pages. At the same time, in his writings and in his production of books at the Kelmscott Press from 1890, Morris wanted to go 'back to the future' advocating type forms based on historical precedents, for example the Venetian Roman types of Nicholas Jenson and which formed the basis for Morris's Golden type design.

Morris's Kelmscott Press was one of many 'private press' initiatives in the period 1890–1914, often started by artists, social reformers and visionaries who typically combined consciously avant-garde ideals for the future of society with a 'primitivist' regard for the supposed simple life of pre-industrial

times (Cave 1971; Ashbrook 1991). Morris showed both these tendencies in his own practice, using modern photographic enlargements as a design aid, but also calling on the 'eye' of a skilled craftsman Edward Prince as his punch cutter (Peterson 1991). With his reverence for craft skill, Morris created an idealised narrative of book production: the skilled artisan, judging and cutting characters; the designer laying out the pages and assembling the book as a unified statement; the reader with his mind free to enjoy the literature whose beauty is enshrined by these decisions. Even within traditional artisan workshop systems, this picture leaves out many intermediate operations and the workers (usually women or children) who performed them, for example collating and sewing printed pages into a book. In relation to typography and design in the late nineteenth century, Morris's notion of 'ideal book' manufacture did not address the changes that had already taken place in printing, such as the development of punch-cutting machines or typecasting and composing systems such as Linotype and Monotype. These mechanised processes removed from production the actions of sculptural cutting and shaping of letterforms by an experienced craftsman and changed the nature of manipulative contact the compositor had with the texts he was setting. Nevertheless, the notion of type design as a monumental or sculptural project still continued to influence the ideas and self-presentation of many modernist typographers such as Stanley Morison who did embrace the notion of industrial production in the first half of the twentieth century. One link between the ideas of Morris and Morison can be seen in the design teaching of the Central School of Art and Crafts of London (founded 1896), which combined respect for craft knowledge, interest in Roman lettering and the aim of educating designers to work on industrial or public works, rather than for elite patrons. W.R. Lethaby (1857–1931), as Director of the school, developed a system of workshop training in order to promote these virtues. Lethaby supported teaching in graphic arts, and his staff included Edward Johnston, the tutor of Eric Gill. As an architect, Lethaby admired the 'rationality' he discerned in Roman inscriptional lettering, specifically as cut into Trajan's column. Lethaby's enthusiasm for these ancient Roman letterforms had wide consequences, both on the printed page and beyond. Trajan-derived inscriptions and signage on shop fronts of government and business premises created a British style regime that came later to be derided by critics as a blanket imposition of 'ministry of works' respectability (Gray 1960; Mosley 1978–79; Harvey 2009).

Morison, Monotype, and corporate efficiency

In the commercial world of mass printing, hot metal casting changed working practices for designers, type founders, compositors and publishers, and changed the appearance of letters encountered by readers on the 'marked surface' of the page. Two types of machines dominated; Ottmar Mergenthaler's Linotype machine of 1885–88 and the Monotype Tolbert Lanston machine, developed in the US in 1887, and introduced into Britain in 1898

(Moran 1971: 10; Tracy 1986: 38–42). Typecasting machines meant that printers no longer bought in their types from founders; in addition, this machinery changed the work of compositors. Traditionally compositors had picked up and set lines of text from individual letters in the printing house (a process described at more length in Chapter 3) but now the machine operator sat at a keyboard and 'typed' in the letters, spaces and other characters that were required to make a line of text, automatically calling up the moulds that were now aligned and ready to be filled with molten metal. In type design for hot metal, so-called 'kerning' became problematic. A 'kern' is when part of a letter or other character projects beyond the edge of its piece of metal type (for example, in the tail of a letter 'y'), and is easily accommodated in hand setting techniques. But in hot metal setting, each casting unit had to be self-contained, so that the letterforms within them were more discrete (Tracy 1986: 40). Visually this threatened to disaggregate words into conglomerations of separate letters, slowing down reading and making the text more 'jumpy' and less flowing to the reader. The adoption of hot metal setting presented a challenge and an opportunity for designers to develop new forms of type for the large printing and publishing concerns that could afford to invest in these expensive and elaborate machines.

One particular design challenge was to create letterforms that were readable and also fitted in with established modes of presentation, in accord with the expectations of both educated readers and those aspiring to respectability. The notion of high-volume printing for a mass market often carries an assumption that these materials will have lowbrow content and appearance. However, this perception ignores the fact that some of the most widely distributed publications, such as textbooks or Bibles, have official status, marked by dignified and authoritative design. Towards the end of the nineteenth century, with the promotion of universal education and literacy through state policy, such mainstream publications increased in both range and volume. One example of such 'official' demand for new designs for mechanical setting machines came from the printers R&R Clark of Edinburgh, who were printing a history of the British Army during the First World War (1914–18) and were struggling to maintain supplies of traditional hand-set type due to materials shortages. As a result they asked the Monotype Corporation to devise a heavily kerned type for mechanical setting. Monotype had already demonstrated its ability in this area in a commission from the publisher J. M. Dent to produce a new face for the 'Everyman's library' of literary classics in 1911. Stanley Morison developed his typographic practice, and his long association with the Monotype Corporation, within these contexts.

Morison was self-taught, and developed his interest in the art of printing from 1912 in the strenuously avant-garde and visionary environment of the small private press movement. In this atmosphere, Morison assembled an idiosyncratic collection of personal ideals; he was a pacifist conscientious objector during the First World War of 1914–18 and a convert to Socialism and Catholicism, a dual loyalty he retained through the course of his life.

Morison pursued his research into types and type history using resources such as the St Bride Library and developed a professional practice of consulting and researching into typography. As a consultant employed by the Lanston Monotype Corporation from 1923 Morison, along with his associate Beatrice Warde, provided typographic advice to clients such as Cambridge University Press, and, famously, to the *Times* newspaper, for which he devised the Times New Roman face for mechanical setting in 1932. Morison's design language was eclectic but strongly in thrall to past examples. For example, the typeface Bembo of 1929, used by book designers, was derived from a type developed by the printer Aldus Manutius for his patron Pietro Bembo in 1495 (Moran 1971: 139). Neither craftsman nor trained designer, Morison was an advisor and organiser, promoting his own style of print culture through writing, lecturing and exhibition organisation, for example as seen in the trade show *Printing and the mind of man* of 1963 (Moran 1971: 68). The typographic role of Morison and Warde was to devise promotional campaigns for Monotype in a thicket of artists, craft enthusiasts, businessmen and civil servants, through developing a narrative of the power of 'good design' in industry and through demonstrating how typefaces could project national and corporate identities. For example, Gill Sans was chosen by HMSO (His – or Her – Majesty's Stationery Office, the official British Government publishing and printing house) for the Post Office telegram form, designed by Morison in 1935 using various weights of the Gill Sans face (Badaracco 1996: 26–37; Moran 1971: 121). Morison invited Eric Gill to devise this sans serif face between 1928–31 as a response to competition from German type foundries who were promoting avant-garde forms of 'new typography' by designers such as Jan Tschichold or Herbert Beyer at this period. Gill derived his letterforms from examples developed by his teacher Edward Johnston who had designed the sans serif face for London Underground in 1915 (Badaracco 1996; Moran 1971: 117). The transport company L&NER (London and North Eastern Railway) also adopted Gill Sans for all its signs, timetables and other printed matter, forcing over ninety printing establishments with railway contracts to install this Monotype face. As this weight of interconnected practice and type uniformity built up, by 1935 Gill Sans had become one of the most dominant type families for modern composition and display.

Timetables, a new form of printed reading matter, were developed during the nineteenth century. Changes in travel and communication from the 1840s onwards, by rail and sea, formed a new kind of 'time consciousness' in travellers (Esbester 2009). National and international transport enterprises pushed for the development of 'railway time'; agreed standard times, firstly across the nation, and later through international agreements on time zones. Reading and negotiating one's journey with timetables became a life skill – by the 1870s tens of thousands of timetables were printed and distributed every season. The name itself, 'timetable', suggests the matrix-like grid that is familiar today in stations, with places along the line arranged vertically at the left, and departure times across the horizontal axis. Different weights of

typeface were used to indicate meaning and to break up the page. The clear grid-like structure of the timetable, oriented to horizontal and vertical axis, aimed to reinforce the concept, dear to administrators and entrepreneurs, that the railway journey was a rational progression, a straight iron line between two points (Schivelbusch 1986; Freeman 1999). However, this aim was at odds with the experience of the traveller and viewer once embarked. From inside the carriage, myriad landscape views unfolded, mixed up with domesticated pursuits as the passengers indulged in quiet reading, knitting or conversation as the carriages rolled along their smooth gradients. Esbester (2009) therefore argues that timetables promoted only one kind of time consciousness, an official and functional view that would have liked to contain both the time and space of an administrative zone, ultimately a nation, within one net. The spread of official typefaces such as Gill Sans was a supporting form of 'network-building' through design, where cultural and technical infrastructures are established in such a way that systems like railways or post offices begin to colonise increasingly distant areas of social and working life in ways that are made to appear unstoppable and inevitable (Grint and Woolgar 1997: 28–29).

The ostensibly clean and functional ethos of rational design, promoting efficiency, provided a good corporate image for government organisations and large business organisations that endorsed the creed of 'scientific management'. Executives such as Thomas Watson of IBM, for example, widely promoted the notion that 'good design is good business' in the period after World War II (Watson 1999 [1975]: 246–51). Professional graphic designers also claim to strive for transparent public service and clear communication, combining virtue and self-fashioning. Good design, in the view of Stanley Morison, represented a 'reconciliation of authority and freedom … the best guarantee against experiment or innovation or irresponsibility', where he looked to government printing offices and academic presses to defend good practice (Morison 1972: 339). Modernist designers such as those associated with the European avant-garde and the Bauhaus also promoted their trade through a similar discourse of functional efficiency. For example, Jan Tschichold, promoting his 'New typography' in 1928, based on simple geometric relations, announced himself as an 'engineer' creating clean hard objects that were akin to the 'standard forms' of 'typewriter, lightbulb, or motorcycle' (quoted in Lavin 2001: 32–33). These have been the public faces of professional graphic design in the twentieth century, promoting a kind of Roman virtue of rational form, and familiar in exhibitions and design history books for the general reader. But in contrast to this elevated tone of professional gravitas, graphic designers also worked to create more ostensibly frivolous and fashionable typefaces and page layouts for advertising and other promotional work. Archive trade journals such as *The Studio* reveal a world of much more anonymous commercial artists busying themselves with conferring glamour on a host of homely and perishable objects: 'ham and eggs, syrup, shirts and socks, and glue' (*The Studio* 1925: Special autumn number, art

and publicity). Although this aspect of graphic design history is less celebrated, recent design historians have now begun to examine this legacy of 'commercial modernism' that should now, according to Steven Heller, be recognised as the true 'mother of graphic design' (Heller 2001: 295–302). However, creating more inclusive versions of graphic design history will be something that is more easily said than done. Understanding commercial design in action requires an analysis of business and cultural networks, rather than aesthetic form. But designers, publishers and their clients, who are after all responsible for graphic output, need to maintain the public face of their trade, with an emphasis on attractive work and the process of formal and aesthetic decision. In this particular area of print culture, practitioners still dominate the literature and critical debates in the history of typography and graphic design. While such professional and monumental aspects of letterpress design came to dominate the history of typography, those narratives occluded other aspects of nineteenth-century cultural self-understanding of print culture. Victorians admired the power of manufacturing production and engineering innovation that was manifested in metal forms and structures. These dominated the environment and also the experience of many industrial workers. While metalworking knowledge developed enormously in relation to cutting, shaping and design, metalwork also included forging, casting and moulding. Although letterpress uses both these aspects of metalworking expertise at different stages, the sculptural and inscribing aspects of type production were more evident in the language used to describe and promote typography, so that type design was described in ways that are more akin to the 'setting in stone' of sculptural monuments and inscriptions, asserting an enduring cultural authority for typography as design and minimising the expertise of print workers, in their 'typographical associations'. To close this chapter, we move from text to image, from letter to line, to consider another area of print culture also characterised as 'sculptural' in its craft production; engraving on metal.

The diamond point of steel engraving

Intaglio printing is a high-status medium that (as steel engraving) carried many and varied representations of class and value in the nineteenth century. Line engraving for print was extremely skilful, painstaking work with traditions of technique going back to the Renaissance, and was used for scientific illustrations and fine art reproductions. Engraved images were expensive, but they were valued because the intaglio process that squeezed damp paper into fine lines filled with ink produced fine detail. Such detail was not possible in other mediums until after the development of smooth machine-made paper around 1800 (Dyson 1984; Ivins 1992; Griffiths 1996; Gretton 2005). In the first half of the nineteenth century people who were interested in art, or wanted to develop drawing and design skills for their trade, rarely encountered paintings in a gallery. In Britain such public institutions did not really exist until at least

the 1820s (Trodd 1994; Duncan 1995). Instead, artworks were viewed in the form of so-called 'reproductive' engravings. It might be more accurate, however, to describe prints as the predominant medium of art, for although fine art engravers aimed to reproduce the appearance and atmosphere of drawings and paintings into the medium of intaglio plates for the fine print trade, artists, students and art lovers rarely saw the originals. Visual training came through prints. Even three-dimensional objects, for example the ancient Greek statue known as the Apollo Belvedere, were celebrated throughout Europe in engravings. Engravers inscribed metal (originally copper) with a sharp pointed burin, deploying a range of marks, from lines to flicks and points, to denote contour, texture, or to indicate colour variation. Often, a large plate represented several years of skilled work, longer than that given to the original painting (Griffiths 1996: 55–56), and wealthy connoisseurs, mainly aristocrats, amassed cabinets of prints for their private enjoyment. The amount of skilled labour in an engraving was signalled by the appearance of the name of the engraver in the print, prefaced by the abbreviation 'sculp.' or 'sc' denoting the Latin *sculpsit* or *sculpebat*, meaning 'sculpted/cut by' (Griffiths 1996: 134).

Steel engraving was a nineteenth-century development, exploiting and celebrating industrial and economic technologies of production (Klingender 1972; Hunnisett 1980; Dyson 1984). Steel is much harder than copper, and is much more difficult to work. Cutting lines into steel made use of two particular technological innovations; first the development of metallurgical techniques for altering the relative hardness of steel plates, allowing them to be worked while relatively soft, and then to be hardened up for durability in printing, and second, new engraving tools such as the diamond point cutter were developed to cut extremely fine and unvarying lines into the hard surface, giving a 'silvery, almost luminous effect' (Hunnisett 1980: 6). Engravings on steel could produce a much longer print run than those made on softer copper plates before breaking down, feeding an expanding market for reproductive engravings of artworks in this period, both as individual prints and also increasingly for illustrated books and journals. Engravings remained prestigious objects, but they became less expensive, no longer the hobby of the elite connoisseur, but an aspirational purchase for middle-class consumers. In the hierarchy of print mediums, intaglio prints still retained luxury status through to the end of the nineteenth century, while relief printing was associated with mass markets (Hunnisett 1980: 3; Gretton 2005: 375). Initiatives to promote the 'industrialisation of taste' such as the *Art Union* journal of London, founded in 1837, aimed to provide a 'steam engine for the manufacture of a love of art' (King 1985: 1). Subscribers acquired a library of steel-engraved reproductions of contemporary art along with essays and articles to be consumed in the privacy of the home, and although the intended purchasers of this journal were members of the comfortable middle classes, it was also included in the libraries of many mechanics' institutes (King 1985: 42–45). Thus the love of art and the development of good taste would in turn, it was hoped, drive increasing manufacturing consumption.

Ernest Gambart (1814–1902), the 'prince of the Victorian art world' (Maas 1975), is one example of art entrepreneurship that flourished in the expanding market for steel engravings. Gambart amassed a huge fortune from two complementary sources. He promoted original contemporary artists and their works by courting new patrons and staging touring exhibitions whilst simultaneously developing a much larger aspirational demand for reproductions of those originals from the 'new collecting class' emerging from the 1840s onwards (Maas 1975: 17). Living artists at the beginning of the nineteenth century had had low status and low earnings in comparison to the prestige of 'Old Masters'. Print marketing, supported by copyright law, changed this situation. Artists and dealers could show their work much more widely and profit from their exposure in terms of celebrity and fortune. For example the painter Edwin Landseer earned an unprecedented seven thousand pounds in 1842 for just four paintings, two thirds of which came from copyright sales to print dealers (Maas 1975: 20). Several artists based their practice on copyright income, notably John Martin, the artist of apocalypse; Edwin Landseer, the painter of animal subjects (famous for *The Stag at Bay*); and the pre-Raphaelite artist Holman Hunt who provided the original of Gambart's financially most successful print publication *The Light of the World* (Maas 1975: 68–69).

Figure 2.3 Detail of steel-engraved plate with ruling machine line-work, author collection.

The very fine lines of steel engraving were made with tools devised initially for technical illustrations by inventors and engravers such as Wilson Lowry. Lowry invented a mechanical ruling machine around 1790 fitted with a diamond engraving point that would generate rows of parallel straight lines of unvarying thickness. Parallel ruled lines were used to denote shaded areas in engraved images, and also to indicate the graded effect of the sky, paling towards the horizon. Lowry was one of the foremost London engravers of his period, and although his family business reproduced artistic images for print, his personal specialism was technical subjects, producing thousands of plates of machinery, built structures, inventions and geometrical figures for publications such as the *Edinburgh Encyclopaedia* (Hunnisett 1980: 88). The ruling machine saved time and labour and rapidly became a widely used device for all kinds of images, being described as of 'as much importance to engravers, and the advancement of their Art, as the steam engine is to the manufacturer' (Society of Arts *Transactions* 1826: 44). While these neat and detailed effects were valued by some observers in the period, for example the engraver T.H. Fielding who praised the 'admirable degree of regularity and sweetness' given to the image (Fielding 1841: 33), other commentators, both at the time and subsequently, loathed the machine-worked elements of these engravings. Hilary Guise, for example, cautions unwary print collectors to be on guard against the 'lifeless regularity' of the ruling machine (Guise 1980: 4) that in her opinion tainted the rendering of the sky in Charles Mottram's 1861 engraved version of William Holman Hunt's 1854 painting *The Scapegoat*.

As the concepts of originality and spontaneity came more to the fore as distinct artistic virtues towards the end of the nineteenth century, reproductive engravings came to be treated with contempt, as being derivative, formulaic and stiffly rendered. In addition, the success of the medium commercially, with increasing purchase of engravings by aspiring middle-class people, eroded their cultural status. In the centre of this commercial success story, many fine art engravers were in a thankless position in terms of status. While their work enhanced the earnings and reputations of painters and print dealers enormously in the lucrative nineteenth-century market for prints, they themselves did not gain proportionally. Middlemen and dealers promoted mixed technique plates that could be produced rapidly by unskilled labourers working at separate tasks in an industrial manner, and squeezing down the wages of skilled artisans (Guise 1980: 5; Dyson 1984: 57–79; Eaves 1992: 186–88; Fyfe 1996: 206). Mechanically aided marks used in many steel engravings also carried overt industrial connotations for, as we have seen, in parallel to the fine art market, there was an expansion in the production of engraved technical illustrations in the nineteenth century, where the machine-made quality of the image was highly prized as a sign of mechanical ingenuity. Technical styles of drawing showed off drawing procedures derived from the factory system of manufactures in webs of identical repeated marks.

The virtues of exact replication in industrial production were widely trumpeted in the early nineteenth century in popularising works such as

Charles Babbage's *On the economy of machinery and manufactures* (Babbage 1835: 66). Techniques of mechanical drawing familiarised viewers with these ideas, and also built an audience for industrial methods, for 'engineering' and for engineers in cultural life. The hard-edged unvarying fine lines of steel engravings were a perfect medium in which engineers and industrialists might claim control over the material and natural world. Engineers and industrial entrepreneurs improved their status in the industrial and commercial economy of Victorian Britain through schemes of construction and manufacture. Engineers also 'sold' their expertise and built their professional status by visual means in print. Apart from the most obvious modes of self-presentation in mechanical illustrations, engineers also contributed in the early nineteenth century to an aspect of print culture that is often overlooked today because it is so commonplace; paper currency. But in the nineteenth century banknotes were a new and alarming innovation. While the security of paper currency was an intense focus for alarm at both personal and national level, banks and governments sought to reassure consumers through an engineered control of imaging technology.

Promissory notes

As a new form of currency in the nineteenth century banknotes were widely mistrusted, and with reason. Banknotes are 'promissory notes', acting as a stand-in for hard cash. Banknotes had been introduced as currency, displacing gold, in two trouble spots around 1800, notably in France during the Revolution of 1789, following the example of the American revolutionary states during the War of Independence 1775–83. The chaotic conditions of the 'mobile, anonymous society' in the newly independent United States before the Civil War in 1860 created a 'nation of counterfeiters' (Mihm 2007). Hunger for credit, and ambivalent attitudes towards the law, gave rise to a huge effervescence of counterfeiting activity that gained protective colouring from the thousands of banknote designs issued by barely legal commercial enterprises. In Britain, although the conservative and aristocratic government was at war with these revolutionary countries, there was an equal shortage of gold, and so much instability in banking, that Britain too had to issue its own paper currency in the period 1797–1821. In each country, the introduction of paper currency was accompanied by a massive illegal production of fake notes, exploiting the difficulty that ordinary people had in dealing with this strange form of money. In the first decades of the nineteenth century, three capitalist trading countries in the world had tried paper money and had an enraged public to deal with, deeply distrustful of the new flimsy banknotes that stood in such deplorable contrast to solid, heavy, gold coins. In America the Corps of Sculptural Engineers (as the banknote engravers of the US Bureau of Engraving and Printing were titled) combined art and technology to combat fraud. In Britain too, engineers and artists collaborated to develop methods of steel engraving as a form of security printing

(Society of Arts *Transactions* 1820: 47–56; Bower 1988: 19–20; Robertson 2005).

To create trust in paper money, the very technologies of print that might seem to undermine its value were put to work. The problem of forged banknotes somewhat paradoxically elicited a series of print inventions for copying and duplicating images at various levels. This depended on the risky strategy of being one step ahead of the criminals; the aim was to create a printed image that was too innovative, too difficult, and hence too expensive to merit the labour of forgery. Steel plates, for example, were to be multiplied by stereotyping (see also Chapter 3). The banknote became a 'gallery' of multiple styles, with machine drawing, letterpress texts and hand-sketched images all crammed into one plate in a montage of techniques extremely difficult to imitate cheaply. One distinctive banknote motif, the spirograph-like guilloché pattern, was originally derived from the penman's flourishes of the eighteenth century bank clerk. Reinvented for the mechanical hand of the geometric lathe, or 'rose engine', it was deemed to be extremely secure, because impossible to copy. Although these spirograph-like obsessively repetitive banknote patterns were machine-drawn, there was nothing predictable about the set-up of the machine that allowed thousands of permutations of the elliptical cams driving the diamond etching needle. Those secret combinations acted as 'security code' in banknote design, defying the forger to hit on the correct combination in time (Dyson 1984: 133–37; Robertson 2005: 32–34). Ornamented banknotes juxtaposed artistic and technical styles of drawing in equality and tacitly reinforced the engineer's mastery of metal and machinery. When the penny post was instituted in 1840, similar motifs, equally trumpeted, decorated the millions of identical stamps in any print run (Heath 1993: 21). Thus the introduction of paper money to commercial economies in the first half of the nineteenth century created an extremely large general audience (the adult population) all anxiously scanning the finer points of image copying and mechanical drawing in steel engraving. The success of this graphic campaign can be seen in the continuing use of similar patterns that are routinely used for many supplementary 'security' printing applications such as official certificates, or as a sign of value in small commercial money vouchers (Figure 2.4).

In print, techniques of cutting and inscribing metal had high status. The work of artisan punch cutters had prestige due to their hand skills and the appeal of long cultural traditions carried by Roman letterforms. Typographic designers took over these narratives of cultural distinction to support their own new kinds of working practices. Steel engraving, with its direct echoes of the iron and steel industries of the nineteenth century, generated a distinctive visual style that was used to underwrite conventions of cultural and monetary value within the Victorian economy. Both these strategies supported the development of ideas of the skilled designer and craftsman, in control of difficult techniques of material shaping, creating the authoritative impress of value in engraving and letterpress. This authority helped form a

Figure 2.4 Voucher to purchase goods at Navy, Army and Air Force Institutes (NAAFI) clubs shops and bars for British military servicemen, author collection.

'currency' of trust, not just in banknotes, but in other official forms for ordering knowledge, the movement of people and the exchange of information. New occupational groups in formation, graphic designers and engineers, bent on presenting an authoritative professional demeanour through the display of objective rationality used basic elements of print culture, line and letter, to craft a narrative of professional authority that relied on a particular view of print expertise and print history. These views minimised workshop practices and the contribution of skilled and unskilled labour. As we see in the following and subsequent chapters, skilled tradesmen such as compositors also constructed their counter-narratives of print expertise in the struggle for control of print culture.

3 Steam intellects

The Victorians were not afraid to moralise, and they were willing to put money into the production of 'good works' (Roberts 2002). The material residue of philanthropy is spectacularly on view in such hefty civic edifices as libraries, sewers and hospitals. Equally, righteous purpose was impressed into the page. Specifically, the medium of letterpress production was invested with moral significance through narratives of progress, social justice and salvation that appeared in many self-reflexive, self-congratulatory celebrations of print culture in nineteenth-century publications (Secord 2000: 30; King and Plunkett 2004: 6). Furthermore, future progress would not be frightening, because it was rooted in past cultural production. This chapter considers the 'default' print technology of the first part of the nineteenth century that at first glance has clear links to Gutenberg's process of 1450; letterpress accompanied by so-called 'run-in relief' illustrations. Production in this medium expanded tremendously in the period 1800–50 due to industrial methods of paper-making and the adoption of steam power. Self-help publications, aimed at improving and educating industrial workers, celebrated the very printing machines that had brought them into being, alongside a crash course in high culture, while conservative factions reiterated endless warnings of the dangers of universal education. Alongside this expansion came developments of specific 'printer cultures' of wood engravers, print tradesmen and journalists.

In Britain, Europe and the United States, letterpress printing was hailed as a democratic medium that would increase literacy for all. Publications aimed at working-class readers linked together print, freedom and industrial progress, celebrating the press as a 'powerful engine' for improvement (*Glasgow Mechanics' Magazine* 1824: v). Artisans hailed print as a virtual archive of knowledge that would place the arts of the workshop beyond 'the reach of vicissitude and decay' and thus lead to endless progress (*Mechanics' Magazine* Volume 6, 1 January 1827: iv). Publications for popular general reading such as the *Penny Magazine* ran a blow-by-blow illustrated account of its own production processes in its opening issues. And while these print methods were presented as the motor of progress, the spirit of Gutenberg was resurrected as a modern 'hero of invention' alongside industrial giants such as James Watt, developer of the condensing steam engine, or Robert Stephenson

the powerful railway engineer (MacLeod 2007; Fox 2009). Expansion in print production took place amongst the social, economic and industrial infrastructures of the nineteenth century, organised in terms of market capitalism and the development of political ideologies of liberalism and 'free trade'. New means of transport such as the railway (Schivelbusch 1986; Freeman 1999) increased the speed and quantity of travelling objects both animate and inanimate; newspapers and their readers circulated endlessly as part of the 'uninterrupted disturbance of all social conditions, the everlasting uncertainty and agitation' of capitalist modernity, attacked so exhilaratingly in the *Communist manifesto* (Marx and Engels 2008 [1848]; Berman 2010). Rapid communication, increasing readerships, and the notion that culture could be formed within national and international networks developed literary technologies for 'engineering empires' in the expanding imperialist nations of Europe (Marsden and Smith 2005). In this battlefield of values, persuasive words were only one weapon. To many, the medium of letterpress itself also became a focus for attention as a potential source of order.

In letterpress printing, inked metal type impresses the white paper as well as marking it with pigment. If you run your fingers down a printed page you can feel the indentations of the lines of type and the individual letters. To many readers and commentators, this heavy impress acts as a kind of brand into the skin of the page, a 'clawmark of meaning' (Chappell and Bringhurst 1990: 285) that gives authority to the text. The long duration of this printing technique lent an aura of tradition. Influential popularisers of print culture

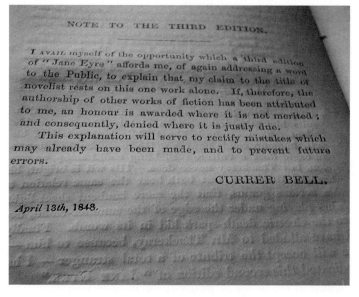

Figure 3.1 Preface to *Jane Eyre* (1847) by 'Currer Bell' (Charlotte Brontë), with marked letterpress indentation, author collection.

𝕴𝖓 𝖙𝖍𝖊 𝖇𝖊𝖌𝖎𝖓𝖓𝖎𝖓𝖌 𝕲𝖔𝖉 𝖈𝖗𝖊𝖆𝖙𝖊𝖉 𝖙𝖍𝖊
𝕳𝖊𝖆𝖛𝖊𝖓𝖘 𝖆𝖓𝖉 𝖙𝖍𝖊 𝕰𝖆𝖗𝖙𝖍; 𝖆𝖓𝖉 𝖙𝖍𝖊
𝕰𝖆𝖗𝖙𝖍 𝖜𝖆𝖘 𝖜𝖎𝖙𝖍𝖔𝖚𝖙 𝖋𝖔𝖗𝖒 𝖆𝖓𝖉 𝖛𝖔𝖎𝖉.

Figure 3.2 Illustration from the chapter 'Leviticus' dedicated to the laws of printing, depicting individual characters and spacer blocks from *The Pentateuch of printing* (Blades 1891: 46), author collection.

such as William Blades stressed the historical aspects of hand press work in a way that appealed to non-specialist audiences who would have been familiar with the small jobbing print workshops in their local economies. Less obviously, but of equal importance, new industrial techniques of production such as stereotyping created mechanised forms of letterpress that modified previous notions of the status of the printed word, and challenged the status of printers as skilled craft workers. Letterpress was the medium through which many of the most charged debates about power, truth and culture in the period were staged, while in printing houses parallel struggles for the moral high ground between traditional values and new ways of working were also staged in relation to control of production.

Technology, mechanisation and the invention of tradition

Letterpress printing made use of one simple insight; words can be dis-aggregated into individual letters that can be composed and re-composed into pages of text. By combining this idea with the technique of relief printing, pages of metal text can be inked up and copied many times. Text could be combined with pictures, if they were made in relief like woodcuts. Printing work was divided into areas of expertise in the separate trades of type founder, compositor and pressman. As seen in Chapter 2, at the start of the nineteenth century type founding was a separate trade conducted outside the printing house. Printers then bought in 'fonts', that is whole sets of one style of type in quantities appropriate for particular purposes. Bibles, for example, required different proportions of particular letters, numbers, and symbols than books of logarithmic tables. Within the printing house, compositors and pressmen were separated by the different characteristics of their work; on the one hand nimble and quick-fingered, on the other strong, careful and systematic, marked in France by their nicknames of 'monkeys', compositors, and 'bears', pressmen (Reynolds 1989: 14). Compositors were in charge of 'composing' the appearance and layout of the pages and of the overall text, picking out individual letter types from the letter case to form rows of text in a composing stick. Extra blank spacing bars were used to separate words and to make minuscule small adjustments between letters in order to 'justify' each line of type so each line was exactly the same length and was pleasingly arranged, balanced at both ends. Lines were slowly assembled into pages.

Images cut into relief on wood blocks could be inserted into this page layout. Finished pages were then assembled into a larger array of up to sixteen pages on an iron frame known as the 'chase' and this large heavy assemblage was then bound together with screws and wedges of wood in order to make a heavy flat 'forme' ready to be placed in the press. Now the pressmen took over. Ink was padded on to the forme with large soft ink balls while another, non-inky, pressman placed white paper on the 'tympan', prior to the heavy work of pressing the two together to create a printed sheet. These pressmen each personified two print extremes of marked and unmarked surfaces, because the inkmen got very dirty indeed. The ink was made from an evil brew of boiled linseed oil and pigment, and the balls were made of sheepskin with the fur inward. At night these balls were 'capped' to keep them soft; wrapped in blankets soaked in urine so the balls could be used day after day. 'Printer's devils', small boy workers, were well named; smelly and coated in the oily spirituous ink that was a constant fire hazard in printing districts. But despite radical differences of practice that meant tasks were alternately finicky or heavy, dirty or clean, the whole printing house team had to co-ordinate their work very carefully. To keep up the speed of profitable output everyone had to concentrate, communicate and plan continually. For example, printers did not usually hold vast reserves of letter types, so as soon as a particular run of pages was all printed up, the forme would be broken up into letters to build another forme that had not yet been printed (Blades 1891; Finkelstein and McCleery 2005: 49–50). When the Caxton Celebration was staged at the South Kensington Museum in 1877 to commemorate the first edition of the *Canterbury Tales* in 1477, one old inkman was pressed into service as a live attraction, dressed up in medieval jacket and hose to create an 'authentic' period printing spectacle for the exhibition (Bullen 1877; Blades 1891: 56). This event was one of many staged recreations of a largely mythical past that were put on in museums and historic sites. Dramatisations of everyday life in 'the Olden Time' gained a powerful hold on the imagination of Victorian working-class tourists in this period, and was reinforced by guide books and magazines (Hobsbawm and Ranger 1983; Mandler 1999).

Although aspects of these traditional methods could still be seen in small printing firms well beyond the nineteenth century (Rummonds 2004), such nostalgia and its cult of tradition was fast becoming outdated. Printing, pub-lishing and associated industries such as paper production changed radically during the nineteenth century due to mechanical invention and changing business practices. Many techniques that changed letterpress dated from around 1800 such as wood engraving, stereotype printing and steam-driven mechanised printing presses, as well as later changes in the second half of the century such as the development of composing and typesetting machines. In large-scale printing, machines such as Koenig's steam-driven cylinder press, installed to print the London *Times* from 1814 onwards, increased the speed of production by four times (Moran 1973; Meggs 1998). In the cylinder press, type formes were arranged into two cylinders, automatically

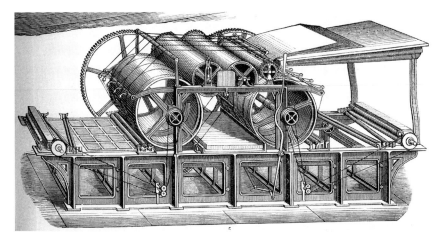

Figure 3.3 Kirkaldy double-cylinder book-machine press, from *The Popular Encyclo-
paedia* (Annandale 189–93: Plate CLXII), author collection.

self-inking, that printed the front and back of one large sheet simultaneously.
One might ask at this point how all those heavy individual metal letters and
wood blocks that had to be bolted together to create sixteen pages of text
could possibly be wrapped around a cylinder. This was achieved through
stereotyping. The vast conglomeration of individual objects (some heavy and
unwieldy and others very small and fiddly) that had made up the traditional
forme was reduced to a single object, a light curved metal plate carrying the
same relief configurations as the original set text. For newspaper printing,
eight of these curved plates, representing one broadsheet page each, would
be applied to each cylinder.

Stereotyping sounds like a dull detail of technological tweaking, but it
generated a heady amount of rhetoric and theorising that has shaped
our current views of print culture and its relation to industrialisation and
mass-production in general. The process of stereotyping helped to build the
notion of the so-called 'fixity' of texts (see Chapter 1 for a discussion of
the debates around this topic). Before stereotyping, metal letters were con-
stantly needed in the print shop for setting the next print job, with the result
that print formes were constantly being disassembled. This meant that
texts changed between editions, sometimes by human error, sometimes as a
result of re-writing; indeed many texts were changed and revised even during
the course of a single print run if mistakes were spotted in the first few sheets
(McKitterick 2003). But if stereotyped plates were used, the actual configura-
tion of texts and pages became frozen into the plate and continued until it
was worn out, possibly only decades later. Texts (and their mistakes) became
more fixed. Stereotyping was a costly process, so it was used for vast print
runs. Official texts such as schoolbooks or Bibles were produced in volume.
This branch of production has traditionally provided steady everyday
business for printers and booksellers, combining lucrative trade with a more

ideological function as the 'principal enforcement authority' of the state (St Clair 2004: 61). This led to standardisation of printed materials for mass readerships, and helped to establish notions of accuracy and uniformity that added to the authority of sacred and official texts from Bibles to banknotes (McKitterick 2003; St Clair 2004; Casper et al. 2007).

Thus standardisation through print was not the result of technological determinism; print is not inherently uniform. Instead, the drive to make printed items as identical as possible was an ideology of manufacturing in the era of industrialisation. Print and mechanisation were frequently conflated in this period so that printing terms were used both as a metaphor to guide attitudes to mass-production, but also to shape and illuminate the notion of print culture itself. For example, in the writings of Charles Babbage, prophet of the 'economy of manufactures' in the 1830s, new print techniques became his most faithful analogy when he was searching for examples of excellence in industrial production (McKitterick 2003: 211–15). For Babbage, stereo-typing was a crucial metaphor that illuminated his dream of a factory system churning out an infinite amount of mass-produced items. In the nineteenth century print culture was a discourse that supported other contemporary preoccupations with practices of copying, imitation, and the regulation of habit. Thus the idea of the stability of texts, fostered by the invention of stereotyping, supported broader aims for putting useful knowledge into orderly systems. From the end of the eighteenth century onwards language was ordered into many new dictionaries and grammars; men of science such as Linnaeus began to set out systems of taxonomy for amassing orderly observations of the natural world (McKitterick 2003: 166–71; Daston and Galison 2007), while for general readers publishing houses set out on the lucrative business of compiling and selling multi-volume and endlessly up-dated encyclopaedias (Yeo 2001).

Letterpress enterprises varied enormously in size in the nineteenth century. Large steam-driven machines overawed visitors to the printing rooms of newspapers and at the spectacular trade and industry fairs that were held in cities around the capitalist world following the London Great Exhibition of 1851. Naturally, because these behemoths were used to print newspapers, the same machines featured in stories about the power of the press. While mammoth cylinder presses increased production, the ceaseless pressure of deadlines and the need to rationalise and coordinate all stages of work meant that formats and designs became more uniform. The costs of setting up such large businesses meant that production became concentrated in fewer and larger companies and corporations (Casper et al. 2007). At the same time there were fragmenting forces at work too. Despite their traditional aura, small hand presses were also changed through mechanical innovations. In Britain, Charles Mahon, third Earl of Stanhope, invented a robust metal frame press (he also invented the plaster mould method of stereotyping) while in the US two presses predominated – the Columbian, designed and produced in Philadelphia by George Clymer in 1814, and the Washington, patented by

Samuel Rust in 1821. Such presses, sturdy and effective in amplifying the pressing power of one individual through the application of the mechanical lever principle, became available to the hobby printer and led to an explosion of amateur newspapers in the 1870s. Small commercial printers took on everyday work such as the printing of tickets, advertisements and small pamphlets for a multitude of customers (Cave 1971; Gaskell 1974; Rummonds 2004; King and Plunkett 2004; Casper et al. 2007). At the end of the nineteenth century, the private press movement contributed further distinctive strands to these various letterpress print cultures through the work of enthusiastic amateurs, aesthetic hobbyists and utopian revolutionaries (Ashbrook 1991).

Gutenberg, patron saint of 'modern industry'

In August 1837 the city of Mayence (Mainz), Gutenberg's home, laid on an extensive festival in Gutenberg's honour as an expression of civic pride and tourist lure combined in one (Knight 1864: 255–56; Flood 2000: 5–36; McKitterick 2003: 183–86; Briggs and Burke 2009: 107). This feast, somewhat premature, of the '400th anniversary' of the invention of print by movable type was intended to assert Gutenberg's status and priority of invention in the face of rival claims from rival cities touting different printer heroes (Johns 1998). Across Europe skilled artisans from the print trades took the chance to attach themselves to this publicity, such as the musical evening and dinner held by Edinburgh printers in Gutenberg's honour on 12 July 1837 (Timperley 1839: 949). Gutenberg was annexed as a figurehead, variously, for asserting national superiority (Blades 1891), liberal laissez-faire trade policies, or left-wing defiance of the status quo (Driskel 1991: 359–80). In France, the positivist philosopher Auguste Comte, aiming to found a 'religion of humanity' in the aftermath of the 1848 political upheavals in France, devised a Calendar of Great Men (1849), organised in a revolutionary style, deposing the established Christian/Roman ordering of time. Instead he proposed thirteen months of twenty-eight days each, where every day was dedicated to a heroic individual. Comte elected Gutenberg as overall patron saint of his new-style ninth month, now called 'modern industry', standing at the head of a cohort of more recent industrial heroes such as Arkwright, Watt or Montgolfier (Harrison 1892: 371–72; Sarton 1952: 332). Comte's British disciple Richard Congreve (1818–99) carried this version of the positivist creed to London in 1855 where he founded the 'Comtian shrine' of Newton Hall (Sarton 1952: 356–57; Royle 1980) that by 1900 had become a well-known centre amongst a growing international ferment of new-age visionaries, anarchists and revolutionary avant-gardists. In 1892, when Frederic Harrison, the 'happy humanist' (Wright 1986: 8–9, 101–2), published his expanded English version of Comte's calendar, he continued to eulogise Gutenberg as the father of Modern Industry: 'In the long run the world is governed by ideas ... the machine that disseminates thought is therefore the greatest of machines' (Harrison 1892: 372). This weirdly religious aura even remained in the face of challenges to

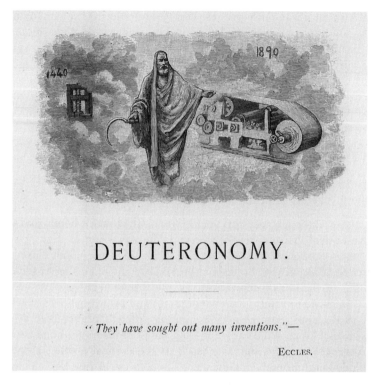

DEUTERONOMY.

" *They have sought out many inventions.*"—

ECCLES.

Figure 3.4 Illustration from the chapter 'Deuteronomy' discussing 'the repetition and development of the law' specifically in relation to the 'expansion and second birth of the press ... viz. the invention of the Steam Printing Machine' *The Pentateuch of printing* (Blades 1891: 83), author collection.

Gutenberg's supremacy. William Blades rejected the cult of Gutenberg. In his view 'heroes' were a device invented by lazy historians to save themselves the trouble of thinking (Blades 1895: 16–22). Nevertheless, in his short history of printing he actually constructed a more spookily powerful super-hero: printing itself. In Blades's hands, traditional letterpress techniques are put forward as the very law and foundation of knowledge. His *Pentateuch of printing* (1895) thus has chapter titles following the first five books of the Bible: Genesis, Exodus, Leviticus, Numbers and Deuteronomy.

Today, it is evident that the label 'Gutenberg' is still firmly established as a shorthand phrase used to mean 'the development of Western print traditions around 1450'. Sometimes this shorthand is used neutrally and conventionally to save time, but often this name simply reinforces a notion of history as a succession of heroes in accord with the 'celebrity approach' (Finkelstein and McCleery 2005). The cult of Gutenberg continues, famously with Marshall McLuhan's ecstatic techno-determinism of the 'Gutenberg galaxy' and its alleged impact on the mind of 'typographic man' (McLuhan 1962), and

more recently in the popular television documentary *Stephen Fry & the Gutenberg Press* (McGrady 2008).

The ABCs of culture

The enormous increase in the volume and the range of types of printed materials in the Victorian period was accompanied not only by increasing levels of literacy, but by the discovery of reading as a pursuit for many different classes of people (King and Plunkett 2004). Reading skills improved throughout the nineteenth century mainly though self-motivation. In Britain, literacy was high even before the 1870 Education Act enforced compulsory schooling for all (Altick 1957: 167–72). Before this, working-class readers learned to read on the one hand from 'respectable' attendance at Sunday school classes and on the other, according to Richard Altick, through the 'avid consumption' of cheap, sensational 'penny bloods' such as James Malcolm Rymer's *Varney the Vampire* (Altick 1957: 287–92; Boone 2005: 49). In the period 1750–1850, the widest distribution of cheap reading material across the country came in the form of chapbooks and broadsides. Chapmen and pedlars, 'the Honourable Company of Walking Stationers', carried their wares to towns and remote rural areas alike (St Clair 2004: 38; Cowan and Paterson 2007). Chapbooks were simple items, made from one printed sheet folded into eight pages. While most people were encouraged to read so they could study the Bible, their chapbook purchases provided very different and various material: love-songs or bawdy humour, mixed with broad political and religious satire (Cowan and Paterson 2007: 12–18). William St Clair argues that this large and thriving area of trade, at the 'boundaries of the reading nation', eventually came to function as a culture of exclusion in the nineteenth century. Children of all classes, as well as poorer adult readers, had traditionally read ballad romances and chapbooks but over time, and in association with the development of 'intellectual property' laws, the least wealthy lost access to current literature and ideas. The 1842 Copyright Act protected writers and publishers from piracy, but at a cost to readers. Cheap literature cycled and recycled often centuries-old texts and images that were not subject to copyright, supporting first the Romantic myth that common people had access to 'age-old' folk wisdom before fuelling later Victorian condemnation of muddled thinking by the poor (St Clair 2004: 356). Literacy alone was not a passport to one unified democratic print culture.

Literary scholars and cultural historians have in the past more often studied 'canonical' texts in relation to print culture, that is, writings putting forward ideas that are deemed to be innovative or influential. But as historians such as Richard Altick or William St Clair have argued, print cultures for the vast majority of readers are not like that. Indeed, for all readers just entering the world of print, first texts, however banal or ancient, have equal influence. To early readers, the material quality of the object they handle is as powerful as the text itself. Learning the alphabet is one of the earliest and most intimate

of subjective childhood experiences where the means of internalising the alphabet, of recognising letters through intoning, drawing and writing, create an 'intersection of print, oral and manuscript practices' (Crain 2000: 4). If reading develops a sense of inner subjective life, it is also a means of socialisation, a path to God or at least to improvement. Early aids to reading, for example the ABC hornbooks used from the sixteenth to the late eighteenth century, adopted the same unvarying arrangements. As well as the alphabet, and a syllabary (i.e. strings of syllables systematically presented as in ab/eb/ib/ ob/ub), early ABCs also typically displayed an invocation to the Holy Trinity, and the text of the Lord's Prayer (Avery 1995: 3–4). The form of most horn-books, a small rectangle with a handle, resembled a bat, and was named by association a 'battledore'; a name also later applied to alphabet primers in tiny books sized for infant hands, or printed onto folded sheets. Every letter in these productions was embellished with a woodcut image (Isaac 1990: 20–23; Avery 1995: 4–6; Rickards and Twyman 2001: 43–49). In the US *The New England Primer*, a printed booklet that was produced by the million between the early eighteenth century and 1860, followed this familiar pattern. Its alphabet teaching was linked directly to Biblical narrative. Although the rhymes varied with editions, often reflecting topical events (such as the Battle of Independence), the opening at A was almost invariably: 'In Adam's fall/ We sinned all', with B for Bible, through to 'Zaccheus', a frequent choice for Z (Crain 2000: 15–17).

Crain notes how, in bringing together rote learning of the alphabet with words and texts, alphabet primers demonstrate the strangeness of the mental processes involved in moving from McLuhan's 'meaningless sign' to a flow of ideas in text. This strangeness is underlined by their dual function as objects as well as carriers of information. The early reader would handle and ponder the paper pages or folded sheets, the printed letters and phrases, and the often hastily assembled or inappropriate stock image vignettes. To adult readers and collectors this is part of the charm of crudely printed ABCs as their often haphazard assemblage alerts the reader to their method of making much more clearly than more carefully designed texts for fluent readers, where attention is most immediately seized by the task of deciphering the argument, rather than the function of the lettering or the layout. The structure or 'narrative' of an ABC often presents a string of heterogeneous objects one after another, simply because of their initial letter (Crain 2000: 18). Strange chains of events emerge, with Biblical and moral narratives juxtaposed with small contemporary vignettes, as for example in the Glasgow chapbook *Child's instructor, or pocket alphabet* of 1815, where A, B and C are introduced as: 'An An-gler is one who catches fish-es with a hook/Black men and wo-men are natives of warm coun-tries/A Captain is an officer who com-mands a hundred soldiers'. Simple reading exercises, concocted for example only using words of three letters or less, presented the stumbling reader with such surreal accounts as: 'A man had a nag in a van, and the man sat in the van, and a cat sat on the mat by the can' (*Ward, Lock, and Tyler's Picture ABC Primer* of 1868).

During the course of the nineteenth century, ABCs became more 'childish', filled with homely and more reassuring objects (such as A for Apple Pie), in part due to the development of ideas amongst middle-class parents that childhood was a time of sacred innocence (Cunningham 2005: 69–70). But despite these changing ideas about early childhood, at least in more privileged homes, parents still wanted to prepare their offspring for the rigours of adulthood and schoolbooks continued to discipline and socialise body and mind through repetitive exercises (Howsam et al. 2007).

Reading has long been seen as a virtue in Western Protestant culture because it allowed the individual to engage with the Bible directly, and to ponder the word of God. Martin Luther (1483–1546) for example hailed the printing press as 'God's highest gift of grace' (Briggs and Burke 2009: 24, 62–75). In the nineteenth century, this idea developed into the Sunday school movement. Here children were offered a diet of improving moral tales, for example those published by the Religious Tract Society (founded 1799). Many of these stories built on existing popular romances and fairy tales where a virtuous sufferer is rewarded. Millions of tracts such as *The story of a pocket Bible* by G.E. Sargent were printed from the beginning of the nineteenth century, later supplemented by a flood of more permanent and prestigious Sunday school prize books in the religious publishing boom of the 1850s and 1860s (Bratton 1981: 31–67; Goodman 1994). Religious tracts were intended to convert people who were ignorant or weak in faith so they could move to direct Bible study. The British Foreign Bible Society (BFBS) was set up in 1804 to evangelise through print, and showed particular organisational flair by combining commercial, personal and philanthropic virtues in a 'Bible transaction' designed to minimise conflict amongst members. Because the Society aimed to be inclusive and non-sectarian members deliberately agreed to promote and discuss their business together in purely commercial terms in order to avoid the religious dissent and argument they knew was a constant danger. Getting the product (Bibles) out to unconverted readers was the main aim. By 1825, the Society had coordinated the printing and distribution of four million copies (helped by the latest technology of stereotyping and steam printing), and continued its work through to the twentieth century, targeting both the 'deserving poor' in Britain, as well as conquered heathens in the Empire abroad (Howsam 2002). The success of this pragmatic strategy in selling a docile version of religion to the formerly loud and bawdy English working classes in the nineteenth century enraged political and social activists. In the novel *Hard Times*, Charles Dickens showed his anger in a passage where the character Stephen Blackpool, a down-trodden factory hand, suffers an apocalyptic vision of religious denial of earthly pleasure, where the fiery letters of the Commandments took on the shape of the mills and chimneys of his working life, wreathed around with the printed word. To Simon Eliot, this passage is a confirmation that 'print products didn't just surround the nineteenth century, they penetrated and pervaded it; became so ubiquitous and so commonplace they were taken for granted' (Eliot 1995: 19).

Eliot does not expand his commentary on this passage, but in the context of the novel, we learn that Dickens intended us to see that the coercive effect of print in *Hard Times* was not uniform, but was directed towards keeping workers in their place. If printing had been a useful metaphor for industrialists striving to sell the idea of factory production, printed words were also useful in the reproduction of the social relations of manufacturing.

Steam intellects: workers, knowledge and power

Print culture and the aim of universal literacy was a focus for furious debate and the cause of various attempts at social engineering (Inkster 1985; Haywood 2004). The first decades of the nineteenth century in Britain were marked by an atmosphere of constant political ferment that had initially included both middle-class liberals and working-class radicals, all agitating for the right to vote (Rubinstein 1998: 37–46). The French Revolution of 1789 acted as an irritation to oppositions in Britain. People who were against social change, and who wanted to hang on to their privileges, saw treason and threats everywhere, whilst radical thinkers and working-class agitators began to hope that revolution might take place in Britain too. Much of this argumentation was conducted in print, with radical newspapers and pamphlets being printed illegally. Many printers were touched by this struggle, as they could have their business raided at any time on suspicion that they might be involved in criminal activities. Literacy was feared as a goad to revolutionary ideas (Prothero 1979; Desmond 1987; Haywood 2004), prompting a violent reaction in Britain after the French Revolution, marked by events such as the Peterloo Massacre in 1819 and the Six Acts in the same year intended to clamp down on uncontrolled publication (Haywood 2004: 83). Eventually, instead of revolution, changes to the political structure in Britain took place through Parliament with the Reform Act of 1832 that extended the franchise (that is, the people who were entitled to vote), but only in a grudging way. In the event, only a few men from the well-off middle classes got the right to vote, creating strong feelings of betrayal in their former allies lower down the social scale. This situation maintained the desire to continue the struggle amongst those in the majority who were still shut out from power (Belchem 1996).

This rancorous period was marked by a paternalistic approach to worker education promoted by organisations such as the Society for the Diffusion of Useful Knowledge (SDUK). While middle-class liberal reformers promoted education for the 'operative classes', their apparent philanthropy masked other less altruistic motives. Many apparently liberal middle-class observers were filled with 'fear and loathing' of factory workers. New to urban living they were seen as displaced people, cut loose from traditional communities and established systems of skill and knowledge, prone to drunken riots. Reformers hoped that initiatives such as the Mechanics' Institute movement in the 1820s might educate and refine workers though lectures and reading

rooms, with cheap educational reading matter provided by the SDUK (Tylecote 1957; Shapin and Barnes 1977). Conservative, non-liberal observers, untroubled by any desire to benefit the working classes for any reason, mounted a contemptuous attack on the presumptions of ignorant self-education by these means, and on their privileged liberal champions. Satirical responses to the whole notion of workers' education made extensive use of the dismissive catch phrase 'steam intellect' (Inkster 1985: 1–2; Secord 2000: 41–52). Comical prints and caricatures ridiculed 'The March of Intellect' that gave full rein to class hatred in the 'chav-bashing' vein (George 1967). After the Reform Act, political agitation refused to go away, but was strengthened by the growth of socialism, marked in 1848 (the 'year of revolutions') by the publication of the *Manifesto of the Communist Party* (Marx and Engels 2008 [1848]), which provoked this alarmed editorial from the respectable *Art-Journal*:

> Nothing could be more dangerous to society than for the middle classes to find their position periled and their social relations dislocated by the upheaving of intellectual pauperism from underneath ... To confer on the lower classes the knowledge which Lord Bacon rightly identifies with power, and to leave the classes immediately above them in a deplorable state of weakness ... is to prepare an assured way for a revolutionary pressure of class upon class ... Communism and Red republicanism ... are nothing more than educated distress struggling upwards against what it ... regards as unenlightened oppression.
>
> *The Art-Journal* 1849 IX: 3

Illustrated magazines and newspapers

In the world of industrial print, newspapers and periodicals became a dominant part of the market. The establishment of illustrated newspapers in the 1840s – such as the *Illustrated London News* and *Punch* in Great Britain, or *L'illustration* in France – aimed at respectable readers, is well known (Fox 1980; 1988; King and Plunkett 2004). The print market differentiated rapidly from the early decades of the nineteenth century, with areas of mass-production and distribution as well as restricted elite and specialist markets (King and Plunkett 2004). Thousands of cheaper illustrated periodicals were launched for less wealthy readers (Jobling and Crowley 1996). The thought that many poor and ignorant people might get access to reading matter was unsettling to the powerful classes. Even self-help journals that aimed to educate previously illiterate workers were suspect, in addition to the threat of illegal radical publications that called for the right to vote, revolution or worse. The *Penny Magazine* was launched in 1832 with the aim of educating and taming the lower classes. Its high-minded aim was to use wood-engraved images to cultivate the taste for art 'in a style that had previously been considered to belong only to expensive books' (Fox 1988: 8; Anderson 1991).

The publisher, Charles Knight, along with his friend Henry Brougham, was a supporter of guided education for the working classes through the means of the SDUK (Haywood 2004). Equally respectable, but more expensive, the *Art Union* (later the *Art-Journal*) offered steel engravings of artworks (see Chapter 2) as well as wood engravings relating to topics in art and design on every page (King 1985). Wood engravings were a new and respectable form of woodblock image. Earlier crude and simple images were made on wood cut along the grain like a normal plank, and were associated with cheap ephemeral printed materials such as ABCs, pamphlets or chapbooks with topical, comical and sensational easy-to-read content. Thomas Bewick developed the technique known as wood engraving: using very hard wood (such as boxwood) and making very fine cuts across the grain with an engraving tool in order to produce much finer delicate results. His work was justly celebrated in publications such as *A history of British birds* (1797) where he crafted miniature, sophisticated and evocative images of poetic landscapes. Bewick's work and that of his pupils established the techniques used to illustrate most newspapers and books in the nineteenth century.

After the development of wood engraving, the simpler blocky styles of older woodcuts were nonetheless often retained deliberately, either for economy in advertisements and posters, or in order to impart the tang of scandal to publications such as the *Star of Venus* or *Shew-up Chronicle* (a tourist guide to the brothel and music scenes of London) and to spice up the 'demoralizing' genre of low literature devoted to the lives of criminals such as *Dick Turpin*, or the *Black Pirate*, denounced by a Parliamentary Select Committee of 1851 as 'the foulest filth of the printing press' (Fox 1988). Moreover the market demand for such sensational and romantic literature ousted more self-consciously respectable journals such as the *Penny Magazine*, which closed in 1846. To combat the tide of sensation, social reformers had to think again. Straightforwardly improving publications filled with 'useful knowledge' had not succeeded, so new cheap publications were developed that included fictional content of a more uplifting tone (this is the era of the serialised novels of well-known Victorian writers such as Charles Dickens).

Some self-help publications did survive, for example the *Mechanics' Magazine* founded in 1823, creating a disputatious forum for debate, comment and mockery. It celebrated self-directed learning, and printing as the vehicle for emancipation. The frontispiece to the very first issue proclaimed an allegiance to the scientific method with its aphorism 'Knowledge is power' derived from Francis Bacon (1561–1626), alongside the figure of the Roman god Mercury, carrier of intelligence (that is, information). The journal combined a sparky, critical tone of commentary on current affairs whilst avoiding uplifting or overtly moralising passages. Despite a similar content to the more improving publications, there was little didactic or preachy tone when it was launched, instead the editors encouraged an active readership by printing readers' contributions on topics of invention, popular science and mechanical arts. Illustrations were vital to the magazine from the beginning for sharing visual

knowledge such as geometry, technical and architectural drawing. Popular science writing also flourished, in part because such writing built on a 'rhetoric of spectacular display' that shaded into a lively culture of shows, entertainments and exhibitions in the nineteenth century which, in Richard Altick's phrase, presented and sold a narrative of 'technology for the million' (Secord 2000: 439; Altick 1978; Cantor et al. 2004; Lightman 2007). Images in popular scientific publications were used to convey both the 'wonders of nature' but also to sell new and potentially alarming ideas in palatable form. For example, Martin Rudwick (1992) has shown how the use of sumptuous wood-engraved images of prehistoric landscapes filled with frolicking dinosaurs encouraged viewers to believe in a time that existed before humans. The promotion of dinosaurs to the popular imagination evidently worked, as a visit to any contemporary toyshop will show, but in the 1840s the daring of these scenes was the more remarkable for they proposed a version of the distant past that contradicted Biblical accounts of Creation. Exhibitions and illustrated newspapers were understood to give the same kind of pleasure, as urged by the article 'Speaking to the eye' of 1851:

> Those whose office it is to dispense instruction are practicing a new art. Our great authors are now artists. They speak to the eye, and their language is fascinating and impressive … the Great Exhibition itself, which is a representation to the eye, is a part of the same process. It is performing the office of a large illustrated newspaper. It is the history of modern art and invention taught by their actual products. Like sun painting [i.e. photography, that was developed around 1839] it speaks to all tongues … representations of the material world of common life … the common and the useful predominate.
>
> *Illustrated London News* 1851

Wood engravers

The development of wood engraving around 1800 encouraged the production of far more illustrated texts. Before wood engraving, anyone who wanted to insert detailed illustrations in a publication had to use different print techniques that were carried out separately. Text was printed with letterpress, finely detailed images were traditionally produced through the intaglio method of copperplate engraving, and bound into the text as separate sheets. Wood engraving, as a relief method, allowed fine images and text to be printed at once on the same page. By the 1830s, many wood engravers were working for the London print trades in the territories of 'printer culture' of this period in the parishes of St Giles, St Clement Danes, Seven Dials and Fleet Street. Wood engravers frequently worked in 'poky and squalid' premises in converted houses off the Strand and Drury Lane. Subordinate engravers, the 'cutters', trained through apprenticeship of 5–7 years, and learned during this time to discipline their eyes and their body to very close demanding work

for 60–70 hours of work a week (Martin 1939; Fox 1988). Free time would be spent in the pubs and meeting rooms in Fleet Street area, in contact with the radical political opinions of fellow engravers such as W.J. Linton (1895), and also keeping up to date with other workers such as rival engravers, jobbing artists, hack writers and printers. Wood engravers were part of a small, intimately interlinked community of journalists and editors, living in the same area, frequenting the same pubs and living an equally hand-to-mouth existence (Fox 1988).

The *Penny Magazine* in 1832 expanded the demand for wood engraving, and its illustrations were deemed the 'paper currency of art' being numerous, valuable and freely circulating (Fox 1980). By 1833 there were over 100 engravers in London, and their number continued to grow throughout the century. However, as trade expanded and became more embedded into larger, more industrialised networks of print and news production (such as the deadlines of steam-driven mass-market newspapers) levels of worker control and job satisfaction diminished. Loss of control and creativity can be seen in changes in engraving techniques and in work organisation. Initially Bewick had developed his admired style using the so-called 'white line' method of cutting where the engraver was in charge of deciding how to create and cut the image. Later wood engraving moved to the 'black line' approach. Here the engraver was presented with a pre-existing drawn image (made up of black lines) and the engraver's task was reduced to a depressingly drudging 'rat-like gnawing' (Linton 1889: 204, quoted in Fox 1988), meticulously excavating around the edges of lines already laid down by the draughtsman. This shifted creative status away from the engraver to the illustrative artist. The artists' power can be seen in the heyday of wood engraving in the 1860s, when books and journals embellished with imaginative and poetic wood-engraved line illustrations became fashionable commodities. This market provided an exhibition space, an income and a new medium (book illustration) for contemporary artists, and contributed to the fame of such celebrated figures as the Pre-Raphaelite artists Arthur Hughes (1832–1915), and Dante Gabriel Rossetti (1828–82) or John Tenniel (1820–1914, the illustrator of *Alice in Wonderland*) (Goodman 1994). Illustrated books, embellished further with decorative bindings, were intended to be bought as gifts, for example as Sunday school prizes, or as Christmas presents (McLean 1972; Goodman 1994). The invention of Christmas as a 'traditional festivity', had begun in the 1840s, when previously unknown consumer goods such as Christmas trees and Christmas cards were introduced (Connelly 1999). Publishers exploited this new retail opportunity and established the same kind of publishing cycles, with a reliance on selling showy or sumptuous books in the months before Christmas, that are still familiar today (Eliot 1995). Railway networks offered another notable new opportunity for making, selling and distributing books, for as well as providing a method for transporting books and magazines, railway journeys also prompted the habit of reading in travellers. Railway bookstalls, operated for example by W.H. Smith, provided a new market for

Figure 3.5 Detail of Plate D from *Common objects of the seashore* (Wood 1857), author collection.

publishers such as George Routledge (1812–88) who started his 'Railway library' in 1848. Routledge, whose aim was to provide 'literature for the million', was an important publisher of illustrated books. From imaginative literature and poetry, Routledge moved to the lucrative venture of cheap, popular illustrated natural history guides, for example, *Common objects of the seashore* (Wood 1857) that ran through multiple editions through to the twentieth century (Mumby 1934). These editions functioned as 'railway reading' at many levels, for they served a new urban travelling public intent on excursions or holidays at the seaside or in the country.

To the growing urban army of wood engravers, changes in work organisation around 1860 made the cutter's task even less inviting. To speed up the production of large images (for example, a double-page spread for a news item), images were divided up into small square portions that were then cut as separate blocks. Each cutter might prepare a portion that looked meaningless (for example a piece of sky), for the image would only be unified at its final assembly, when the master engraver smoothed over the joins by cutting in extra lines. The work demanded patience, self-discipline and close attention to detail, while retaining a faint if diminishing glow of artistry. Unsurprisingly, this meant that it was one of the few occupations that were deemed

to offer an 'honourable, elegant and lucrative' employment for 'educated women of the middle classes' with the result that classes in wood engraving, inaugurated at the Female School of Design in London in 1842, were amongst the first opportunities for women to gain access to art school training (Fox 1988).

Printer culture: printing, politics and the print trades

'Journalists' were seen as a new kind of worker in the 1830s, akin to the impoverished hack writers of 'Grub Street' in a previous generation. Many jobbing journalists were embedded in the printer's world, hanging around the printing house to check their proof texts, just as much wedded to the inexorable deadlines of the steam presses as any cotton-mill operative. When the *Times* installed electric lighting in 1879, the year of its invention, newspaper production moved to a 24-hour working day (Rogers 1972; McKitterick 2003; King and Plunkett 2004). Journalists and editors were employed not just to scent out 'stories' but for their ability to craft regular column inches of printed text to fixed deadlines. 'News' was not just intangible information but also a material product to be purchased. In printing houses and newspaper production plants, the two central printer trades, compositors and pressmen, were derived from traditional working practices in printing, where master printer, journeymen and apprentices shared the same intensive working and even living environment. Print tradesmen were involved in a craft with many customs marked by a distinctive terminology. The workplace, for example, was called the 'chapel' and the oldest printer the 'father of chapel'; they looked forward to the 'wayzgoose' feast with plenty of eating and drinking, held at the time of St Bartholomew's Fair in late August (Cockburn 1983; Johns 1998; Duffy 2000). As well as their manual craft knowledge, which was considerable, printers also had to have cultural skills. Printers had not only to be literate, but also had to gain a working knowledge of the specialist terms of the scholars and writers they worked with. William Savage's *Dictionary of the art of printing* (1841) carries a formidable number of such lists, from botany, law and ancient or Biblical languages. Printers had to know for example that 'Bolt. Pil.' was the agreed abbreviation that denoted the botanical authority on unusual toadstools, 'Bolton (James) *Geschichte der merkwürdigesten Pilze* Berlin, 1795' (Savage 1841: 59). Printers also had to be conversant with everyday and colloquial languages such as in advertising catalogues or goods labels, and be able to decipher the baffling mess of scribbled phrases and crossings-out that writers (such as Charles Dickens, racing to fulfil a deadline), might present as a 'finished copy' (Duffy 2000: 38). These hard-won skills meant that printer culture was strong, distinctive, and supportive of the group. This engaged group mentality meant that printers became active trade unionists and canny political operators. However, despite the fact that print workers were educated and politically aware, their brotherly solidarity did not necessarily translate into universal benevolence. While the printer trade unions

have been prominent in several important battles with the 'bosses', the issues they have fought for demonstrate some of the less heroic aspects of trade unionism such as elitism, sexism and racism.

The demand for printing work was not constant across the industry, and at the beginning of the nineteenth century the working lives of journey-men printers were very precarious. While pressmen in large organisations worked with mechanised steam presses, compositors still continued with hand setting following the now 'centuries old' method (Musson 1954). The working rhythms of these two trades came apart as printing in mechanised presses was done much more rapidly than setting the type, destabilising working allegiances. Seasonal fluctuations and trade slumps meant that workers would go 'on the tramp' moving from one town to the next; indeed, in the 1830s the compositor Charles Manby Smith, who moved from Bristol to London in a fruitless search for work, ended up going as far as Paris where there was a lucrative trade in the production of pirated versions of the work of English best-selling authors such as Sir Walter Scott or Lord Byron (Smith 1967 [1857]). Compositors in work supported their unemployed fellows, and they also formed trade societies. By the 1830s unions, such as the Northern Typo-graphical Union, existed in most large cities and many of these produced their own newspapers such as the *Compositors' Chronicle* or the *Printers' Register*. The Typographical Association coalesced in 1854 as a national trade union. In relation to other working-class political groups, the skilled print unions did not support the notion of violent protest or revolution, instead they advocated education and social advancement for their members. Some historians describe this as a 'labour aristocracy', whereby certain elite sections of the working classes abandoned political solidarity in the second half of the nineteenth century in favour of sectional trade unionism and deference to middle-class values (Gray 1981). To many on the left, this embrace of elitism by skilled workers in the trade union movement was a betrayal of unskilled fellow workers and a denial of long-term struggle for political change towards socialism or revolution.

Compositors were hostile to the idea of women as fellow workers, with reason. Unlike the heavy and dirty work of the pressmen, compositing was light work that needed nimble fingers. After centuries of disciplining in the tasks of needlework, it was universally supposed in Western culture that women were 'naturally' gifted in patient, close-focus, fine manual work (Parker 1984). Women themselves sought compositing work both in main-stream print shops and also in various independent initiatives that aimed at female emancipation in the nineteenth century, for example those run by Emily Faithfull (1835–95) in London, or of Augusta Lewis Throup (1842–1920) in New York (Reynolds 1989; Nash 2007). However, it was not easy to break in, for even if men had welcomed women as fellow workers, the infor-mal workshop culture was not acceptable to notions of gendered propriety. The compositing room had traditionally been a site of strong masculine camaraderie, a source of pride in skilled labour and bolstered with jokes,

physical horseplay and constant drinking, both at work and in the alehouse. William Savage records one 'filthy and disgusting' punishment that printers inflicted on someone who was deemed to have stepped out of line by his fellow workers known as 'capping a man', that is wrapping the offender in the urine-soaked blanket used to steep ink balls overnight (Savage 1841: 94). Skilled workers feared women as a source of cheap labour. Trade unions aimed to control their conditions of work: principally their wage rates, their working hours, and the speed of working, whilst employers wanted to break that power by finding new, cheaper and (they hoped) more docile labourers. Unskilled women workers appeared to offer one option, and some early type-setting machines, devised in the 1840s, were intended by their inventors to be operated by women 'typewriters'. Although their introduction was blocked at that period by union agitation, the introduction of mechanical setting machines such as Monotype and Linotype to large printing enterprises towards the end of the nineteenth century signalled a renewed desire of employers to assert greater control over their workforce through substituting unskilled non-unionised workers under the guise of speed and efficiency (Moran 1963; Zeitlin 1979).

Gender and union politics clashed during the production of the 1911 eleventh edition of the *Encyclopaedia Britannica* in Edinburgh (Reynolds 1989). The publisher, Cambridge University Press, wanted all the volumes to be available at one time. Such a large complex print job would be very difficult to achieve, but Edinburgh printers won this contract due to competitive pricing and because they undertook to get all the typesetting done within the required time. They aimed to do this in two ways, first by hiring women workers and second by investing in Monotype typesetting machines. Together this meant that male compositors in Scotland were in danger both from women and machines as rivals for work. The local typographical unions who had been trying for years to exclude women exploited this crisis. The threat of an all-out strike on this occasion gave victory to the male trade unionists and resulted in a ban on the recruitment of any more women as compositors in Scotland after 1910; indeed, women were barred from membership of the skilled print unions in Britain as a whole until the passing of anti-discrimination laws in the 1970s. The struggle between skilled compositors and employers for control of working conditions in the print industries in both Britain and the United States in the second half of the nineteenth century placed women workers in an ugly double-bind. Employers often hired women (and paid them lower wages) during strikes with the result that their fellow working-class menfolk treated them as both rivals and class enemies (Cockburn 1983; Casper et al. 2007). Mechanised typesetting machines also threatened to make the hard-won skills of hand compositors appear obsolete and unwanted. In fighting back against this double threat, male typographic union agitators chose to claim exclusive rights to operate these machines through a closed shop policy that excluded both unskilled workers and women (Musson 1954; Zeitlin 1979). In Chapter 6 we will see that in the

1970s and 1980s the uneven three-way tussle between unskilled workers, male-dominated craft unions and large corporations had very different outcomes for each party.

In contrast to the narratives of distanced professional expertise, based on a grasp of classical form and high culture, discussed in Chapter 2, in this chapter we have seen how compositors as skilled printing house workers and printers such as William Blades emphasised continuity with manual printing traditions by invoking Gutenberg or Caxton. When hot metal setting changed working conditions drastically, compositors fended off the threat that they might be replaced by less skilled women 'typewriters' by asserting a narrative of print culture and print traditions based on craft expertise and customary practices. Other working-class groups, the 'steam intellects' bent on education and self-improvement, were also invited by narratives of print and its craft production to see how print, and knowledge, was made, and how it fitted into an established framework of trades, values and occupations. The next chapter, by contrast, will consider a new print medium, lithography, which has been categorised since its beginnings as somehow puzzling and defying categorisation, in part because it was used by amateurs and non-specialists, and because it was a medium that explored or attempted to capture new fields of knowledge.

4 Lithography and 'improper' printing

Lithography is a medium that allows a vast range of drawn marks to be reproduced at will almost infinitely; the slightest sketch and autographic writing can be transferred directly to the plate without the mediation of compositors or engravers. Such 'improper printing' (Twyman 1990) was used to reproduce marks and symbols outside conventional typesetting systems, for example in such fields as music, non-Western languages, caricatures or handwritten pages in which text and image were freely combined. From its invention around 1800, lithography was used to disseminate exact facsimiles of historic documents, old prints and contemporary artworks. This medium could thus reproduce the authentic trace of the personal signature or intimate sketch whilst in equal measure it fuelled exaggerated fears of piracy and forgery. Lithography in this chapter will be considered as a subversive element, a perturbation in the 'Gutenberg galaxy' of print culture. For example, it elides some clear distinctions that have been made between writing and printing, or between text and image, just as it destabilised clear distinctions between original and copy.

Lithography was invented by Alois Senefelder (1771–1834) in Munich around 1798. Unlike relief or intaglio printing, this medium is 'planographic'; the inked portions of the image lie on the flat printing surface, held in place by the antipathy between oil and water. The composition of the plate must be porous to hold enough water to repel the oily ink. Senefelder's original experiments used blocks of local Solnhofen limestone, to which he applied other simple materials that were readily available (zinc also offered a suitable surface). To set up the antipathy, the stone was soaked with a solution of gum Arabic and acid and marks were drawn with 'chemical ink': a greasy mixture of beeswax, soap and lampblack (Senefelder 1977 [1819]: 101–39). Senefelder was not a printer, but a writer in the world of theatre and performance, hoping to find a cheap mode of self-publishing, and his experiments were conducted in a fairly haphazard way, apparently only stumbling on the successful method of printing from stone after he rapidly scribbled a shopping list using greasy crayon (Senefelder 1977; Twyman 1970b; 1990; Meggs 1994). Great skill is needed to get the best effects from lithographic printing by hand methods. It is hard to learn how to apply ink most effectively in order to get

the best out of different parts of the drawn image (*L'Imprimerie* 15 January 1900: 26). Nevertheless, this medium is still readily accessible to amateurs and non-specialists, because it is possible to print any oily mark that is made on the stone (as in Senefelder's initial scribbled list). Artists and draughtsmen could draw direct to stone or transfer paper and their exact marks would be reproduced without being reworked by intermediaries. 'Reproductive engravers', whether working in intaglio or relief, were no longer required. Lithography became a medium for disseminating sketch-like images, and the means by which sketchy qualities in images gained status. From art to reportage, lithography offered the contradictory pleasures of intimacy and immediacy – but in multiple copies, speaking to many individuals at once.

If lithography destabilised notions of authenticity and originality, it also unbalanced established notions of value in the fine art print trades. Steven Bann has noted how lithography was rapidly adopted in France for its 'vivid commentary on contemporary events', but despite its recognised ability to convey the authentic handiwork of the artist, it failed to gain status as a print medium in relation to established forms such as engraving (Bann 2001: 150). Indeed, the prominence of the artist's original mark in the print eclipsed any recognition of the value of the print itself or of the printer's work. Printing expertise did count towards the success of lithographs, but in unfamiliar ways. The print-buying public knew about different kinds of engraving and attached a scale of value to the work of engravers in copper, steel or wood as we have seen. But the skills of lithographic printers were invisible, consisting in judgements about inking, colour separation or registration. The hidden skills of printers thus worked negatively against them and in favour of the artist, for the more successfully the print was rendered, the more that value was transferred to the 'account of the authorial artist' (Gretton 2005: 374). Rapid, spontaneous sketches reiterated the artist's and not the printer's presence, and brought this style of working, previously hidden in notebooks and studios, out into public acclaim and onto finished canvases in exhibitions (Boime 1971). Lithography also destabilises received notions of print culture amongst historians and pundits. To writers such as Dennis Bryans, the authority of some of the most influential theorists of print culture such as Ivins, McLuhan or Eisenstein is suspect because of their allegedly 'unreliable' grasp of the true complexity of print production after the invention of lithography. To Bryans, their analysis of our most recent industrial past is seriously lacking because they were mesmerised instead by the 'fascinating and romantic' technologies of mechanical letterpress printing (Bryans 2000: 287).

It is true that many accounts of print culture concentrate on letterpress, either by choice or by default, but historians of lithography do exist. For example, Michael Twyman has addressed many aspects of lithographic printing history throughout his career from the 1950s through to the present, in part because he too had noticed a relative lack of interest in this medium amongst other print historians. Twyman attributes that neglect to

various causes. Lithography is a relatively new medium that was rarely used for conventional printing, and in comparison to the established medium of letterpress was rarely used to produce books in the first decades of its existence. The great nineteenth-century classics of fiction or ideas that attract readers and historians from many disciplines were almost all published in letterpress. Texts that were produced in lithography were often unconventional in appearance and subject matter. Lithography was seized on from the first decades of the nineteenth century for map and music publishing, for artistic or comic prints, and for small-scale unconventional books or pamphlets for specialist and 'in-house' types of publication such as military or trade instruction manuals. In *A directory of London lithographic printers 1800–1850,* Twyman notes that many lithographic printers did not register themselves under the terms of the Seditious Societies Act of 1799 (which aimed to control radical printers). Because the wording of the Act referred repeatedly to type and typography, lithographic printers quietly and privately decided to accept the letter of the law at face value, and so became less visible (Twyman 1976: 20). In addition, the handful of earliest London printers found by Twyman from the 1820s were based not in the expected areas of the established print trades (around Fleet Street, the City of London, Holborn or Soho), but were located further west, serving rich amateurs and the fine art print trade. Later expansion in the number of lithographic printers further to the east in the City of London reflects increased lithographic production not so much of books, but of printed materials for banks, insurance offices and other commercial ventures, while a similar expansion around Chancery Lane served the many legal establishments there (Twyman 1976: 15–16). As a result much lithographic printing from this period has not been preserved, having been used for rapidly produced, short-run materials of low cultural status that would have been discarded when outdated. When lithography was used for book production, often this was still unconventional in various ways in terms of layout, subject matter and clients. Such 'improper books' (Twyman 1990: 11) in Twyman's opinion thus draw attention by virtue of their inventive new formats to the 'limitations of conventional book-production methods' that had become so deeply embedded they often passed without comment.

One such limitation was the range of characters that could be printed. Many letterpress printed books left gaps where non-Roman characters or words, for example from Greek or Hebrew, were to be inserted by hand. Equally, non-conventional layouts such as tables, graphs, and diagrams that were laborious to set by letterpress methods were easily created in lithography. Certain constraints of letterpress technique, in particular the gridded layout implied by the medium, had become naturalised conventions. In lithography words, images and other decorative or graphic marks could interact in more experimental ways on the page. Lithography could reproduce almost any kind of drawn, blotched and scribbled mark, so that books could, if wanted, take on the appearance of handwritten notebooks and sketchbooks.

For Michael Twyman, who established and ran courses in typography and graphic communication at Reading University from 1968 to 1998, these styles of publishing and print design were not simply of historical interest, but resonated with the changes he saw in print production and graphic design in his own lifetime, due to major shifts in the printing industry from letterpress production to offset litho printing and photocomposition in the 1970s and 1980s (see also Chapter 6).

Amateurs and eccentrics

In the first decades after its invention, lithography was used to circulate amateur sketch journals, to document political upheavals or to protest, to publish music and to pass on fashions in clothing (Purdy 2010). Rodolphe Töpffer, university teacher and part-time artist, celebrated the free, uncontrolled and wobbly lines of lithographic sketching that he used to craft graphic narratives from the 1830s onwards. Töpffer, often regarded as the originator of the comic strip idea, recognized that unplanned markings, when applied to faces and bodies, became animated by the viewer in a new and vigorous way (Twyman 1990: 186–90; Groensteen and Peeters 1994: 10). Senefelder himself, neither an artist nor a printer, was alert to the possibilities of marketing his invention to a range of amateurs (Twyman 1990). One account of the 1890s, written in the 'popular history' mode (Bouchot 1895), describes how Lejeune, a general in Napoleon's army, was persuaded to sketch a fallen Cossack direct to stone during a visit he made to the Senefelder workshop in the aftermath of the battle of Austerlitz in 1806. The object was to demonstrate to this sceptical visitor that lithographic printing was virtually instantaneous, at a time when translating a sketch to print normally meant weeks or even months of careful labour by an engraver. According to Bouchot's account, the completed print was delivered while the general was eating his meal later that day, with the result that he carried home the news of this amazing technique to Paris and helped to promote its use (Bouchot 1895: 30–32). In this one anecdote, Bouchot neatly joined together both amateur and military interest in lithographic printing at the beginning of the nineteenth century. And as we shall see, Bouchot's book also spoke to the print culture of his own period – to the lithographic revival in France in the 1880s and 1890s that appeared to many on the left to offer a democratic art-form for the Third Republic.

In Britain, Twyman (1990: 168–99) notes the wealth of privately published unconventional books, printed in small editions. Many were produced by women authors for distribution to friends, as sketchbooks, journals and diaries, where pictures were combined with poetry or prose. Although these books were on a very small scale, and are often dismissed as the 'vanity publishing' of wealthy amateurs, Twyman argues that such productions nevertheless display experimentation with page layout and integration of text and image that was new and exploratory. Such publications are also a testimony to the practice of amateur sketching that developed in Britain as

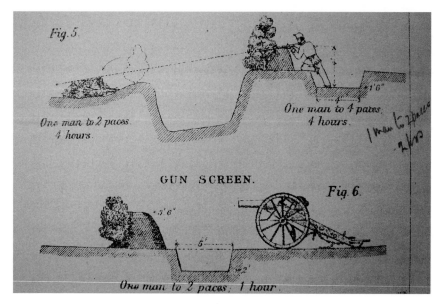

Figure 4.1 Example of 'hasty entrenchements' from *Text book of fortification and military engineering* (Ross 1884: Plate XII), courtesy of Glasgow School of Art Library Special Collections.

a means of cultivating a sense of personal subjectivity amongst the middle classes (Bermingham 2000). Equally, the intimate, momentary and diaristic qualities of the publications uncovered by Twyman show how fragmentary, vignette-like forms of expression in the Romantic period, normally discussed in association with celebrated artists as Thomas Bewick or William Blake (Rosen and Zerner 1984), were echoed by viewers in their own notebooks.

Mapping the territory: military surveyors and training manuals

Military establishments used lithographic printing as a cheap and convenient way of producing training and instruction materials and maps. Military training and operations from the beginning of the nineteenth century demanded more technological and scientific skills from officers, with strong emphasis on visual representation and draughtsmanship, for example in surveying and engineering. The establishment of the Ordnance Survey (the British state mapping service) after the defeat of Jacobite uprising in Scotland in 1745 is one example. Military teams were sent out to survey, draw up maps and facilitate road building in order to pacify previously wild Highland regions and bring them under control of central government, 'forging the nation' of Great Britain under Hanoverian rule in the late eighteenth century (Jones 1974; Alfrey and Daniels 1990: 100–101; Colley 1992; Lenman 2009: 185–206). Military efficiency came to depend on graphic communication in mapping,

surveying and reconnaissance, for the construction of buildings, fortifications and bridges, and for calculating the trajectory of artillery fire. Training in all these areas was consolidated after the establishment of the Royal Engineer Department at Chatham in 1812. Engineers gathered, presented and circulated information in multiple visual forms, such as tables, sketches, diagrams and calculations. Lithography was much better suited than letterpress and engraving for rapid transfer of these multiple visual and textual registers to the printed page. New styles of visual communication for military use were elaborated and practised in the Royal Engineer Department College at Chatham due to the efforts of Sir Charles William Pasley (1780–1861) its first director, and circulated in printed manuals. Pasley was an energetic organising officer and author with a strong interest in education (Twyman 1990: 60–67). In his opinion, the ability to draw well, to design structures and to communicate effectively using visual means was necessary for every soldier. To this end, he devised many courses to enable non-commissioned officers to teach themselves and their men (Vetch 2004) and authored many textbooks. Lithographic printing equipment was installed at the Royal Engineer establishment from at least 1822, and used to produce many internally circulated instruction manuals, such as *Exercise of the new decked pontoons* of 1823 (cited in Twyman 1990: 61–64). These manuals used handwritten copperplate script as text, with diagrams and sketches being placed freely wherever they were needed in the description, frequently with the text flowing around the images. Other British military establishments such as Ordnance Survey set up lithographic print works, in parallel with similar initiatives in neighbouring European countries such as France where the École d'Application de l'Artillerie et du Génie (the military academy at Metz) installed lithographic print works in 1824. The British military lithographic printing works at the Ordnance Survey Office, Southampton, later developed expertise not just in map production, but also in photographic imaging and facsimile reproduction of historic documents (Twyman 1990: 244–56). When the military Survey of India established their Photo and Litho Office in Imperial Calcutta they also geared up to produce a vast amount of work for military, government and business clients, ranging from simple pamphlets and diagrams to prestigious press release brochures and books featuring studio photographic portraits, landscape views and images of mechanical and scientific instruments (Renny-Tailyour 1913; Burrard 1914).

Colour, ornament and Victorian design

Lithographic plates when inked up supported a very fine film of pigment that floated off the plate onto the paper in printing. So just as lithography reproduced very small tentative marks, it could also print flat uniform areas without the ink spreading. In colour, this allowed some powerful and dramatic graphic effects. Colour chromolithography was first developed in the 1830s France and Germany, and was dependent on skilled printers and

controlled inking. One plate, usually in black, established the image and its design, while other plates laid in layers of colour, building up depth and atmosphere with each addition (Meggs 1994: 155). Although 'chromolithography' as it was known was used to illustrate books, it was also widely associated with decorative prints and colourful novelty items of many kinds. In Britain, the paper and stationery manufacturer De La Rue took out a patent for the 'Manufacture of ornamental playing cards' by colour lithography in 1832 detailing the fine judgement required in inking and registration, that is, getting each layer of colour to be exactly aligned (Easton 1958; Ferry 2003). Chromolithography was used to create advertising novelties such as a *trompe l'oeil* 'wallet' filled with coins, banknotes and postage stamps and a little memo card reminding the owner to buy 'Pears soap', or even more ingeniously in mechanical pop-up books designed by the Munich illustrator Lothar Meggendorfer (Rickards and Twyman 2001: 8–9). Colour lithography adorned trade catalogues. The military outfitters William Jones of Regent Street, London used full-colour plates, ornamented with copperplate hand-rendered wording, to present their splendid range of uniforms and accoutrements of masculine display (Jones & Company c. 1868). Sears Roebuck, the 'cheapest supply house on earth' ornamented the front page of their mail order catalogue in the 1890s with images of consumer abundance, from parlour pianos to garden tools, flowing out from their Chicago headquarters to distant rural homesteadings (Woodham 1997: 15–18).

Blocks of saturated colour, characteristic of De La Rue playing cards, form a large part of the visual appeal of the lithographed illustrated books produced by Owen Jones (1809–74), notably *The grammar of ornament* (1856), created as a designer's resource book, and which presented an eclectic compendium of ornamental motifs from Arabic, Chinese, Gothic or Ancient Greek sources. Jones, who initially trained as an architect, was an enthusiast for exotic non-Western design and a convert to the notion of polychromy in ancient architecture. He established his reputation as an authority on Moorish decorative building, after an extended study trip abroad, through an early publication *Plans, sections, elevations and details of the Alhambra* (1836–45), embellished with large lithographic colour plates based on Jones's detailed watercolour drawings on site. In the 1830s colour lithography was a new medium and Jones could not get the quality of work he had envisaged from any established printers. Instead, he taught himself lithographic colour printing and developed the sumptuous style later to become familiar in *The grammar of ornament*. The final costs of the book on the Alhambra far outstripped any income it generated from subscriptions and sales despite Jones's contribution in labour, and it was only produced because Jones was a wealthy man who was able to raise the money to complete his project (Ferry 2003: 175–88).

Shades of democracy

In France, the development of left-wing political caricature through the work of artists such as Daumier in publications *Le Charivari* and *La Caricature* in

the 1830s is well known. Daumier used lithographic drawing in crayon on the stone to develop an immediate and assertive style in monochrome, with harsh dark scribbling marks and scratched-out accents that conveyed the anger and satire of political commentary. Here the sketch-like style was used to impart urgency and a sense of involvement. Linda Nochlin conveys the scene in one of Daumier's famous prints, *Rue Transnonain, le 15 Avril, 1834* representing the aftermath of popular protest and its harsh repression by the authorities: 'we are brought face-to-face with the results of a socio-political outrage: anonymous, ordinary figures sprawled around in the wreckage of their very commonplace dwelling' (Nochlin 1971: 76). Daumier was one of several artists in this period that worked on the printed image in journals, rather than in fine art mediums. Grandville developed fantastical commentaries on the strangeness of the everyday life of fashions and commodities, while Gavarni, alongside Constantin Guys, created images of fashionable beauties and scenes of social gaiety. Charles Baudelaire's essay on Guys, 'The painter of modern life' famously celebrated the 'ephemeral', 'fugitive' and 'contingent' beauties of modern experience captured in these prints (Baudelaire 1998 [1859–63]) while rejecting the past certainties of academic art. Baudelaire's essay was deliberately provocative in creating an opposition between fashionable journal illustrations and the kind of art that might be found in galleries and museums. Most people who take an interest in art history are now very familiar with Baudelaire's essay, and its insistence that the artist's task is to capture the experience of life in the modern city. The expression of those ideas, as every gallery-goer knows, can be seen in the work of Impressionist painters with their scenes of contemporary life and use of sketchy, unfinished-looking, gestural painting techniques. However, the work of such gallery artists and their paintings was only part of the visual culture in nineteenth-century Paris. The circulation of prints in the illustrated press was an equally important space for the exhibition of new styles of expression that had previously been rejected as casual, rapid and sketch-like (Boime 1971). The close match of ephemeral subject matter and ephemeral means of expression we see in journal illustrations came to be valued as a key strategy in the development of modernism in twentieth-century art, so that the medium of print came to be adopted and revisited many times by artistic avant-gardes in the following century, as we will see. The example of lithographic caricatures shows that sketches of contemporary scenes came to be valued in art in the nineteenth century, not simply through the efforts of elite avant-gardes, consciously setting out to attack academic values, but also through dissemination 'from below' by public support for more popular print media, produced for a range of political or commercial motivations often removed from the preoccupations of the fine art world (Farwell 1977; 1989).

Although Daumier's bitterly topical satire was attacked and suppressed during subsequent turbulent changes of political regime in France in the mid-nineteenth century and was never truly revived, the 'politicised' medium of lithography still retained a flavour of democratic liberalism that was

congenial to later political reformers during the Third Republic, in power from 1870 after the downfall of the Second Empire of Napoleon III. Republican supporters such as Emile Zola promoted the power of colourful lithographic posters as a force for good, as 'a new form of print culture capable of simultaneously helping people to claim urban spaces and social and economic power for themselves' (Levin 1993: 83). Even colourful scraps and apparently tawdry decorations were congenial to this mindset, being seen as the 'poor man's means of asserting his feelings', the means by which ordinary people might 'intrude themselves' into a bleak and regimented industrial landscape (Levin 1993). In the era of the art poster in the 1880s and 1890s artists such as Alexandre Steinlen, Henri de Toulouse-Lautrec and Jules Chéret gained prominence for posters that were hailed as 'the frescoes ... of the crowd', rather than for gallery work. Chéret himself was an experienced commercial illustrator, who developed a style of allure and atmosphere full of reinvented Rococo motifs and forms in the manner of Watteau and Tiepolo. In the 1850s, seeking employment, he had gone to work in England where he designed covers in colour lithography for the sheet-music publishers Cramer and Company, and perfume bottle labels for the British manufacturer Eugene Rimmel (Collins 1985: 43). On returning to France, Chéret's work was championed in the press during the 1880s, when art critics such as Zola and J.K. Huysmans adopted the cause of poster artists in their campaign to break the power of academic conventions in art and forward the claims of the 'painting of modern life' (Collins 1985). Critics, artists and designers on the left in this period had a broad and often conflicted agenda; although they wanted to forward 'modern' art, they also wanted to break the dominance of the fine arts and elite culture. Instead, just as in the Arts and Crafts movement in Britain, championed by William Morris, they urged the unity of all applied and decorative arts, and celebrated the importance of taking delight in the design of everyday objects and images, such as posters.

The attention given to poster art by elite commentators, and the status of Chéret and others as artists of the street, meant that these ephemeral advertisements became desirable items to collect and keep. Building on this interest, publishers produced collectors' portfolio versions of smaller-scale reproductions under titles such as *Les Maîtres de l'Affiche* that found their way into the homes of middle-class buyers and art students. In the 1890s, commercial art for advertisements was an expanding area of graphic design, of interest to both consumers and students training in schools of art; indeed, the copy of Chéret's poster *Lidia* illustrated here (Figure 4.2) is taken from one of these portfolios of small prints that found its way into the library of Glasgow School of Art at this time. But as middle-class collectors began acquiring poster reproductions as commodities, so also the enthusiasm of left-wing propagandists of poster art in the street diminished. When writers such as Huysmans really looked at the content and marketing networks of poster production, they felt disillusioned by the 'painful recognition that the poster was an integral part of a new, highly commercialised industrial

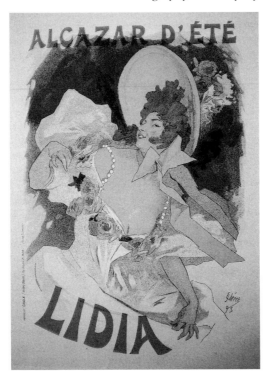

Figure 4.2 Jules Chéret *Lidia*, portfolio size edition 39.5cm × 28.75cm (original poster
 1.24m × 0.88m), one from the monthly series *Les Maîtres de l'Affiche*, Paris:
 L'Imprimerie Chaix June 1896, courtesy of Glasgow School of Art Library
 Special Collections.

world' (Levin 1993: 102); that 'festive' quality in the images was there to lure
consumers to branded commodities such as beer, soap or bicycles.

In America, although colour lithography was equally promoted as the
'democratic art' by publishing businesses (Marzio 1980), elite cultural
commentators scorned this medium as a kind of fake art from the start. Peter
Marzio notes how the editor of the *Nation* attacked popular publications
as an ugly and false 'chromo-civilisation', in which a 'smattering of all sorts of
knowledge' had led to a cheap, assertive, 'pick-up' culture, painfully 'ignorant
of its own ignorance' (Marzio 1980: 1–2). This invective was to be repeated in
very similar terms a century later in Clement Greenberg's famous essay
'Avant-garde and kitsch' of 1939 in which he blasted as '*Kitsch*: popular,
commercial art and literature with their chromeotypes, magazine covers,
illustrations, ads ...'. Similarly, these were all seen as the evil products of
'what is called universal literacy' (Greenberg 2003 [1939]: 543). American
colour lithography was indeed distinctive, colourful and 'popular'. The
'Boston school' of chromolithography developed a style of 'high realism'
achieved with careful tonal gradation and a muted naturalistic colour range

Figure 4.3 Partially completed copy exercise, late nineteenth century, from one of *Vere Foster's Copy Books* (No. 10) London: Blackie & Son, author collection.

typically deployed in portraits that according to Meggs pioneered a 'photographic' look before photography was invented (Meggs 1994: 156). With the invention of Richard Hoe's rotary lithographic press that increased printing capacity sixfold, colour lithography developed into a mass-market industry. In the 1860s Louis Prang and Co. produced highly ornamental printed items such as ephemeral scrapbook images, Christmas cards and also more expensive art reproductions. Prang's images were built up with graded colour layers, omitting any black tonal overlays, a technique well suited to reproduce the effects of atmospheric painting, such as the sublime colour effects of Alfred Bierstadt's romantic images of the Californian wilderness of Yosemite that were Prang best-sellers in the 1870s (Marzio 1980: 95). In addition to the critical hatred that was directed against allegedly sentimental chromolithographic images and their lower-class buyers, Meggs also claims that letterpress printers and admirers of fine typography were appalled by broader changes in graphic design language that emerged from the growth of lithographic printing. Lithographic designers, working on the drawing board instead of the compositor's metal press bed, could invent any letterform that pleased their fancy, allowing lettering to run and flow into and around images. Lithographic printing companies such as the Krebs Lithographing Company used such free layouts in strong and vibrant colours to advertise exhibitions, theatre productions and circuses, attracting business away from more traditional printers (Meggs 1994; 158–62).

Handwritten: individualism and getting on in business

Many lithographic publications in the nineteenth century used handwritten script, produced by lithographic writers who developed their skill in reversed writing from copy manuals, using scripts such as copperplate or English round hand (Twyman 1990: 28–32). In *Art and the material book in England* (2002), Gerard Curtis reminds us that formalised hand scripts were the standard vehicles for many official communications. In a commercial age of clerks and counting houses, built on the technologies of ruled ledgers and fine copperplate handwriting, penmanship was at a premium, and acquired through the

discipline of repetitive copybook exercises. In teaching manuals, letters of the alphabet were frequently characterised as looking like images of natural objects or animals (with the letter Y as a palm tree for example). Learning to read, starting to write and the rudiments of drawing skills were all inculcated at the same time through hand, eye and memory training gleaned from printed manuals (Curtis 2002: 11). Thus, claims Curtis, hand-drawn linear markings had a special significance for both producers and viewers in Victorian England, and created unified 'visual and textual systems' (Curtis 2002: 9). The work of clerks, journalists and secretaries of all kinds in business and 'news' industries relied on having cultivated legible and rapid handwriting, supplemented with shorthand writing techniques. Systems of penmanship, such as those promoted in the US by one Platt R. Spencer, inculcated a discipline of hand, body and spirit in the interests of cultivating a good personality for working in a commercial business environment (Drucker 1995: 245–47). In Britain, Isaac Pitman invented one of the most successful systems of shorthand, which he called 'phonography', and promoted his business through lecture tours and publications such as the *Phonographic Journal* from 1842 onwards (Twyman 1990: 146–65). In effect, Pitman developed a pictographic script with thousands of minutely differentiated linear marks and glyphs. Differentiation was the key; an exactitude underwritten, literally, by Pitman who chose to use lithographic printing to sell his system as he could scribe the various marks onto transfer paper himself. For students of this system, remastering this invented language of mysterious glancing signs from the pen of Pitman was frustrating, and well described by Dickens in the mouth of his semi-autobiographical hero David Copperfield, struggling with the 'unaccountable consequences that resulted from marks like flies' legs' while teaching himself the craft of parliamentary reporting, journalism and authorship (Dickens 1900 [1850]: 571).

Autographic marks were characterised as a trace of the creative imagination of authors and artists (Curtis 2002: 7). Perversely, autographic drawings and handwriting gained extra value in this period because they were circulated through printed copies. Lithography provided the means for reproducing and marketing such traces of authenticity. Original signatures, prints, drawings and rare copies of old books and manuscripts could be rendered in facsimile by lithography through several routes. Texts and images could be traced to stone or transfer paper. More invasively, original prints could be treated as if they were a lithographic plate; that is, if the paper was damped with gum arabic and acid, new ink could be applied to the original inked marks and prints taken. This method of taking a print from an original printed page offered a true facsimile with the added lure, as in the cult of relics, of taking an image from direct contact with an original that might be centuries old. This was a violent form of homage or appropriation because it effected drastic change or even destruction of the original. Finally, in photochemical processes, originals could be photographed and the negative could be exposed direct to sensitised stone or paper, for processing and inking

up (Twyman 1990: 201). Photolithographic techniques of copying photo-graphically onto zinc plates (photozincography) that were developed around 1860s opened up the possibility of copying almost any printed or hand-made document and image and reproducing it, and led to the production of facsimile copies of historical documents. Photozincography was developed at the Ordnance Survey Office, Southampton in the military printing works. Originally it was intended to use this technique for making accurate printed plans at a reduced scale, but the Office got involved in a piece of national heritage-building instead when they started to make prestigious high-value reproductions of national manuscript holdings such as the Domesday Book. The facsimile craze lasted for several decades through to the late 1870s. Several facsimile copies of Caxton's works were released, using photo-lithography, in the 1877 celebrations noted in Chapter 3 (Twyman 1990: 256). However, this process also suggested that more alarming possibilities − forgery and copyright piracy − were equally achievable. Previously, 'piracy' had entailed a certain amount of skilled labour, for example in engraving a faithful copy of a banknote as seen in Chapter 2, or by re-setting the text taken from another printed copy of one of Sir Walter Scott's novels (as we saw in the Paris editions that were set by the tramping compositor Manby Smith in Chapter 3). Creating fakes by photolithography was much simpler and more cost-effective.

Leisure: music, home decoration and other sociable pleasures

Senefelder made his experiments in order to speed up music publishing. One of the earliest known surviving lithographed books was an edited catalogue by A. André of Mozart's work, published in Germany around 1805 (Twyman 1990: 40). Most lithographed music was produced in Germany and France, although the Royal Engineer Department printing works in Britain issued some military music and bugle calls (Twyman 1996: 389). But lithography served the music business even more in the nineteenth century as a medium for decorative and appealing sheet music covers and music manuals such as Ferdinand Pelzer's *A practical guide to modern pianoforte playing* in 1842 (Scott 2001: 52). After the invention of the piano in the late eighteenth cen-tury, and the subsequent development of cheap factory-built upright pianos during the nineteenth century, the trade in music publishing became profitable and intensely competitive (Scott 2001: 46). Music publishing ran in tandem with concert promotion, from respectable music festivals to end-of-the-pier entertainments in seaside resorts. Music making was a communal and cultural activity, and regarded as a suitable leisure activity for the feared 'masses', particularly in approved outlets such as choral societies or colliery brass bands. Different publishers settled in different niches, with Novello in pushing oratorios, or Boosey in promoting ballad concerts (Scott 2001: 201). Very popular pieces were transcribed and arranged for many different combinations of amateur performers, from piano and singer in the parlour, to choral

Home, Sweet Home

Figure 4.4 'Home Sweet Home', chromolithographed postcard, with hand inscription 'A Merry Christmas', late nineteenth century, author collection.

arrangements, brass bands or organ (Scott 2001: 122–24). By mid-1890s music publishing began to be dominated by American compositions using the simpler emotional styles of Tin Pan Alley, and the scope of the music business expanded again due to aggressive marketing, through the visual appeal of colourful lithographed cover sheets and through 'pluggers' hired to applaud the songs in vaudeville performance. Home entertainment, singing around the piano, offered a 'takeaway version' of the pleasures of music hall, operetta or dance halls, and also built in echoes of other leisure sprees and activities, with titles such as 'The Railway Guard', 'The Croquet Gallop', or 'A Motor Car Marriage'. Although this trade gave work to thousands of now unknown composers and lyricists, it was equally an important branch of commercial art giving work to artists, designers and printers (Rickards and Twyman 2001: 291–95).

Colour lithography has had a bad press as the source of allegedly foolish and sentimental kitsch. Looking at fancy album covers or perfume labels might appear as a trivialising way to approach popular music making, or the work of Jules Chéret. But these examples of such ephemeral, emotional and colourful products of colour lithography destabilise the notion that print culture is a medium for general intellectual improvement, or 'information transfer'. This, however, is a very limited concept of the value of prints to many users. Attacks on frivolous, sentimental, kitschy chromolithographs and similar print productions have often been framed as an attack on consumerism, with the suggestion that consumers are mindless victims of brainwashing.

These critical attacks often mask class antagonism (with the suggestion that the uneducated lower orders are too stupid to see what the critic can see only too clearly). Further, these attacks are often gendered too. Design historians such as Penny Sparke have shown how women, constrained into a domestic sphere in the nineteenth century, were encouraged to enjoy decorative and frivolous pursuits, but were simultaneously denigrated for their lack of intellectual clarity and wider interests by their menfolk (Sparke 2010 [1995]). Ellen Gruber Garvey shows us how a similar kind of domestic sphere, but now allied with lessons in consumerism, was reinforced in women's magazines at the start of the twentieth century. At this time, publishers made a change in the business footing of magazines, moving towards generating income from advertisements rather than from sales, by reducing the cover price and attracting advertisers so that by 1905 there were 20 such general publications sharing a circulation of 5.5 million. This incursion of the 'adman in the parlor', as Garvey has it, aimed to train young women for domestic life in a consumer economy that was becoming permeated with slogans and brand names (Garvey 1996: 80–92). To reinforce brand names, advertisements and trade cards were given away in attractive chromolithographed formats, with visual themes such as pretty children, flowers or birds. Readers were encouraged to collect these images in scrapbooks, or to trade them with their friends (Garvey 1996: 16–50).

But in these social activities we also see that scraps and decorative arrangements gave value to friendships and to domestic spaces. When Clement Greenberg attacked kitsch as 'vicarious experience and faked sensations' he meant to denote the second-rate quality of the life of impoverished ill-educated people. However, some of the cheapest and most apparently ephemeral printed objects are often invested with different and much deeper cultural meanings by their users than the flashy superficial fun that is denoted by the knowing label of 'kitsch'. We can see this in the old postcards laid out in volume at antique fairs and street markets. Postcards first came into use around 1870, and by around 1900 the idea of sending postcards as part of the experience of leisure travel had become a jolly pastime and a commercial craze (Rickards and Twyman 2001: 249–50). But the testimony of many of the postcards that have remained through time often convey more monumental and private significance that take us beyond superficial judgements about 'fake art' or 'unoriginal expression'. For example, the chromolithographed postcard in Figure 4.4 shows a Constable-inspired pastoral scene of cows by a river and the printed legend 'Home, Sweet Home', with the second text 'A merry Christmas' inscribed across the top by the sender. The very awkwardness of these incongruous juxtapositions, and the continuing existence of this card, remind us that this card lingered in someone's domestic space as a memory object and a link between friends. Some of the cheapest printed objects continue to fulfil memorial and even sacred functions, as for example in the prayer card to St Joseph (Figure 4.5). On one side there is a contemporary laminated reproduction of a nineteenth-century chromolithograph with

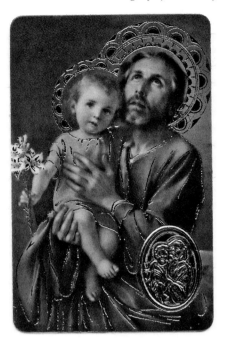

Figure 4.5 Contemporary prayer card to St Joseph, with image in nineteenth century chromolithograph manner, 2011, author collection.

gold decorations, on the other a short prayer. Prayer cards are given as small gifts on significant occasions and, like the Christmas postcard, take on true and complex meanings in personal lives. Home and church are both spaces in which women have developed social, creative and organisational talents, but within the constraints placed on their sex. In church, just as much as in the Victorian parlour, this results in 'kitschy' expressions of devotion expressed through a surplus of decoration (McDannell 1995).

Foreign bodies and undecipherable texts

Lithography, developed in Europe, was almost immediately used to capture and disseminate unfamiliar non-Western written discourses in a period of European colonial expansion into all regions of the globe. In the Middle East and India, administrators and oriental scholars accompanied conquering armies and merchants, intent on studying the languages and cultures of these regions (Said 1978; MacKenzie 1995). Studying these cultures brought distant territories closer to European control. Western colonial ambition extended not just into geographical space but also backwards in time, as archaeological expeditions took possession of artefacts for European state museums that were being amassed with the aim of creating a narrative that linked the 'civilised nineteenth century with the race of the primeval world' (Malley

1996: 161). Scholars wanted to decipher, then connect, families of languages into one vast net. Discoveries such as that of the Rosetta Stone during the Napoleonic campaign in Egypt in 1799 offered a key for deciphering ancient hieroglyphics for the first time. But printing unknown languages in written form was expensive and often impossible in the established medium of letterpress. Cutting and founding type and then composing texts even in known non-Roman scripts such as Greek or Hebrew required a familiarity with these languages from readers and printers. In Europe, Renaissance printers such as Granjon or Plantin had developed non-Western types for scholarly publications, while in Rome the missionary organisation of the Catholic church, the *Propaganda Fide* (f. 1626), also ran a polyglot printing office (Hanebutt-Benz et al. 2002). However, apart from missionary use, demand for such European printed texts was low, and editions were expensive. In Europe specialist scholars were the only buyers, whilst in other parts of the world native readers were suspicious of local scripts rendered in print. Letterpress was too unfamiliar and too clumsy. For scripts in languages that were completely unknown to scholars and printers from newly encountered regions of the world or from ancient inscriptions such as cuneiform, lack of knowledge made it difficult to even begin the processes of abstraction and synthesis that is inherent in typographic design for letterpress characters. Inscribing texts by hand from observation direct to lithographic stone or transfer paper offered a workable cheap alternative, universally adopted for the task of deciphering Egyptian hieroglyphic inscriptions. Influential groups such as the Royal Asiatic Society of London (founded 1823) also promoted lithography as the best medium for studying contemporary languages such as Farsi, Sanscrit, Chinese and Arabic (Twyman 1990: 126–45).

Outside Europe, in the Middle East or in China, texts had been printed with wood blocks for almost a thousand years before the development of movable type in the West (Hanebutt-Benz et al. 2002: Baron et al. 2007). After Gutenberg, knowledge of printing and type-founding techniques quickly spread beyond Europe, for example printers began setting Hebrew texts with metal types in Constantinople and Fez from around the beginning of the sixteenth century. However, Arabic texts produced by European printers did not succeed because they appeared to be 'foreign' with errors both in language and orthography. Muslims, with strong established cultures of book learning and scholarship, regarded their script as sacred. Because they looked hard at texts and the forms of words, they were very sensitive to the mistakes and awkward effects of letterpress (Roper 2002). In addition, distrust of printing came from different conceptions of learning and scholarship than those held in the West. In the widespread Muslim territories, scholars and patrons constantly exchanged information, travelled around to hear other viewpoints and applied themselves to the production of books. Understanding, particularly of religious texts, was believed to come only from recitation: reading out loud and memorising in the presence of someone who had already undergone this process, so the sacred words could be understood and taken in

to the heart. Print destroyed that person-to-person transmission, and although the existence of printed books was well known, religious leaders continued to withhold approval of the medium until the nineteenth century (Robinson 1993: Sardar 1993: 43–59). Thus Sultan Bayeizid banned printing in the Ottoman Empire in 1485, although this ban did not apply to his non-Muslim subjects (Glass and Roper 2002: 177–205).

In the nineteenth century, reactions against Western print technology became even more fraught, because of European colonial incursions and 'print campaigns'. After the French invasion of Egypt (and the discovery of the Rosetta Stone) at the end of the eighteenth century, Napoleon set up the Imprimerie Nationale in Cairo in 1799 to issue military orders and proclamations and to produce the newspaper *Courier de l'Egypte*. The majority of the Egyptian population was hostile to these publications but some members of the Egyptian ruling particularly if they had reforming and modernising aims, saw possibilities they might use themselves to consolidate power (Glass and Roper 2002: 182–85; Mitchell 1991: 128–33). In Morocco print was initially perceived with even greater suspicion than it was in Egypt but became accepted as a medium that would enhance Muslim culture when Muhammed at-Tayyib ar-Rudani set up a lithographic press in 1865 to produce school textbooks and other respectable works such as an edition of a revered Islamic mathematical commentary on Euclid (Glass and Roper 2002: 204–5). Unlike letterpress, lithography was more acceptable in many parts of the Muslim world, because it could reproduce handwriting directly. Although calligraphers and scribes (a powerful occupational group) mounted an effective campaign against letterpress, they were not so hostile to lithography, for lithography was seen as a confirmation of the calligrapher's skill and techniques, a kind of 'printed manuscript' (Marzolph 2002). Lithographed editions of the Koran were printed in many Middle Eastern and Indian centres from around 1830. Lithography was also used as a shortcut to facilitate the production of numerous cheap hybrid 'handwritten' texts, printed in black ink only, with gaps left for hand-painted and gilded decorations to heighten the impression of handiwork.

In India, Britain's trading and imperial incursions over three centuries created a turbulent fermentation of print cultures that were complex and localised. In *Indian ink* (2007) Miles Ogborn notes that many established views about print culture, based on Western experiences, were destabilised by the realities of printing in India. He argues that neither the 'long-standing' myth that printing promotes freedom nor the more recent myth that print is an instrument of tyranny can hold up in these circumstances. The East India Company traders found themselves up against a complex culture in which religious sects and legalistic debates generated an argumentative culture dedicated to close critical reading with a keen understanding of writing as the exercise of power (Ogborn 2007: 17–18). Ogborn also shows the murky nature of the first Western press established in Calcutta in 1777 by one James Augustus Hicky, 'the most objectionable rowdy that ever landed in Calcutta', who printed the *Bengal Gazette* as a gossip rag simply to annoy

and embarrass his enemies. Western missionary organisations did interest themselves in converting the Indian population to Christianity, but these were very diverse and there was no common strategy or approach (Ogborn 2007: 200–210). The Wesleyan Missionary Society, based in Madras, supported one Elijah Hoole in his travels, ministry and study in the region in the 1820s, where he was in competition with other Christian evangelists, not least the Jesuit missionaries who had established a shrine at the reputed grave of St Thomas the Apostle several centuries earlier. Hoole studied Tamil with a variety of native teachers and scholars, speaking warmly of their personal qualities and the breadth of their knowledge (for example, he reproduced a lithographed example of Tamil poetry by one his teachers), even when they refused to convert to Christianity (Hoole 1829). The sheer diversity of missionaries and of languages developed a two-way cultural transformation, rather than a simple imposition of alien Western culture. The British Imperial Government, and the British army in India imported their own printing plants for internal administration and for propaganda, but these forms of knowledge were also subverted and re-shaped by the many channels of information, knowledge and writing that already existed in India (Ogborn 2007: 19).

While Western powers may have attempted to use print to impose control on colonial territories, print technology was frequently adopted by the colonised for resistance. In Egypt, younger protesters involved in nationalist political agitation lost their suspicion of print to produce subversive lithographed books and newspapers (Mitchell 1991: 128–33; Anderson 2006: xiv). In North India, even before the British fully developed their Imperial ambitions, Muslim groups began to develop printing and publishing initiatives in Urdu. Print businesses catered for many publics in this region (Bhandari 2002). Some businesses, such as the launch of the daily newspaper *Avadh Akhtar* catered largely for a wealthy local elite of readers, with digests of social events and world news (Stark 2003), while other print initiatives were more politically slanted as a new and deliberate strategy to defend Islam. In these circumstances print was no longer seen as a danger to religious faith, but a weapon for defence because Muslim minorities in North India feared both the Hindu majority and the conversion attempts of Western missionaries. Thus the adoption of printing in North India launched 'an era of vigorous religious experiment' of pamphlet wars and partisan newspapers where forms of Islamic fundamentalism, based on a worldview of Muslim brotherhood were first developed (Robinson 1993; Sardar 1993). In other parts of India under direct British rule, print was equally a vehicle for protest. Despite constant closure and repressive laws imposed by the Imperial authorities, newspapers in vernacular languages were easily and frequently launched in late nineteenth-century Bengal, thanks to lithographic printing that could multiply handwritten copy quickly and cheaply. *Almora Akhbar* for example launched in 1871 to campaign against social injustice and corruption, with anti-Government commentary, exposés of violent acts and features on

topics such as bonded labour, forestry, juvenile education or women's rights (Kesavan 1997: 275–307).

In comparison to older, more established mediums such as letterpress and intaglio engraving, this chapter introduced lithography as a 'subversive' medium. Lithography breaks up some of the clear separations that those older mediums made between writing and printing, or between text and image. The medium was open to amateurs or non-specialists, raising questions about control of production and making it harder for viewers to judge value, either in relation to the level of skilled labour that had gone into a print, or because it was harder to discriminate facsimiles and forgeries. Lithography was also a medium of decorative colour effects, used to create printed novelties for pleasurable or frivolous ends, contradicting the austere view that print is a democratic and progressive technique for education and information exchange. Finally, lithographic subversion does not just affect our concept of what printing is or can do in a formal way, but also challenges established ideas of good taste or social hierarchy. This chapter considered lithographic printing in isolation, before it was combined with photomechanical processes. Chapter 6 will consider aspects of the 'improper printing' associated with photolithography.

5 Greyscale

Half-tone printing and the age of photomechanical reproduction

To English-speaking readers in humanities, the phrase 'photomechanical reproduction' frequently invokes Walter Benjamin's influential essay 'The work of art in the age of mechanical reproduction' (1936). Benjamin (1892–1940) was a German Jewish writer, theorist and social critic active in the decades leading up to the Second World War. He claimed that new photomechanical forms of media representation such as film or photomagazines were a revolutionary challenge to established elite forms of art. He developed his ideas by observing practical avant-garde graphic experiments of montage artists such as John Heartfield or Hannah Höch and by absorbing the theoretical atmosphere of critical debate generated by the Marxist-oriented 'Frankfurt School', named after the Institute for Social Research, Frankfurt, founded by Max Horkheimer in 1923, set up to investigate the formation of cultural attitudes in contemporary society. Benjamin's insights into matters such as the status of photographic representation in media networks of communication and the changes effected by mechanical reproduction had on our perception of artworks were prophetic and thought-provoking, but his writings at the time were not the canonical texts that they have become today (Elkins 2003; Jennings et al. 2008). Benjamin and the revolutionary avant-gardes are now widely known in retrospect. Avant-garde strands of critical practice from the 1920s, now almost a century past, are a vital part of the mythology of print culture today, but it would be misleading to consider these in isolation from the many and diverse examples of photomechanical reproduction that were freely circulating elsewhere in print by around 1900. In popular journalism the adoption of photomechanical half-tone images as illustrations accompanied changes in marketing, content and design strategies. Photographs were 'news'; for example, the *Daily Mirror* ran a full-page image of stricken bystanders hearing of the loss of the Titanic on 22 April 1912, used to give a sense of immediacy and the raw 'facts' of an event, but displacing text spaces of comment, argumentation and analysis. Decisions to use photographic illustrations were accompanied by different kinds of campaigns to persuade viewers that photographs were good visual testimony.

From its beginnings in 1839, many observers of photography characterised the process as a kind of automatic imprint or trace, where nature was being

forced by man to 'represent herself' through new chemical and mechanical processes (Gernsheim and Gernsheim 1968; Scharf 1974; Schaaf 1992; Batchen 1999). Photographic imaging made use of the chemistry of certain silver salts that were sensitive to the effects of light. In Talbot's process, for example, common writing paper was steeped in a silver chloride solution that on exposure to light broke down into tiny particles of silver, forming the image. This exposure created a 'negative' that in turn was used to print multiple positive copies by contact. In daguerrotypes, the process captured exceptionally fine details invisible to the naked eye – to uncanny or supernatural effect. Commentators marvelled at the fact that light could travel directly (for example) from a loved person to the plate, preserving a true fragment of a past moment, both intimate and yet authoritatively sealed off from the present. As noted in Chapter 1, photographic printing was not readily compatible with other print mediums. First, most established commercial printing processes produced linear markings of uniform tonal value, whereas photography, with its fine silver grains, produced a continuous tonal scale of greys. Second, the chemical procedures of photography, the darkroom, silver salts and water washings, were far removed from the habitual materials and techniques of other print mediums where oily, carbon-based ink was applied to paper through heavy pressure. Finally, these two industries were located differently, and recruited different kinds of workers (Jammes 1981). Sunshine, not steam, was the motive power of photographic printing until the twentieth century, and many early businesses ran to seasonal rhythms, close to light and running water. Such technical and logistical difficulties meant that it was difficult and expensive to devise ways of using photography in print and these discontinuities complicated the alliance of photography and printing from the start, so that photomechanical reproduction developed in many different and hybrid alliances of technologies.

Photomechanical image reproduction does not necessarily make photographic images for print. The first photomechanical methods in commercial use exploited light chemistry as a pragmatic addition to traditional print mediums to speed up image transfer, not to reproduce the graded tonal images of photography (Nadeau 1994; Beegan 2008). For example in plate production for photolithography or photogravure, chemical mixtures such as gelatine bichromate that hardened on exposure to light were used to transfer artwork to lithographic or intaglio plates, by masking off areas of the plates ready for further processing. Photographic transfer techniques were also used in the wood-engraving industry from the 1850s. Even though it was not possible to reproduce photographs at this time, publishers sometimes announced to readers that a wood-engraved image had been derived from an original photograph rather than a drawing, and in these cases they asked engravers to modify their cutting techniques to simulate the continuously graded tonal effects of photographs and captioned these images accordingly, for example in the *Illustrated London News* of 6 September 1851: 'The Great Exhibition: the west nave viewed from the north east gallery (from a daguerrotype by

Claudet)' (Beegan 1995: 261). Towards the end of the nineteenth century, photomechanical techniques for creating relief printing surfaces in metal (that could be combined with letterpress) were also developed. Collectively known as 'process' prints, these techniques were used either for black and white line artwork (dealt with in more detail in Chapter 6) or, in combination with 'half-tone' screens, for tonal images. By the 1880s photographic imaging methods had become thoroughly mixed up with existing print production methods, when publications such as *Picturesque California* (1888) displayed a 'menagerie of mediums' so that techniques such as etching, photogravure and wood engraving all jostled on one page (Jussim 1974: 284–88). In her study of American book and periodical production in the period 1865–1905 Estelle Jussim shows us how commercial artists deliberately played with levels of illusion in their work, for example in the work of William Hamilton Gibson and his book *Sharp eyes* (1892) that assembled many different mediums into one layered image. Thus on a page headed 'Through my spectacles', we see a *trompe l'oeil* effect that appears to show a pair of folded wire-framed spectacles laid on top of the page, whose ordinary letterpress text was embellished with a hand-drawn initial letter T. All these effects were married together by a combination of process half-tone and line block engraving (Jussim 1974: 186–87). While Gibson's work achieved its sophisticated effect through a particularly knowing and self-referential use of photomechanical imaging, 'process' illustration was also exploited much more straightforwardly at the end of the nineteenth century to embellish mass readership publications at low cost. By around 1900 adventure yarns, detective stories or romantic fiction almost all carried at least one frontispiece illustration in half-tone (Figure 5.1).

The work of historians such as Jussim, Beegan and Tom Gretton, with their micro-histories of half-tone printing, served to modify the broader claims of earlier writers such as William Ivins, Jr in *Prints and visual communication* (1992 [1953]) about the effect of photography on print culture. Ivins was the first curator in the department of prints at the Metropolitan Museum of Art and at the time his arguments were influential because, unexpectedly, he did not give a connoisseur's guide to fine art printing. Instead he characterised print as a channel for reliable communication of 'exactly repeatable pictorial statements' that fuelled 'modern life and thought'. One key point of Ivins's argument rested on an unfavourable comparison between the era of engraving and its alleged 'tyranny of line' against the virtues of photographic images in half-tone. Ivins held that photography, unlike engraving, was 'syntax-free', by which he meant first that it escaped the remediation of the engraver, and second that the marks of photographic grains are so minute they are undetectable and are produced automatically (Ivins 1992: 49), as it were, by 'Nature' herself. Ivins developed his contested idea of syntax-free images because he believed that communication and knowledge transfer is the main function for print. He valued observational data and consequently placed a high premium on images, like photographs, that appeared to offer a direct view of reality.

" When you are going to be angry with me, say to yourself, 'It's only my child-wife.'"
Page 676.

Figure 5.1 Frontispiece to *David Copperfield* (Dickens 1900), watercolour illustration reproduced in half-tone in the uniform pocket edition from Thomas Nelson and Sons, author collection.

Ivins's technological approach was innovative and still retains power today, even though a few examples will demonstrate that looking at photographs is not like looking at real objects. Photographs do have 'syntax', as they are manufactured images with a wide range of different surfaces and styles in their appearance. The same subject rendered as a daguerrotype in 1840, or as a Sunday magazine colour supplement item in 1970 differ as images; and neither of these resemble the lived experience of vision. In fact photographic images (re)produced in standard print mediums through half-tone screens at low resolution display their process of mediation quite bluntly as an array of dots (Jussim 1974; Crawford 1979; Snyder 1980; Maynard 1997). Ivins's account was also misleading when it suggested that photographic half-tone images arrived fully formed and replaced other print mediums in a decisive way whereas photographic imaging methods were developed in a piecemeal hybrid fashion in various combinations with printing operations. Finally, close description of the production and reception of photographic images, for example in the work of Estelle Jussim, demonstrates that photographic imaging was not always a vehicle for truthful witness but on the contrary gave artists and designers a simple means for assembling fictional illusory spectacles.

Photomechanical truth: photographs as contested evidence

Despite clichéd ideas that Victorians had a naïve belief in the truth of photographic images, or that early film audiences ran in terror from the sight of a train pulling in to a station, such urban myths are not true. In fact, the use of photographs as evidence whether in science, in law or journalistic reportage had to be established through hard work and persuasion by interested parties (Green-Lewis 1996; Tucker 2005). Men of science began to use photographic images as evidence around 1870 because they had come to distrust personal subjective experience when making observations. Instead, they hoped to rely on the mechanical objectivity of the camera (Daston and Galison 1992: 81; 2007). Paradoxically, this rejection of personal observation was made in order to shore up larger claims about the personal authority of professional individuals in science. In effect, this elite group then claimed a unique ability to judge what counted as evidence. In *Nature exposed* (2005), Jennifer Tucker examined these contested margins of scientific authority in the nineteenth century, demonstrating some of the conflicts and anxieties aroused by photographic journalism in the service of popular and amateur science. From around 1900, when photography was used in science to examine 'invisible' entities such as X-rays and microbes, the conflict between science and science fiction became especially problematic (Tsivian 1996: 82–85). Tucker's work shows us how Victorians were informed and critical viewers of photographic images in print. Rather than receiving all photographs as the absolute truth with credulous naïvety, they were on the contrary aware that photography is mediated. Britain was home to one of the world's largest extended communities of photographic amateurs, judging the trustworthiness of photographs in relation to who had taken the pictures and why. The specific publications where photographs were shown mattered too in terms of credence. General interest magazines illustrated with photographic images such as *Strand* (1891), *Cassell's* (1897) or *Pearson's* (1896) were launched at this time and aimed to cover a wide spectrum of interests, including the more sensational aspects of science, with a popularising mixture of education and amusement. *Pearson's* in particular presented many scientific topics 'in a context of adventure' that featured colonial warfare, photography of the invisible, microbes, Mars (and Martians) and other scientific sensations, later moving into the thrills of science fiction, publishing for example H.G. Wells's story *The war of the worlds* (Tucker 2005: 112–14). Such sensational general interest publications were the target of a scathing attack by cultural critic Matthew Arnold who dismissed their style as 'feather-brained' rubbish that would stop readers from becoming rational citizens (Williams 1980: 3–8). Such criticism was an expression of fear; social fear of the lower orders and their demands for a voice, but also a gendered attack on women and their increasing demands for equality and a proper education. Middle-class women were starting to move into public life and into paid employment at this time, for example by writing

in the 'easy personal style' that marked the 'New Journalism' so abhorrent to Arnold.

Investigations into the spirit world and the genre of spirit photography provided one site where popular journalism, conflict about who could legitimately conduct scientific investigations and fears about women's place in society came together. In 1894 the journalist and campaigner W.T. Stead founded a new journal *Borderland* to explore the border between science and religion with features on spirit photography and occult phenomena. Stead, as editor of the *Pall Mall Gazette*, was a particularly high-profile figure in literary and political life at this time. He embraced mass circulation newspapers as a forum for the clash and meeting of many voices. In opposition to spokesmen for high culture such as Arnold, Stead aligned himself with a more inclusive and chaotic 'voice of democracy' in sympathy with the followers of Comte's religion of humanity (Tucker 2005: 114–15). *Borderland* invited reader contributions in articles, photographs, interviews, first-person narratives and scientific commentaries in order to 'democratize the study of the spook' (Tucker 2005: 117). Photomechanical printing allowed half-tone photographs to circulate in scientific discourse but they did not in themselves create or guarantee 'truth' or objectivity. Instead, different parties tried to assert their own claims to authority through publication.

Photoreproduction and the labour value of printed images

Tom Gretton has argued that the advent of photographic images in illustrated newspapers such as the British *Graphic* and the *Daily Graphic* at around 1900 destabilised previous values that consumers attributed to established mediums and finally eclipsed those values completely. Previously consumers had rated printed images on the basis of their knowledge of the amount of skilled laborious work that had gone into their production; they prized the artisan skills of engravers and printers. By contrast the new photomechanical images, processed for print by unskilled or anonymous workers, did not display any recognisable markers of labour value in the image (Gretton 2005: 371–90). By 1900, the labour costs of hand-work on wood engraving meant it was three times as expensive to produce as half-tone screened imagery. At the other end of the scale, non-tonal line block prints were cheapest of all (Gretton 2005: 377). In this hierarchy of cheap to expensive techniques, wood engraving was still used to confer status on the most prestigious images in a visual story. For example during the Boer War a portrait of the British Field Marshall Lord Roberts was rendered in wood engraving, a captured enemy general was shown in a 'coarse half-tone' and supplementary crowd scenes were added to the story in the economical line style (Gretton 2005: 378–79). Because half-tone screening of all kinds of tonal images provided a cheap resource for illustrated journalism from 1880 onwards, the percentage of space given over to pictures increased, with frequent use of half- and full-page images. In this popular 'new journalism' approach, visual skills became more dominant.

Editors began to use the page as the basic unit of design, rather than each individual article or story, commissioning artists and graphic designers to produce large decorative compendium pictures with multiple scenes in mixed styles in a manner reminiscent of the cut-out scrapbooks or decorated screens of the period. Large page or double-page spreads with little captioning showing topical spectacles of entertainment frequently used asymmetrical pictorial compositions. Later, however, once actual photographs began to be used as news images, page design changed again, with more rigorous ordering of text captions in box-like layouts, and small rectangular photographic images all aiming to emphasise the factual status of photography as sober documentary (Gretton 2010: 706). Editors and publishers made decisions about supporting the 'truthfulness' of photography that was achieved not through the photographs themselves but through page design.

Commercial art, mass media and 'visual culture'

Historians such as Tucker and Gretton thus show the complexity of the workings of photomechanical reproduction amongst the producers and consumers of various print cultures around 1900. This detailed scrutiny breaks up the common notion of an Edwardian media phantasmagoria in which a seductive 'visual culture' imposed consumerist behaviour on society. In *A social history of the media from Gutenberg to the internet* for example, the authors briskly encapsulated popular publishing ventures of the period into the whirl of new 'entertainment industries', so that the launch of the low-cost *Daily Mail* by Lord Harmsworth in 1896, complete with 'women's page', sports and 'stunts' was seen as part of a continuum of 'leisure industries' that also stretched to the establishment of professional football clubs and similar ventures (Briggs and Burke 2009: 184–96). There is nothing wrong or necessarily inaccurate with this characterisation, but the picture of mass culture in this rapid overview is misleading, because the suggestion is that everyone was changed in the same way by media brainwashing. The reader nods sagely and forgets (for example) about the new structures of work and education that developed active forms of photomechanical print culture. Instead, as we have seen, different groups evaluated images and communications mediums in different ways. The broad picture is too passive, making everyone into a consumer of visual culture, whereas the expansion of popular publishing and publishing within business practices meant that many more workers came to be employed actively as producers in photomechanical print production in image processing, photography and graphic design. By 1900 when photomechanical reproduction of images was becoming widespread, many art schools had been established, supported by state and commercial funding (Bell 1963; Macdonald 1970; Bogart 1995). Schools across Europe and North America introduced courses in graphic and commercial art and, like the Glasgow School of Art (Fairfull-Smith 1999; Rawson 1999; Robertson 2012), were closely linked with their industrial and manufacturing environments.

But the 'passive' model of viewers has often taken over descriptions of the formation of artists and designers in the era of half-tone images. Looking at pictures of artworks captured by photography and circulated in print changed the way that artists and designers worked in quite radical ways. Half-tone reproductions allowed art lovers to scrutinise work in books and magazines, removed from context, and reduced in scale and presence to a uniform visual manifestation. Using photographs to study art and artefacts encouraged the development of that now standard procedure in art history, 'comparative descriptive analysis', where outward features of style can be addressed through formal visual analysis (Fawcett 1983; Stankiewicz 1984; Nelson 2000). Andre Malraux famously reworked this idea into the form of the 'imaginary museum' (Malraux 1951) that stands ready, potentially, to hold all the cultural artefacts of mankind in the photographic archive. More recently Douglas Crimp submits the same idea to melancholy postmodern treatment in *On the museum's ruins*: 'Art as we think about it only came into being in the nineteenth century, with the birth of the museum and the discipline of art history, for these share the same time span as modernism (and, not insignificantly, photography)' (Crimp 1993: 98). These notions of the dissociated viewer, browsing at random from an imaginary museum of photographic reproductions had their most ecstatic expression in the writings of Jean Baudrillard and his thesis that all reality has vanished into a 'hyper-realism' of simulation (Poster 1988: 143–47). These approaches dismiss the details of print production as a diversion from visual culture, treated in the abstract, as we see in the work of Mirzoeff (1999: 3).

By contrast, if we emphasise the active viewer, the print culture of half-tone illustrations appears as a resource used by increasing numbers of art and design students, and as a new form of employment. These resources were used actively, not passively, and formed a medium where readers developed new visual languages for themselves. Many art students in the nineteenth century were from artisan or lower-middle-class backgrounds, and worked during the day at a trade or in business with self-directed study in the evenings (Schmeichen 1995). Workers applied themselves to the study of decorative, architectural and fine art design and drawing, in order to get work in various local manufacturing industries, and towards the end of the nineteenth century students also began to train themselves for work as commercial artists and illustrators. The Central School of Art in London (see also Chapter 2) was thus just one among many other schools that introduced graphic and commercial art training in the late nineteenth century. Many art schools that were founded in the nineteenth century will have their early library holdings in dusty archives and special collections. These hidden collections, rarely consulted, reveal the diversity of print resources that shaped the visual languages of art and design training in their time. For example, from the Glasgow School of Art in Figure 5.2 we see the title page from a large illustrated textbook from the series *Studies from the museums* (Rowe 1889). The book presented a series of historical designs of decorative art objects from the holdings

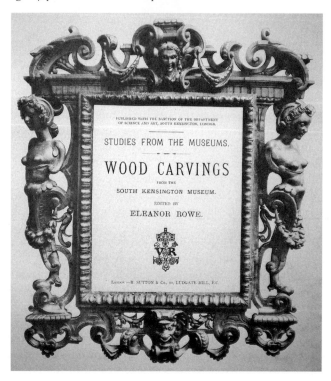

Figure 5.2 Rowe, Eleanor (1889) *Studies from the museums: wood carvings from the South Kensington Museum*, London: R. Sutton & Co. Five folios of examples of 47cm × 30cm size photomechanical reproduction with letterpress text, courtesy of Glasgow School of Art Library Special Collections.

of the South Kensington Museum intended to present a graded series of exercises for students at the 'numerous Home Art Classes throughout the country', to draw and then make for themselves.

Popular publications, such as the *Strand* magazine, also contributed to discourses about the uses and functions of half-tone photographs. With a practical and commercial ethos similar to that of design schools, many picture stories were presented as 'how-to' descriptions, with photographic illustrations used to support a step-by-step narrative through the technical processes, for example, in the article 'Making a life mask' (Figure 5.3) of 1898. In the *Strand*, articles illustrated by photographs sat alongside more analytical articles about the status and functions of different photographic practices, for example in the 1890s, the magazine carried articles such as 'A day with an East-End photographer' (*Strand* 1891: 458), '22 photographic images' (*Strand* 1897: 72) or finally 'Some curiosities of modern photography' (*Strand* 1895: 47–56) that discussed the truth and falsity of photographic evidence, the use of forensic microphotography in crime detection or photography as an aid

Making a Life Mask.

By Harry Turner Hems, Jun.

THE taking of masks from the dead by any but a skilled operator accustomed to such work is distinctly disagreeable and difficult, and perhaps particulars of the *modus operandi* upon such occasions would somewhat disturb the nerves of our more sensitive readers. In the accompanying interesting photographs we are able to illustrate the process of obtaining a mask of the face during life, the subject operated on being very far from dead. Death masks are usually taken for the purpose of securing an exact reproduction of the features, so that any artist or sculptor who intends to execute a painting or statue of the deceased may have something definite to work upon.

One often observes when reading of the

A mask from life is taken almost precisely in the same way as after death, save that much greater care has to be used, as the subject's life hangs but on a very thin thread, or, to be more precise, two small quills. It requires a great deal of nerve and patience to undergo, the sensation being most disagreeable. When a mask from life is about to be secured, the subject reclines on a long table, and towels are placed around his neck and forehead to prevent the plaster going where not intended. The face is slightly greased, but not enough to fill the pores of the skin. Care has to be especially taken with the eyelashes, as otherwise, in the subsequent operations, these are likely to be pulled off, which would not be exactly pleasant. A small quill is now inserted in either nostril (No. 1) to allow the subject presently to breathe

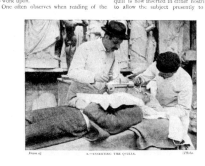

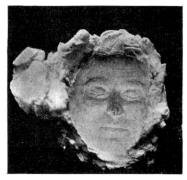

Figure 5.3 'Making a life mask' Harry Turner Hems, Jr, *Strand* 1898: 197–200.

to fraud and forgery, for example when an innocent person's head might be placed on the body of someone in incriminating circumstances.

Avant-garde artists, political agitation and photomontage

By the first decades of the twentieth century a vast amount of half-tone imagery was circulating in mass-market publications. In the decade from 1910, avant-garde artists began to criticise, parody and attack these media representations. To revolutionary and avant-garde artist groupings such as Dada, common-sense genres of 'realism' or 'naturalism' in both art and photography were not just outmoded, but were methods of brainwashing audiences into accepting the status quo and the power of existing ruling classes in society. This suspicion of the workings of power was strengthened by political and social upheavals such as the Russian Revolution of 1917, and the long-drawn horror of the First World War that destroyed or maimed tens of thousands of young people. Elite high culture now seemed merely the mask for an incompetent or malicious ruling class. Nevertheless avant-gardists still believed that the right sort of art could break the stale old patterns of life. In the Soviet Union after 1917, artists and educators such Alexander Rodchenko experimented with photography, film and photomontage as critical art-forms, hoping to wake up viewers to the artificiality that lurked behind the apparently straightforward realism of photography. Hence Rodchenko and other leftist artists adopted strange camera angles or juxtaposed several photographs in one image, often combined with text, as an intentional strategy to

defamiliarise everyday codes of representation (Edwards 2004: 408–9; Lodder 1983: 181). Defamiliarisation was a key idea to all the left-wing politicised avant gardes of the early twentieth century such German Dada, the anti-art protest movement that aimed to cut through the 'beer belly' of bourgeois culture (Lavin 1993). This motive lies behind the use of montage and any kind of jarring juxtaposition, for example in Bertold Brecht's use of *verfremdungseffekt* or 'alienation effects' in theatre. Agitators such as John Heartfield and Hannah Höch developed photomontage as a weapon for political satire (Scharf 1974: 278–89). Heartfield, in collaboration with communist and pacifist protesters, had already been involved in scurrilous and satirical publication through the establishment of the socialist publishing house Malik Verlag in 1917 during the war, where he used unconventional format and presentation both to stir up his readers and to confuse the censors (Heller and Pomeroy 1997: 8–9). Meanwhile Höch, whose day-job was in the commercial world of popular journalism, drew on vernacular forms of photomontage that had developed before the avant-garde exploitation of this medium. If anybody searched through Grandma's drawers and boxes, she remarked, they would quickly find a collection of such sportive photographic jokes as the heads of family menfolk applied to brawny military torsos or 'souvenirs' of romantic family trips to beautiful but fictitious landscapes (Höch 2003: 112–14). The beginnings of avant-garde photomontage in fact coincided with a revival of this fashion amongst the soldiers in the First World War who sent back photographic postcards of themselves within some fantastical or obscene comic tableau (Rickards and Twyman 2001: 249–50). Höch also alerted her readers to the manipulative uses of montage encountered in everyday reading. In advertisements, for example, some humble item such as a man's shirt collar would be made into a dazzling commodity through multiplying its image then laying it out in decorative patterns of the page. Even 'straight' journalism, she reminded readers, might use a news photograph that had been manipulated and constructed to enhance its visual impact (Höch 2003: 112–14). Because Höch worked in the new genre of illustrated magazines that were intent on pushing fashion consumerism onto women in the early twentieth century she was acutely aware of the onslaught of imagery now being directed at women to make them anxious about their personal attractiveness and the need to keep up with fashion; she could see the mechanisms of representation at work in the construction of gender. The fascination of photomontage, and its ambiguity, came from the hallucinatory effects produced by incongruous juxtapositions of realistic photographic fragments, similar to the effects of film or a dream. Photomontage in commercial applications was not necessarily truthful or liberating. Instead it could create a dazzling dreamworld of 'commodity-as-image' (Crary 1999: 117). Artists such as Höch hoped that by pushing the effects of photomontage to ludicrous or surreal lengths she might force a 'new vision' in the viewer, or at least a critical awareness that photographic fragments could be used to play visual tricks.

These avant-garde practices and the explorations of Marxist academic critics of society shaped the ideas and working life of Walter Benjamin who is now, according to James Elkins, the most-cited 'patron saint of visual studies' (Elkins 2003: 94). Benjamin was interested in so-called 'distraction' effects on the human spectator of early twentieth-century mass-culture imaging industries as an aspect of life under capitalist technological modernity. The sociologist George Simmel, in essays such as 'The metropolis and mental life' (2003 [1902–3]), claimed that individuals in the modern city, battered by confusing sensations, live in a permanent state of shock. To Benjamin, photography was a medium that registered this negative state of affairs but perhaps offered the promise of liberation. Photographic reproduction of artworks would, he hoped, destroy their 'aura' of ritual and social deference. Benjamin welcomed photography as a revolutionary medium, a 'training manual' for modern life. The mechanical eye of the camera, like and yet strangely different from the human embodied observer, would by its strangeness show viewers the artificial, manufactured and conventionalised aspects of representations within cultural and commercial life. Photographic imaging was inherently communal and mundane, produced by teams of anonymous people; visual statements were assembled and could be changed, re-ordered and edited in contrast to the single, static and ostensibly 'eternal' work of art (Benjamin 2008: 27–28). The mediums to which Benjamin turned his attention were not the 'fine art' gallery photographs or the elite productions of specialist journals, but mass mediums such as newspapers, films and magazines. He hoped that in this environment, readers would not simply be passive consumers but take on the role of 'quasi-expert' ready to jump into print or make some other public statement at a moment's notice (Benjamin 2008: 33). The development of avant-garde photomontage fed his ideas about the revolutionary potential of the ubiquitous procession of half-tone imagery in mass-market publications.

Montage takes fragments of photographs and places them in unexpected juxtaposition with other visual elements. One outcome of this strategy is to accentuate the abstract and formal appeal of photographic fragments. Photomontage techniques also demonstrate the constructed nature of photographic images, undermining belief in the realism of depicted scenes. Hence, photographic fragments in photomontage lose their documentary status and come to function as icons and emblems. In the consumer economies of the West in the interwar period, this function of photographic images was quickly exploited, not to combat capitalism, but to advance sales either through the 'new heraldry' of stock photography in advertising (Wilkinson 1997), or in the clean visual presentations of German *modernismus* (Lavin 2001). While modernist practitioners worked to produce official and corporate communications with focus on objects and products, commercial mainstream advertisers used stock photography more overtly as a resource to tell stories. Photographs from image libraries were adapted and copied to fit the message of advertisements with props and gestures often being changed around to suit.

Helen Wilkinson argues that with expansion of visual modes of entertainment such as cinema, audiences accepted all images as constructed artworks, especially when magazine advertisers adapted cinematic conventions for staged photographs. In these circumstances, while photomontage alerted viewers to the constructed nature of representations, it did not excite critical thoughts, but rather the pleasure of artifice.

By the late 1920s, techniques such as photomontage had become a standard graphic style, no longer associated with Dada rebellion. In the loose grouping of designers known as the NWG *ring* (the *neue werbgestalter*, or Circle of New Advertising Designers, founded 1928) a combination of 'new typography' and photomontage was used to promote business enterprises, denoting variously the seriousness of high art, a commitment to rationality, and an alliance with internationalism rather than local or vernacular styles. The ring designers, who included Kurt Schwitters, Jan Tschichold, László Moholy-Nagy and John Heartfield, were all self-proclaimed modernists, with varying enthusiasms across the group for both capitalism and socialism. Lavin claims that this complicated 'post-avant-garde' moment in graphic design is hidden in general design histories by the clearer and more dramatic narrative of a few well-known oppositional avant-garde works. This is misleading, as it creates a picture of avant-garde artists cut off from society (Lavin 2001: 48). By contrast, in examining the course of working lives in context, we see the ring designers all negotiating design activities within capitalist advertising and mass communications but that also (for some) included left-wing activism (Lavin 2001: 27–33). The main clients of the ring designers were big industrial engineering concerns and government cultural organisations, encouraging an official manner that differed from graphic design in popular magazines. Photomontage was used to achieve clarity and 'information transfer' using analogies to science and technology. Corporate advertising design controlled and ordered the potential chaos of montage through layout grids and the 'stark legibility' of the text (Lavin 2001: 42–43).

In popular and fashion magazines, by contrast, advertising was aimed at the so-called 'new woman' who was the main purchaser of clothes, food, personal hygiene items and domestic products. In contrast to the sober 'informative' style of corporate modernism, photomontage was used to create narrative, using cinematic conventions such as close-up and dramatic lighting to enhance drama and excitement. Cinema used an emotional rather than an intellectual structure, as did advertisements, aiming to arouse sexual pleasure or anxiety, snobbery, envy and fear. Narratives were crafted using stock photography, the 'new heraldry' of instant communication (Wilkinson 1997: 38). The vast majority of stock photography in this period was portraits, often in settings such as a bar, living room, or beach. Advertising increased in the recession of the 1930s, aiming to sell small luxuries in volume. As admen argued, advertising was not about selling objects and products as such, but 'imponderables' such as the joy of motoring, and the pleasure of gaining social acceptance. Promises of pleasure were heightened by

complementary 'insecurity advertising', that raised fears of social and personal disasters (Wilkinson 1997: 23–38). Any kind of image can be lifted and used as stock photography. Many pictures encountered today in magazines, news, promotional material and advertisements have been bought in from digital image banks like Getty Images, which can be quickly accessed world-wide. These photographs use bright lighting, flat colours, attractive models, and nondescript locations, generic and in a form suitable for reproduction in the maximum number of print or digital mediums. The image bank orga-nises searching categories so that the picture researcher can find marketable imponderables such as 'contentment' and 'freedom' almost immediately. David Machin argues that the world now represented in magazines and other similar media conforms to the limited world of the image bank categories, which in turn are based on marketing categories; an ideologically pre-structured world which is in harmony with consumerism (Machin 2004: 316–36). Hence, just as in photomontage, stock photographs too lose their documentary status and come to function as icons and emblems when used as a print resource.

Photojournalism

In contrast to photomontage, documentary photography claims to present evidence straight from observed reality. Half-tone printing combined with new photographic image capture technologies to develop genres of photo-journalism, in magazines such as *Arbeiter-Illustriete Zeitung* (*AIZ*, founded 1925), *Vu* (1928), *Life* (1936) or *Picture Post* (1938). These magazines promoted a range of political viewpoints, but they were all populist in tone. *AIZ* in Germany was a communist-orientated worker's newspaper now well known for publishing John Heartfield's anti-Nazi photomontages amongst straight news pictures, *Picture Post* in Britain was left-leaning and anti-fascist, while *Life* promoted a populist vision of America as an open, modern and democratic society. *Life* carried powerful photographs in clear focus and strong contrast often celebrating contemporary industrial progress. Charles Sheeler presented the Ford plant at Dearborn, Michigan, in images that showed the factory as an abstract futurist structural composition, for example where vast circular steel tanks, connected by equally gigantic tubes, tower over and dwarf an otherwise substantial conventional office building (*Life* 8 August 1938). Photojournalists made rapid pictures on the move using new portable 35mm cameras such as the Leica, first produced in 1924, and then further developed to allow more rapid photography in many different lighting conditions by the early 1930s (Ritchin 2000: 596). Portable cameras gave pho-tographers the chance to develop new styles of investigative or voyeuristic pictures, showing war or crime in the raw. The Spanish Civil War for example was a tense focus of international attention in the polarised and threatening political atmosphere of the 1930s, also described as the first 'photogenic war' that came very close to readers and spectators throughout

Europe through images in photo magazines such as *Match* or *Picture Post*. Robert Capa's controversial picture 'Falling soldier', also known as 'Death of a Republican', was first published in the magazine *Vu* on 23 September 1936, and subsequently republished extensively again thereafter; immediately in *Paris-Soir*, *Life*, and *Regards* in 1937 (Brothers 1997: 179–83). Arthur Fellig (Weegee) developed a sensational genre of disaster, crime and violence as a commodity from 1935 onwards (Hopkins 2000: 1–2). His images were dramatic, flash-lit night scenes rendered with extreme contrast of tone, particularly suitable for reproduction on newsprint. Weegee also developed his style further with an uncomfortable mixture of voyeurism and surveillance in *Naked city* (1945), that presented infra-red images of people behaving freely while they believed themselves unobserved (Hopkins 2000: 8–12).

Photomagazines presented both documentary picture stories and advertising images to their readers. *Picture Post*, founded by Edward Hulton, developed a mixture of human-interest stories, alongside investigative exposés of political and social ills in its style. It was founded in 1938, at a time when war with Germany was appearing more and more inevitable (Hopkinson 1970). Many stories presented an image of Britishness that ranged in tone from quirkily historical to robustly independent, for example in articles on 'The oldest parliament' (in the Isle of Man), 'Wine auction at Christie's', to occupational portraits of picturesque workers such as the porters at Billingsgate fish market (22 April 1939). In addition, the magazine discussed and analysed its own particular medium of photojournalism in a self-referential way, with articles for example on the history of photography and on photo-montage (both in the same edition of 22 April 1939 discussed above). Even the advertisements supported the photographic theme, with an advertisement of Ilford 'Selo' film presented with a 'how-to' guide to portrait success (Figure 5.4).

Looking at the 'the masses'

While the critical avant-gardes attempted to unmask media manipulations of viewers by revealing the artifice of 'factual' photography, popular photojournals claimed to reflect the diversity of daily life by nosing into unexpected corners. This chapter has considered half-tone images in relation to ideas of what is often labelled 'mass culture': of representations made for mass communication in the context of a society and economy geared to mass production. In the interwar period the notion of the 'mass' was a term that signalled great anxiety in the political and cultural circumstances of the time. Relations of production changed with the development of large corporations, and the growth of scientific management that aimed to control every minute of the working day. The international crisis of trade after the Wall Street crash of 1929 affected large numbers of people, especially in towns or regions where employment may have been concentrated in one failed business. Wealthy people feared masses of disaffected and politicised workers. Totalitarian regimes, such as the Soviet Union under Stalin or Hitler's Nazi

Figure 5.4 Picture Post 22 April 1939: 5, author collection.

Germany, showed how whole populations could be cowed or persuaded into group action, or mobilised towards war. In Britain, the Mass Observation movement (begun in 1937) was set up by a group of left-wing writers, artists and academics to examine from a new perspective, and to ask what might be meant by 'popular culture'. Using print and media techniques derived from photojournalism, allied with statistical and sociological methods of gathering data, the group aimed to invent practical methods for creating an 'anthropology of ourselves' in which ordinary people would be recruited to observe and write about their everyday lives and experiences, as for example in the *Worktown Project* carried out in the industrial town of Bolton and the popular seaside resort of Blackpool between 1937 and 1940 (Jeffery 1998 [1978]).

One particular aim of Mass Observation was to challenge simplistic ideas of 'the masses' – a term that, when it occurs in everyday lazy speech, almost always indicates the arrogant claim that somewhere, far away from the speaker, there exists a herd of common people who all think and act the same. Mass Observation, by contrast, aimed to uncover the differences, the individual voices and the particularities of experience in relation to such diverse topics as religious observance, sporting and leisure activities (pubs became a key location), family planning, dreams, or personal appearance and clothing.

One participant, Humphrey Spender, who had previously worked as a photographic journalist for the *Daily Mirror*, contributed an important body of images on themes such as 'church' or 'ceremonies' to the *Worktown Project* (further information about the Mass Observation Archive and the *Worktown Project* can be found on p.139). However, despite the idealism behind the urge to give voice to everyday experience, many observers and participants such as Spender came to feel uncomfortable with their role as 'mass-eavesdroppers, nosey-parkers, peeping toms'. According to Ben Highmore, this complex reception and history of Mass Observation created exactly the kind of 'awkward moment' that can help us to appreciate the true difficulties in the 'ambiguous but central category' of the everyday in avant-garde thinking at this period. The central aim of Mass Observation was ideally not to scrutinise working-class people as specimens, but rather to recruit them as researchers who by observing themselves performing normally unconsidered activities would set in motion a transformation of everyday life. The Mass Observation project was conceived as 'a form of practical surrealism', in accord with Surrealist ideas of attempting to engage with the unspoken and elusive unconscious mind, and where everyday experience was celebrated as the source of unlooked-for 'convulsive beauty'. By giving significance to the overlooked, Mass Observation at its start generated a surrealism both '*of* and *in* the everyday' in a way that tried to avoid the more distanced scrutiny of 'the masses' conducted by intellectuals elsewhere. Nevertheless in its practical workings the Mass Observation was still an 'awkward moment', where individual 'field notes' gathered from mundane alienated experience came up against the mute suspicion of unwilling participants. These tensions were further complicated after the start of the Second World War when Mass Observation became attached to the Ministry of Information, and later still when members of the group adapted their expertise to the development of market research (Highmore 2000: 245–62).

Photographic realism, suspicion and cultural theory

From the start of the twentieth century, photographic half-tone images circulated in almost every genre of printed publication. Photographs were valued because they took pictures from the world and they were used as evidence in law and science. These senses of realism infused photojournalism. But at the same time, straightforward Realism and the naïve belief that to see is to know was under attack in Marxist-inspired criticism and in avant-garde art and design practice. To these practitioners concerned with the 'politics of representation', realism was stupid and deceptive, because common-sense pictures of things did not show the true, but hidden structures of power in society. Avant-garde subversion, for example in photomontage, aimed to use images to fight images. In some senses, this succeeded too well, for the visual excitement and the frisson of rebellion conveyed by Soviet and Dada experiments with photomontage and typographic design were rapidly taken over by

designers in commercial capitalist economies, while the visual output of the avant-garde is reduced to a dramatic highlight in popular art and design histories and exhibitions. This is what Steven Heller meant (in Chapter 2) when he warned that the visual pleasures of modernism and avant-garde practice had warped the history of print culture and mass communications at this period (Heller 2001: 295–302). Words, or different methods, might offer a better way to fight images, or to account for this flood of half-tone pictures in print economies.

We see an example of how to tackle the problem of re-engaging with the print cultures of photomechanical reproduction in research conducted in a cultural and geographical location far from avant-garde heartlands of Europe. In *Image worlds: corporate identities at General Electric, 1890–1930* (1985) David Nye presented an account of trying to come to terms with the vast company archive of more than 1 million photographs amassed by the General Electric company from its centre of operations in Shenectady, New York. In extent this is an overwhelming source, and still largely unknown. In Nye's view its very impenetrability aids our understanding of how large corporations emerged and dominated American life between 1880 and 1930. To Nye, the 'corporation's creation and control of such materials is a metaphor for its cultural hegemony. The historian confronts an institution bent on controlling the past' (Nye 1985: 3). Thus, although the archive and the channels for corporate communications developed by General Electric have been largely invisible in cultural history, Nye claims that the archive represents the best-funded and the most influential school of photography of the twentieth century, and one that reached a diverse audience numbered in millions (Nye 1985: 10). By 1908, the corporation built on its established in-house publishing activities by launching *General Electric Review* whose content and tone aimed to give the effect of a general magazine offering disinterested educational material rather than being an in-house journal (Nye 1985: 64–65). Photo-magazines were useful to the corporation, as realistic images made unknown products seem familiar; by inserting new items into everyday settings, customers could imagine themselves into that situation. The favoured photographic style for General Electric magazines was objective and naturalistic, with static, grainy monochromes lacking in colour. This industrial aesthetic emphasised realism and factual objectivity. As Nye comments, this kind of photography 'strives for a mundane realism and its success often looks like aesthetic failure' (Nye 1985: 45–49). The corporation observed very careful control of its advertising and communications campaigns tailoring different kinds of magazines to different readerships with a total circulation of over 20 million. For example, advertisements aimed at women contributed to the new myth of the 'homemaker' who performs her domestic duties as an expression of love and service, not as a chore. Thus an image of a mother reading to her two children had the caption: 'the successful mother – she puts first things first. She does not give to sweeping the time that belongs to her children' – in short, she has just bought a cleaning appliance from General Electric (Nye 1985: 130–31).

For Nye, scrutinising individual advertisements remains anecdotal; it is slightly informative in a familiar way, but it is not central to his argument. Instead, Nye claims that this body of corporate communications is important because it is invisible, not because it is well known or particularly attractive to look at. In his approach he has absorbed the suspicion of mass representations developed in the critical theories of the 1930s and has developed a new way of finding and describing a new area of print culture from this period.

Questions of interpretation – and action – posed by the history of photo-mechanical reproduction are of continuing concern to students in practical art and design courses, in humanities generally, and to practitioners in all these fields in their working lives. Benjamin's essay 'The work of art in the age of mechanical reproduction', since its first translation into English in 1969, remains as a live text, for his writing is stimulating, prescient and melancholy. Indeed, complaints that this particular moment of critical writing threatens to obscure other histories and debates (Elkins 2003) suggest it is now firmly part of the canon of visual studies (Barnhurst, Vari, and Rodriguez 2004: 635). Today, continuing suspicion and anxiety about the increasing market in photographic images in print and other media keeps these ideas and histories alive. Thus, although in his own day Weegee was a commercial photographer serving sensational journalism, his work is now a part of contemporary 'visual culture', attracting scrutiny from academic writers and critics (Hopkins 2000: 8–12). In the 1980s, artists in Reagan's 'decade of greed', angry about the rapid erosion of social policy, revived avant-garde graphic styles as they looked back with sadness and even envy to the relatively more powerful voice of radical artists such as John Heartfield in the 1920s and 1930s, whose work enjoyed large circulation in the workers' news weekly magazine *AIZ* (Lavin 2001: 94–107). Meanwhile contemporary digital imaging and the use of stock footage continue to maintain our disbelief in news photographs (Barnhurst, Vari and Rodriguez 2004: 616). But as David Nye suggests, perhaps the true significance of half-tone photomechanical reproduction in mass circulation publications is to be found in the mass that remains largely unconsidered. Half-tone photographic images in smooth shades of grey claimed to appro-priate aspects of the world without judgement, arousing belief and scepticism in viewers in equal measure. Photojournalism appropriated events such as the Spanish Civil War and modified the presentation of artworks in other mediums such as Picasso's *Guernica* (1937). Picasso only ever saw the bomb-ing of this Basque city by fascist forces through news photographs. His painting is a shocking representation of a real tragedy, but it is also an acknowledgement of the mediated expression of that outrage, with its mono-chromatic use of glaring contrasts, flickering effects and schematic rendering of lines of newsprint (for example on the body of the wounded horse). For observers at the time, these references to photomechanical reportage added to the horror of the painting's effect, as it depicted the suffering of the victims in terms that reminded viewers of how their emotions had been both aroused and frustrated by the simulated closeness of photography (Oppler 1988: 216).

To David Nye, however, the more anonymous and forgettable photographic journalistic languages developed by corporations were the most powerful print media of the time, with the largest volume and spread in terms of both viewers and practitioners, and its promotion of an 'industrial sublime of the managerial class' (Nye 1985: 156–58).

In comparison to the print cultures discussed in other chapters, the active work of printers and technicians is far less apparent in most commentaries on half-tone printing. According to Tom Gretton, the work of everyone involved in print production, whether skilled or unskilled, is obscured by half-tone photographic images in print, so that even the act of picture-making appears to become mechanised and impersonal. Instead of seeing or under-standing the labour of representation, the viewer moves directly to thinking about the object photographed, the 'original' artwork or the photographic original. Perversely, critical avant-garde commentaries on mass media and the effects of half-tone reproduction often draw our attention to particular and celebrated photographers, designers and critics; a self-selected group speaking of, or to, 'the masses'. Hence, according to Johanna Drucker, 'the devices so conspicuously laid bare in the experimental work of the ... early twentieth-century artists became, within two decades, the most efficient means of concealing not only the marks of artistic and literary enunciation, but the structures of economic power in corporate, state, and military production as well' (Drucker 1994: 245). In the next chapter, we see how other techniques of photomechanical reproduction that captured the emphatic blacks of line rather than the grey shades of photography have attracted more commentaries on printing techniques, whether line process printing, offset lithography, or other unexpected techniques. Photomechanical means of reproduction combined with offset lithography opened up possibilities of self-publication to amateur and unconventional printers, often through office duplicating tech-nology, and offered the possibility of different and more active forms of everyday print communication.

6 Found objects
Copyshop culture

This chapter expands on the other face of photomechanical reproduction –
mentioned, but not discussed at length in the previous chapter – that is equally
important to the workings of print culture in the twentieth century and
beyond. While the graded greys of half-tones conveyed the effects of photo-
graphs in print, simpler and cheaper photomechanical image processes
captured and reproduced emphatic blacks and harsh contrasts with no inter-
mediate tones. From line block process prints to Xeroxing techniques, any
clearly differentiated mark could register as 'camera-ready' copy, allowing
many shifting assemblages of images and text. At the close of the nineteenth
century, process line block techniques were chosen by the new journal *The
Studio* (founded 1893), which promoted the dramatic styles of pen-and-ink
process line illustration as 'the most vibrant of the contemporary arts' (Beegan
2007: 58). In the 1960s photomechanical offset lithographic printing trans-
formed the appearance of print and the organisation of labour in production.
Although many people feared that this marked the end of print, both under-
ground radical groups and capitalist bosses were strangely united in hastening
this change (Marshall 1983).

Anxiety about changes in the print industries in the 1960s was related
to wider fears of 'new media', particularly with the rapid adoption of home
television viewing after World War II (Briggs and Burke 2009: 212–20).
All communications media industries were expanding in the context of a
consumer economy, and many observers feared the power of media repre-
sentations to shape the consciousness of every individual in society. The novel
Nineteen Eighty-Four (Orwell 1949) visualised in detail a future state of
control by camera surveillance and propaganda. Cultural agitators such as
Guy Debord and the Situationist International railed against the 'society of
the spectacle' (Wark 2011), and academics such as Marshall McLuhan or
Elizabeth Eisenstein hastened to try and capture the essential qualities of a
print culture that now seemed to be under threat. In the art world mass
media techniques and images appeared, for example in the work of Andy
Warhol or Robert Rauschenberg as silk-screened motifs applied to canvas.
The art historian Leo Steinberg famously invoked 'the flatbed picture plane',
referring to the printing press, to describe new forms of postmodern art whose

compositions were conceived as 'opaque flatbed horizontals' taking inspiration from the appearance of tabletops, studio floors, charts and bulletin boards; any 'receptor surface on which data is entered'. Artists now derived their working methods from information processing and modern office procedures, shifting away from 'nature' to 'culture' as their subject matter (Steinberg 2003 [1968–72]). Although in his writing Steinberg was mainly concerned to show how techniques of assemblage and amateur paste-up had invaded fine art, in fact these same techniques were equally new and threatening in the printing industry.

Office and business forms of printing and data storage had developed an independent print culture beyond the world of print and publishing trades. In these bureaucratic systems, typewriting, duplicating, data storage and retrieval, and archiving practices were all interlinked. While most readers might think that librarians cherish piles of dusty tomes, librarians' own perception of their duty to manage information and make it accessible has often clashed with their obligation to conserve material objects. Thus for at least the last century libraries have been secreting an alternative print culture; a vast paper hive of many layers, where the products of mimeographs and varitype machines have been laid down in a constant flux of innovation, upgrading and renewal.

Marshall McLuhan in *The Gutenberg galaxy* (1962) was prompted to conjure 'print culture' because in his view the changing media environment of the 'electronic world' was warping old certainties: 'our most ordinary and conventional attitudes seem suddenly twisted into gargoyles and grotesques. Familiar institutions and associations seem at times menacing and malignant' (McLuhan 1962: 279). But print cultures were changing in this decade as well, and if they appeared to be 'menacing and malignant' it was not necessarily in comparison to electronic media, but in relation to internal transformations. Eisenstein (1979; 1983) picked up McLuhan's notion of print culture, but to her, and other writers such as Herbert Spencer, the problem was not new media, but the old medium of print in overdrive. Eisenstein addressed print culture because she wanted to think about information overload and the ordering of knowledge through print (Eisenstein 1983: ix–x; Spencer 1969: 7).

Process line printing and commercial aesthetics

High contrast photoprocesses first came to the fore in art nouveau graphic styles, as showcased for example in the magazine *The Studio*, launched in 1893. Photo processing was used to create line blocks compatible with letterpress, producing images with strong uniform areas of pigment that created dramatic graphic contrasts. The publishers of *The Studio* deliberately chose to use new print technology to complement its aim of showing the most advanced examples of artistic practice, deliberately seeking out the work of younger artists as well as established practitioners. In addition Joseph Gleeson White, the first editor, set out to treat all forms of art with equal weight,

so that 'a sculpture, a painting, a chair, a tapestry, a photograph, or a bungalow would be shown in an identical manner' (Beegan 2007: 47).

The cover of the first issue featured the work of Aubrey Beardsley, then a young and unknown artist, while inside an article on contemporary pen-and-ink illustration by Joseph Pennell was decorated with more examples of Beardsley's work (Weintraub 1976: Ashwin 1978; Beegan 2007). This exposure, and Beardsley's subsequent association with aesthetic and decadent artists of the 1890s such as Oscar Wilde, made his graphic art agreeably shocking and fashionable. The aesthetic movement, with its doctrine of 'art for art's sake', set out to invoke a full range of sensory and emotional experiences through art, often in erotic and perverse subjects. As an artist, Beardsley worked towards his medium of photomechanical line block process, and once the print was made had no interest in preserving his working drawing. On the printed page Beardsley created intense two-dimensional surface patterning in which expanses of flat black and decorative black motifs play off both against the white paper surface and also against traceries of exceptionally fine, controlled calligraphic lines and dots. Beardsley worked differently from most trained artists who at this time aimed for intuitive and spontaneous movements. Beardsley by contrast gripped his steel pen low down near the point, with a closed hand more akin to a draughtsman or calligrapher. The black and white decorative tension in these prints led to ambiguities in the so-called 'figure–ground' relationship – that is the actual figures and the spaces between them vie with one another for the viewer's attention (Langenfeld 1989). Indeed, Beardsley made use of these ambiguities to take short cuts in his drawings, for example in *Le morte d'Arthur* for J.M. Dent, designed as an affordable rival to William Morris's Kelmscott Press editions. Beardsley used various expedients to curtail this irksome task by chopping off forms and filling in large areas with black, thus generating the puzzling juxtapositions that are now seen as daring examples of modernism (Weintraub 1976: 30–45, 82–83).

Beardsley was largely self-taught. After leaving school at sixteen he had worked at various lower-middle-class jobs, for example in an insurance office in London, while sketching and copying from existing artworks in his spare time. Fame through the medium of *The Studio* was appropriate, for the magazine addressed many readers like himself: young aspiring artists and designers who were aiming to work in the expanding business of commercial illustration or decorative design in the service of industrial manufacturing. Indeed, and despite the highly wrought aestheticism of his work, Beardsley did not feel that art was separate from this commercial world, instead praising advertising as 'an absolute necessity of modern life ... London will soon be resplendent with advertisements and against a leaden sky skysigns will trace their formal arabesques' (Weintraub 1976: 90). Publishers such as J.M. Dent or John Lane of Bodley Head produced a similarly commercial aestheticism in illustrated volumes and magazines for the leisure moments of workers in this consumerist economy, available in several formats aimed at different sectors of

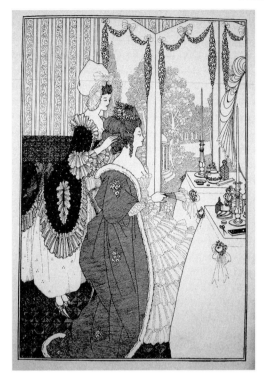

Figure 6.1 'The toilet'. Pope, Alexander (1897 [1712]) *The rape of the lock*, embroidered with eleven drawings by Aubrey Beardsley. London: Leonard Smithers: 7, courtesy of Glasgow School of Art Library Special Collections.

the market, easily achieved by photomechanical enlargement and reduction (Figure 6.1, from the cheaper reduced format edition).

From the beginning, *The Studio* encouraged the commercial practices of artists and art students in several ways. With Gleeson as editor, the magazine carried many articles on drawing and the graphic arts in which detailed commentary on mark making and print processes assumed a knowledge of working practice, down to the choice of pens (Gillot's steel nibs were frequently mentioned), paper, ink or crayons. Volume 1 of 1893 offered, in addition to Beardsley, several articles on observational sketching and on drawing for reproduction by process, pondering, for example, the relative merits of splatter-work or grained papers in achieving texture. Although hard firm lines were favoured in these descriptions (using pen and indian ink), Volume 2 also urged the merits of emphatic dark lithographic chalk for 'cheap photo-zinco processes' (1894: 99–100). Pen and ink, especially when manifested in a sinewy 'Dürer line' was, according to one contributor to *The Studio* (1894: 182–83), a distinctly British style, demonstrated in an efflorescence of work by Walter Crane, Ralph Caldecott, Kate Greenaway, 'the whole of the Birmingham school' and many others. All these articles were

intended for hopeful illustrators whose work was also featured in every issue. The journal set briefs for prize competitions clearly within the constraints of the medium, for example in a call for title-page designs rendered in 'solid black ink upon white cardboard' (1893: 128). Another competition asked for: 'a girl running: summer landscape, suggested sufficiently to account for the lighting of the figure, the object being to test the powers of observation in recording lines of motion, and the ability to distribute light and air in a line drawing for process reproduction'. The winning image (Figure 6.2) was chosen because it was suitable for reproduction, despite the fact that the judge did not like its effects of 'too much black, following the fashion of to-day' (1894: XVII). Other competitions were even more oriented to specific sectors of the process market, such as 'A street scene on line-tinted card' suitable for photo-zinco reproduction (1894: XII–XII), or the competition to make a 'copy of a photograph in pen-and-ink for process reproduction'. A half-tone image from an earlier edition of *The Studio* was set for this task, with the winning entry being a drastically simplified image that made bold use of black and white masses, completely different in effect from the soft graded tones of the

FIRST PRIZE " DELINEATOR "

Figure 6.2 The Studio Volume 3, 1894: XVII Winning entry to reader competition to
brief 'A single figure drawn in line, set and judged by Mr. Henry Blackburn',
courtesy of Glasgow School of Art Library Special Collections.

photographic print (1894: II). These competitions, and the whole discourse of *The Studio* in its early years, shows clearly a visual environment of incessant photographic remediation, with images shuttling from one print medium to another to fit the demands of specific niches in the print market. The competitions also offer a glimpse of the toiling masses of hopeful illustrators, men and women, in the service of commercial aestheticism, hoping for a breakthrough, like Beardsley, in the magazine trade.

Photomechanical line block process printing, with photographic capture of any suitable marks, could easily combine text with images. The interchangeability of text and image in terms of photoprocessing technology was paralleled, according to Lorraine Kooistra, through the operation of 'bitextuality' in alliances of text and image (Kooistra 1995). Taking a well-known example, the Wilde–Beardsley collaboration on the 1894 English translation of *Salome*, Kooistra demonstrated how images in *fin de siecle* fiction created a parallel narrative apart from the text. Hence Beardsley, the 'artist as critic' often inserted a sly meta-commentary on the personal and artistic obsessions of the author, Wilde, and the artist, Beardsley, into this Biblical tale of Salome, Herod and John the Baptist, by inserting fashion plate women of the 1890s and recognisable caricatures of Wilde into the images. For the reader, this 'bitextuality' created not only an enhanced experience of narrative and interpretation but could also be taken as an artistic manifesto. In Kooistra's view, the 'defiant style of art-nouveau artists – the sweeping lines, the stark tonal contrasts, the risque motifs and sexual themes – [all] participated in *fin de siecle* cultural politics', a call to adopt the aesthetic life in order to surmount the 'vulgar horrors of Victorian society by refusing to conform' (Kooistra 1995: 35). But this image–text interplay was just as important in more middlebrow adventure yarns for mass readership, for example in Rider Haggard's tales of empire or in Arthur Conan Doyle's stories of the great detective Sherlock Holmes. The Sherlock Holmes stories only achieved their 'meteoric rise to fame' when they were published in *The Strand* magazine with Sidney Paget's illustrations. When the stories were first published without pictures, they had attracted little interest; by contrast the illustrated versions laid down an iconography of Holmes and Watson that has continued through numerous film and television dramatisations (Kooistra 1995: 58–59). The fictional exploits of Sherlock Holmes also garnered intertextual resonances in a journal like *The Strand* as they were embedded amongst investigative true crime reports, which were in turn equally embellished with dramatic line process illustrations.

Typewriters and office duplicating machines

Many of the voracious readers of light and sensational illustrated fiction in journals and magazines worked in offices and other urban commercial environments as clerks, stenographers, bookkeepers and salespersons. Such businesses generated a distinctive range of print cultures, different from those

of the commercial presses used for books, newspapers and advertising. Machines for typing, copying, data-inputting and storage created a vast archive of alternative printed texts. Office work in businesses and government departments increased enormously at the end of the nineteenth century; indeed, the largest organisations needed more administrative workers not simply for external business but also to deal with internal organisation (Chandler 1977). Before around 1880, clerical work was masculine work, often providing a comfortable living. Nineteenth-century clerks in literature, such as Mr Pooter, Mr Wilfer in *Our Mutual Friend*, and even the apparently down-trodden Bob Cratchit in *A Christmas Carol*, all had families with middle-class aspirations, supporting a wife and children at home with the help of a domestic servant, despite their shabby image. But at the end of the nineteenth century, office work became rapidly feminised. In 1890 women held 60 per cent of typing and stenography jobs, by 1920, 90 per cent (Anderson 1988; Fine 1990; Lupton 1993). This change in the sexual division of labour was accompanied by a shift from quill-driven technologies to an investment by companies in a range of specialised items of office equipment from type-writers (Beeching 1990) to automated addressograph machines for mailing (Lowe 1987). Under the surface, this 'feminisation' of clerical work was accompanied by male defensive action. Men who were already in adminis-trative clerking work set about creating managerial hierarchies of graded posts for themselves that largely excluded women by developing new terminology and job titles. 'Typists', were pushed into female low-status enclaves with no chance of promotion, and formerly general-purpose administrative work

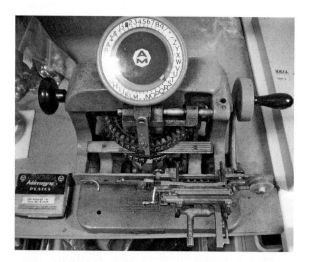

Figure 6.3 Addressograph machine, author photograph (2011), courtesy of Glasgow School of Art, Typographic Caseroom, Department of Visual Communications.

now became divided both horizontally and vertically in order to preserve and secure well-paid 'breadwinning' jobs for men (Wilson 2001).

Typewriters, mechanical writing machines, displaced the 'scribing hand' and according to several commentators shifted human culture society 'from thousands of years of dependency on the drawn and textual line, whether written or printed' (Curtis 2002: 40). As one of the 'great inscribing engines of modernity' (Kirschenbaum 2008), along with the phonograph and film (Gitelman 1999; Kittler 1999), typewriters captured and stored human expression in a new and impersonal way. The urgent rattle of typewriter keys hammered out texts in distinctive office typefaces such as Pica or Elite (Beeching 1990: 78–81), and their percussive sound was added in to avant-garde performances, for example in the anti-art manifestations of the Italian Futurists. In a hierarchical office environment, where the word 'typewriter' denoted both machine and subservient female employee, the act of type-writing was, according to Lisa Gitelman, a kind of automatic writing akin to the trance-like possession of the spiritual medium. The typist's attention and body was chained to her task, and while she transmitted the businessman's ideas to the page, the businessman 'became increasingly divorced from the mechanics of producing [his] own authored texts' (Gitelman 1999: 185–213). Typewriters literally punch their script into the page, creating a material record that on the surface had a uniform appearance with other similar documents produced by the same machine. Nevertheless, every machine secreted its own personal history as minute marks of wear and tear; evidence for new forensic methods of detection as celebrated in the exploits of Sherlock Holmes (Kirschenbaum 2008: 250). Typewriting denotes a kind of bureau-cratic fixity; as is well known, the QWERTY letter order is not the most efficient system that could be devised, but has become so embedded into training and equipment that it remains in place by inertia through to the digital era, despite numerous attempts to change keyboard layout (Beeching 1990: 39–43).

While typewriters use type, they do not print, in the sense of making multiple copies; nevertheless the heavy striking mechanism of typewriters was exploited in other bureaucratic technologies for copying and duplicating. Typewritten documents came to be used as master copies for the printed matter of business and government. Copying official correspondence was an established procedure, through the penmanship of copy clerks supplemented by duplicating devices such as James Watt's copying press (Rhodes and Streeter 1999; Joyce 2011). Copy sheets by the Watt method have a distinctive appearance in archives, with brownish handwritten ink staining thin tissue paper. By contrast, the hectograph (or jellygraph) – a simple invention from the second half of the nineteenth century – used the powerful colouring strength of aniline dyes to duplicate multiples from originals written with violet copying ink (Rickards and Twyman 2001: 363–64). After the production of the first commercially successful typewriters in 1872, more methods of duplication were developed such as carbon paper that transferred pigment to

interleaved sheets of paper through the striking force of the typewriter keys. Duplication, office printing, record-keeping, and information processing and retrieval became more and more central to administrative and business practices, and was promoted by businesses such as Gestetner and Roneo.

In 1881, David Gestetner made an experimental toothed wheel pen, a 'cylostyle' that pricked handwritten notes from a stenographer into waxed paper creating a stencil for printing copies. Soon after he also developed typewriter stencil duplicating paper, where the keys, struck with a special 'even staccato touch' like that of a pianist, would knock out the wax coating from the paper and leave a network of open fibres as a support for the stencil. To control the market for printing equipment, Gestetner also developed rotary duplicators. Duplicators were widely used to print many kinds of material, from business advertising flyers and price lists for chain stores and mail order companies to teaching materials such as examination papers or class notes for schools and colleges, to newsletters for churches and clubs (Proudfoot 1972: 99–111). Gestetner's rival, the Roneo company, used proactive and aggressive marketing methods in its expansion into North America, Japan and Europe before World War II, with teams of girl demonstrators to show their rotary duplicator to potential customers. Other Roneo products at this period also included the 'menu-maker'; an expanded typewriter that had ready-cast slugs of useful phrases, *petits pois* or *hors d'oeuvres,* in elegant type for the restauranteur and his staff (Dorlay 1978: 3–21). Roneo expanded its range of products to consolidate its hold on business and information storage markets, creating specially designed office, library and banking equipment from filing systems to dictation machines (Dorlay 1978: 34–39). In the 1970s the company developed pre-digital automated filing and data retrieval systems such as 'Conserv-a-trieve' for the mortgage company Halifax Building Society to organise and store millions of correspondence files and title deeds (Dorlay 1978: 147–49). Companies like Roneo also carried business forms of print culture and information storage into more traditional academic worlds. In the early decades of the twentieth century Roneo, for example, was simultaneously incorporating notions of scientific management into its designs for totally controlled office environments and at the same time collaborating with architects and engineers to gain prestigious contracts for academic library storage systems, such as the provision of bookstacks for the British Museum, Cambridge University, or the British Library (Dorlay 1978: 47). Many other similar collaborations between business and organisations in charge of state 'patrimony' were in place at this period, for example in the rationally engineered designs for the Library of Congress bookstacks, designed by Bernard R. Green and installed in 1895 (Petroski 1999: 177–78; Galey 2010), forming the 'industrial library' that replicated in scholarly contexts industrial and commercial orders of knowledge, with hierarchical organisation, cataloguing systems and, above all, expressed in tonnes and tonnes of manufactured product in paper, shelving and iron-framed modular buildings (Wright 2007: 165–82).

Information overload

In the first decades of the twentieth century, with at least a century of accumulated material, librarians found themselves pressed down by the sheer tonnage of their archives, generated by many and diverse print techniques ranging from the products of traditional print trades through to the office productions of government bureaucracies and businesses. Librarians added to this weight of material themselves by publishing research into the professional dilemmas of storage, and by experimenting constantly with new printing mediums. Robert C. Binckley, who compiled a *Manual on methods of reproducing research materials* in 1936 for an American consortium of university libraries, explained his dilemma of values. Consumer and custodian interests clash in library policy. Archived texts and documents provide a lot of evidence beyond the written content, and we also have no way of knowing just how this material evidence will be used and interpreted in the future; the duty of preservation is indefinitely long. But at the same time scholars and students often only want to access a text, and quickly, without much interest in the original. One solution is to copy texts to allow a limited form of access, while keeping valuable or fragile originals out of the hands of library readers. Binckley's idea was to get original texts typed out, in effect re-setting those texts through office technology, and then to reproduce them by photo-mechanical means. This preserved content but nothing of the layout or appearance. The *Manual on methods* used this method of production, litho-printed from a typewritten page and aligned to the left margin, not justified. To the contemporary reader the manual has itself become a material record in its own right, because Binckley bound in specimen examples of many different and now outmoded experimental variations of typewriter effects, paper, inks and reproduction technologies. By the 1960s, the McLuhan era, 'information overload' and the sheer range of types of archive documents that had worried Binckley in the 1930s appeared even more apparent to archivists. William R. Hawker, in his *Copying methods manual* of 1966 described the scale of the problem of preserving print culture in all its variety at this date. In contrast to Binckley, office printing technologies onto paper were seen not as a solution to a problem, but perceived as an additional headache by Hawker. Beyond books and newspapers, libraries kept many other forms of printed documents and archives such as maps, printed card files or government pamphlets. Print techniques jostled in storage, from gelatin dye transfer, to 3M thermo-fax copying or Xerox electrostatic methods, all now threatening to age in peculiar ways (Hawker 1966: 65). Hawker's solution to this decay of the page was different from that of Binckley, as he favoured photoreproduction of the original pages in their aged state.

Whatever the proposed solution, a moment's reflection will reveal the conceptual difficulties and contradictions in these attempts at preserving the past, not to mention the sheer horror of contemplating the silting and decaying reality of these layers of record upon record. To librarians, all those

kilometres of heavy shelves and the long-term cost of maintaining storage facilities made the idea of disposing of cumbersome and decaying originals very attractive, if it were possible. Newspapers in particular, that had been printed on low-grade industrial paper for short-term consumption presented particular problems of storage. In the 1980s and 1990s many libraries adopted a policy of photoreproducing such materials onto microfilm, often disposing of the originals. The novelist Nicholson Baker attacked this policy in his polemical *Double fold: libraries and the assault on paper* of 2001. Baker's assault was controversial and made a good news story because he took on some esteemed public institutions such as the British Library, Library of Congress and the New York Public Library. Copying by microfilming, he asserted, involved a wanton destruction of the material record, as old newspapers had to be 'disbound', cut apart for reproduction, and microfilm copies, as most readers will agree, are tiring and frustrating to navigate and read. But although Baker prompted an important debate in a period when digital archiving was gathering momentum, it is important to recognise the insurmountable task of dealing with an archive of print culture that continues to grow. Much printed ephemera is in a very sorry state, being ragged, torn, defaced, frequently folded and compressed into unwieldy bundles where to read is to destroy, and where the sheer extent of documentation, for example in government and company records, seem to defy any attempts at scrutiny (Bülow and Ahmon 2001).

DIY publishing

Cheap photomechanical methods of reproduction, allied with office techniques of document production, have also offered many and different opportunities for self-publishing. Fanzines (Sabin and Triggs 2000) are perhaps the most self-conscious (and well-known) expression of this low-level print culture, understandably popular as a genre with art students and graphic design cognoscenti, and associated with alternative and transgressive subcultures such as punk. But self-publishing initiatives have also included productions ranging from so-called *samizdat* publications under conditions of heavy state censorship of printed materials, to church magazines and other publications serving small-scale local interests. Many of these everyday and humble items have not been near a graphic designer or professional printer, reminding us that an important percentage of print culture comes from untrained and amateur printers, especially since the advent of office printing technologies and more recently of desktop publishing (DTP). While some self-published productions are more knowing, deliberately mashing-up or parodying current styles (with punk and Riot Grrrl as prime examples), many others are much less considered.

Fanzines are associated with the DIY subcultures of the 1970s (Sabin and Triggs 2000; Duncombe 1997; McKay 1998; Rickards and Twyman 2001: 364). When the term came into use it denoted a duplicated, stapled,

non-commercial, small circulation magazine for like-minded readers, fans for example of music or football. The format of most 'zines was derived from sci-fi publications of the 1930s, and from 1960s underground productions. Many were deliberately oppositional, flaunting plagiarism, obscene and opinionated language and sloppy layout. Publications such as *Sniffin' Glue* put forward an aggressive parody of conventional news magazines. For example, its cover page for November 1976 carried a crudely hand-rendered letterpress-style banner and dateline in felt-tipped pen, above a snarling gargoylesque portrait close-up in harsh photobooth monochrome (Sabin and Triggs 2000: 7). Many 'zines were dedicated to violent subject matter, illustrated with crude graphics, as in Mike Diana's *Boiled Angel* of the 1990s, and some had subversive and even revolutionary intent, such as feminist fanzines *Vaginal Teeth* or *Heavy Flow* from the Riot Grrrl scene of the 1990s. Teal Triggs has argued that the 'zine movement in the 1970s was prompted by an intense distrust of the mass media amongst ordinary readers, the despised 'masses', allied with a self-empowering belief in direct personal and local action against social and political inequalities. Two issues in particular stimulated fanzine production: identity politics and attacks on consumerism (with titles such as *Thrift Score*; Triggs 2001: 33–48). However, according to Sabin and Triggs, it would be a romantic exaggeration to claim some kind of outlaw righteousness for fanzines for only a tiny fraction of total output has ever risen above 'self-indulgent, poorly produced drivel' (Sabin and Triggs 2000: 1). Perversely, there is a charm about fanzines. Their amateur, home-made appearance that speaks of simple thrifty methods, cheap and often illegal printing on workplace photocopiers, or labour taken from the 'boss's time' makes them into alternative commodities, and even when the content is dire simply touching and handling actual zines (rather than finding out about the history or theory of zinedom at second hand) can, according to Alison Piepmeier, stimulate thought and action (Piepmeier 2008: 213–38). As desirable objects, fanzines could be seen as a proletarian, vernacular alternative to earlier amateur private press activities or avant-garde print experiments. According to Roderick Cave, Thorstein Veblen (the sociologist of 'conspicuous consumption') attributed the popularity of private press books with wealthy bohemian clients to the workings of his theory, pointing to their 'cruder type … with excessive margins and uncut leaves [and] with bindings of a painstaking crudeness and elaborate ineptitude' (Cave 1971: 141).

While alternative and avant-garde amateur print productions in the capitalist West aimed to evoke in various degrees a mythic past of radical and revolutionary print activism, a range of much more concealed and deliberately nondescript print production, also generated by home and office technologies, came into being in the Communist countries of Eastern Europe and the Soviet Union. Unofficial publishing activities in these tightly controlled regimes have come to be known collectively as 'samizdat'. The word was coined in the 1950s from the Russian word *samesbyaizdat*, meaning 'publishing house for oneself' in parodic echo of the name *Gozisdat*, the official state

publishing house. To keep production as private as possible, samizdat texts were printed and circulated in very limited editions, typically through typing onto interleaved layers of copy and carbon papers on an old-fashioned typewriter, then exchanged clandestinely through oblique social negotiations. Making, distributing and reading such unofficial texts was dangerous in various degrees according to local circumstances, but nevertheless many kinds of readers were anxious to get hold of samizdat texts, even (and perhaps more accurately, particularly) Communist Party members anxious to read between the lines of the regimes they served (Johnston 1999: 115–33). As a print culture, samizdat is hard to categorise and explain; networks of circulation and reception were deliberately informal and untraceable, while the mentality of readers, so far as this can be ascertained, does not translate into any of the various characterisations of 'subcultural consumers' in the West. Robert Darnton, while not addressing samizdat texts directly, gives an account of readership in the former GDR (East Germany) at the time of the fall of the Wall in 1989 that conveys some of the asperities of seeking out unofficial knowledge in a police state where censorship was 'forbidden by the constitution' (Darnton 1995: 47). In conditions of unacknowledged censorship where the state planned and controlled the presentation of publication themes and arbitrarily changed favoured authors from one year to the next, everyone, claims Darnton, became active and aggressive critics of texts and their appearance with a level of 'sophistication and alienation unimaginable to the West' (Darnton 1995: 57–58). This is a print culture in which every text is questionable. Ann Komaroni has argued therefore that samizdat functioned as an 'extra-Gutenberg phenomenon', outside recognisable regimes of truth and falsehood established in Western print culture, foreshadowing the problems of negotiating trust in global internet exchanges (Komaroni 2008: 629–67).

Clubs and societies almost all circulate newsletters in a genre of amateur production that remains ubiquitous, numerous and almost invisible. Parish church magazines, produced in multiple local centres, have been established as a normal part of church activity right through the twentieth century, providing an index to changes in these mainstream styles of everyday print culture. In the 1930s, *St. James's Church Magazine* (Forfar, Scotland), was a modest octavo pamphlet cheaply set by a local jobbing printer into two columns of letterpress, not illustrated, but with ruled separations as minimal decoration between stories. The magazine was dedicated to day-to-day running of the church and its social life with announcements of services and forthcoming meetings of the Women's Guild, Wolf Cubs or flower arrangement rotas. News items described past events such as a 'Café Chantant' held by the Scouts, and their other charitable fundraising activities: 'Dr. Barnardo's Homes ... will be able to take in another baby to keep entirely on the money received for Silver paper'. Overall religious and moral content was sparse, apart from modest exhortations for example to 'join the Silver Paper campaign'. After World War II groups such as the Anglican Church Press and Publications Board began to develop a centralising or managerial attitude

in manuals of advice such as *Better parish magazines and how to produce them* (Blair-Fish 1949). Although individual parishes retained control over the content, production and appearance of their own magazines, *Better parish magazines* urged attention to 'corporate image', for example recommending a certain range of Monotype typefaces such as Perpetua or Aldine Bembo in presentation. This smart new graphic style was to be part of a new evangelism intended to win back the apathetic population revealed in the Mass Observation survey *Puzzled people* on attitudes to religion in the 1940s: 'It is generally admitted that some nine-tenths of the people of this country are outside the Church, and that a generation has grown up in almost complete ignorance of the Christian faith' (Mass Observation 1947; Blair-Fish 1949: 13). Instead of the doings of the Scouts, world news and controversy should now be included, in items such as: 'Christian Unity in India', 'Chaos, or Christianity' and 'The Situation in Germany' (Blair-Fish 1949: 104). The parish magazine, asserts Blair-Fish, should no longer be seen as a chore for the vicar, but as an entrepreneurial challenge and team-building exercise for parishioners, who should teach themselves the niceties of print production and cultivate an aesthetic awareness of typography, and then organise distribution, canvass advertisers, scrutinise advertisements for moral tone and choose a modern businesslike printer (Blair-Fish 1949: 55). Later magazines, however, used local parishioner expertise in a different and more modest way, by exploiting office document writing and duplicating technology in a more grassroots style. For example, *The Circle* (Dowanhill and Partick Churches, Glasgow, Scotland 1976) was composed in typewriter script, duplicated with an office spirit copying machine and all bound together with side stapling, fanzine-style. The text was not justified as in letterpress, but aligned to the left, like a normal office memo or report, and the content carried emotive topical references to local and worldwide events such as space flight, the Vietnam war and factory closure. For the Christmas issue the magazine cover was decorated with a hand-drawn image of Mary and the infant Jesus duplicated in the characteristic violet of gelatin dye transfer technique.

Offset lithography and typewriter composition

From the beginning of the twentieth century then, many people developed a working familiarity with composing and printing texts. The skills came from office work, and the range of copying and duplicating technologies that had been absorbed by a new army of unconsidered low-ranking workers such as typists, office boys and the print room staff of commercial and bureaucratic concerns. Typewritten texts originally differed from those of conventional print mediums, but new machines such as electric office typewriters, varitype machines and particularly IBM's 1961 Selectric 'golf-ball' machines were developed to present type that was much closer in appearance to standard letterpress, with justified line presentation and a choice of typefaces (Beeching 1990: 127; Lupton 1993). Typewritten copy could be pasted up

and assembled without compositors, and transferred photomechanically to offset litho-printing plates. These new techniques, in association with the development of photosetting, meant that labour organisation and control in traditional printing was in question. Employers saw this as a means of breaking the power of print unions, while radical political activists used this technology to seize control of the means of production through self-publishing. In the 1970s lithography was seen truly as a technique for 'improper printing', disrupting good taste and social stability (Twyman 1990; 1992: 15–17).

Cheap, relatively unskilled means of printing and composing texts and images prompted many strands of experimental and radical print production, from the concrete poetry movement (Williams 1967; Sharkey 1971), underground and counter-cultural presses, and student protest posters associated, for example, with the events of 1968 (Döring 2011). Concrete poetry played with the tension of meaning in writing and typography, treating words and letters as things or images, and constantly experimenting with format and presentation (Drucker 1998b: 110–36). For example, the *Concrete poetry* collection assembled by Bob Cobbing (Cobbing 1974), presented a square folder of separate folded pamphlets by many poets and artists, with experimental manipulation of text as image expressed in many mediums, using metal types, office duplicators, typewriters, linocuts and even clockwork mechanisms, but all unified and made into print through photolithographic means. The new, uncouth or unexpected appearance of unconventional print styles was in accord with a critical anti-establishment rejection of mainstream society. The agitations of groups like the Situationists proposed using cultural expression and representation against the status quo through strategies such as plagiarism and *détournement*. Slogans such as 'plagiarism is a necessity in our culture' freely appropriated from *The Songs of Maldoror* (1869) by de Lautréamont (Schwartz 1996; Wark 2011: 34) prompted strategies of free copying of text and images at many levels, both by photocapture but also in approaches to content and 'originality' for example in William Burrough's 'cut-up' writing techniques. *Détournement*, as in to 'detour, hijack, lead astray and appropriate' should be, in McKenzie Wark's view, an 'active place of challenge, agency, strategy and conflict' superior to plagiarism, which 'upholds private property in thought by trying to hide its thefts'. By contrast 'detournement treats all of culture as common property to begin with, and openly declares its rights' (Wark 2011: 41).

But scepticism and anti-traditional attitudes were also ingrained into modernist designers, critics and corporate managers in the improving culture of technological modernism. For example in *The visible word* (1969), published in association with the Royal College of Art, the typographic researcher Herbert Spencer embraced new appearances and techniques for print, deliberately choosing to compose his text on the IBM 72 electronic typewriter in the interests of legibility. Spencer stated that 'the real challenge to the survival of the printed word comes not from other, alternative

communication media but from the torrent of paper and ink which is today pouring from the presses' (Spencer 1969: 8). In his opinion, non-traditional composition would make it easier for readers to read and deal with this torrent of information. He defended unjustified setting in print, saying that readers' eyes were used to typewritten documents, and pointed to many newspapers that had already adopted this style (Spencer 1969: 37). In addition, Spencer also noted that typographic standards would need to change to allow non-human readers to share and process information, noting electronic reading machines that were already printing and creating texts in everyday life such as the typeface E13B developed by the American Bankers Association in 1958, or OCR-A and OCR-B (Optical Character Reading: a typeface familiar in base level or older style screen displays), designed by the graphic designer Adrian Frutiger (Spencer 1969: 64–65).

Famously, there were also many counter-cultural print experiments in the 1960s and 1970s, in imprints as diverse as *International Times*, *Oz*, *Black Dwarf*, *Time Out* or *Gandalf's Garden*, and promoted by cult figures such as Jim Haynes, Tom McGrath or John 'Hoppy' Hopkins, ex-nuclear physicist, peace campaigner and founder of London Free School (Fountain 1988). In *Underground: the London alternative press 1966–74* (1988) Nigel Fountain notes, however, that much of the 'liberation' of consciousness in many publications and in the personal and social scenes around them was of the 'unredeemed macho' variety, with numerous 'pretty chicks' adorning the pages in suitably compliant blissed-out poses (Fountain 1988: 32–33). The quest for a change of personal consciousness in alternative imprints stimulated a powerful wave of graphic experimentation and revisionism, at odds with the prevailing clean modernist styles of mainstream graphic design. Lithographic printing from camera-ready copy meant that journal issues could be assembled communally, perhaps around a kitchen table, and embellished with dry-sheet Letraset motifs and types. *Time Out*, for example, was produced in poster format, while the last issue of *International Times* came out as a psychedelic '14-Hour Technicolour Dream Issue' printed in day-glo colours (Fountain 1988: 46). In a 'retro' strategy of confrontation, old or discredited graphic styles were pillaged and recycled. Thus, Aubrey Beardsley's faded reputation was resuscitated in the V&A exhibition of 1966 as part of a more general Art Nouveau revival at this time, congenial to hippy culture (Guffey 2006). What made this retro revival different from nineteenth-century historicism, claims Guffey, was its lack of misty antiquarianism. In contrast to Victorian medievalism or orientalism, which rejected modern industrial society, retro is knowing and ironic, somewhat distanced from the period it evokes and not too serious in its opposition to consumerism. But in the 1960s it also represented a dissident or deliberately non-serious riposte to modernist design values that until then had held sway. Pop artists and neo-Dadaists used popular commercial print as a resource and as a technique for invoking the spectacle of modernity through its ephemeral urban manifestations such as magazines or advertising, not attempting to invent new formal

configurations on canvas, but appropriating and reproducing images from elsewhere. And in a similar spirit to the Fluxus publications mentioned in Chapter 1, or the concrete poetry assemblages discussed above, graphic designers, poets and artists also used print as a stand-alone art medium in dialogue with their more substantial or traditional kinds of artwork. So, for example, to support an exhibition of artists that included Lichtenstein, Warhol and Rauschenberg, the designer Dorothy Herzka created the souvenir catalogue *Pop Art One* (Herzka 1965), containing an enticing portfolio of 'hand-made' industrial copying effects, with layers of clear acetate pages embellished with Letraset ruled lines and dots, dead-pan artist photographs and texts to create a contrapuntal and noisy visual environment for the reader.

The 'counter-culture' in print was ambivalent in its attitudes to liberation and in its opposition to consumerism. To many people outside the charmed circle, the alternative scene appeared to be nothing but an elitist party by invitation only. For example, one angry letter to *Oz* read 'Reading your magazine makes me feel very small ... I can't play the guitar, I can't write poetry, act, paint, or sing and my understanding of politics and economics is very limited. So what happens to me in the great cultural revolution? In my nineteen years I've had three women, a nervous breakdown and some poor education. Can't you people in London realize that twenty miles north of *It*, *Oz*, Arts Labs, etc., *nothing has changed*!' (quoted in Fountain 1988: 93). In the 'macho' slant of the drive for liberation, women and gay activists also felt excluded, and fought to gain control of cultural production through setting up alternative press voices, in journals such as *Spare Rib* or *Gay News* (both 1972: Fountain 1988: 91, 171–75) and in alternative communal press and publishing businesses such as The Women's Press or Virago (Cadman et al. 1981). Nevertheless, in relation to consumerism and popular commodity production, by its very nature photoready graphic surface decoration can migrate easily from one surface to another, for example from paper to the artist's canvas and then onto T-shirts. When Bridget Riley's work was first shown in a prestigious show, *The responsive eye*, in the Museum of Modern Art in New York in 1965, her dazzling Op Art works were immediately plagiarised in shop windows and textile designs (Riley 1999: 66–69, 224). Despite the idealism associated with alternative print techniques and networks of activity, much of the most celebrated counter-cultural initiatives in this period actually supported the capitalist market system in its expansion. According to Sedlmaier and Malinowski (2011), the rebels of 1968 contributed to the breaking down of conservative checks to consumption, where the 'performative hedonism' of protestors proved highly fitted to the agenda of consumer culture, increasing the desire for acquisition.

Printing trade, conflict and 'control of the keystroke'

In the 1970s and 1980s, print culture did not disappear, but changed. Many publications from this period show unconventional layouts that embrace

typewriter text composition. In the print trades, most notably in newspapers, occupational 'printer cultures' that had developed in association with letterpress were overturned and destroyed in a relatively short period. Printing and newspaper production work moved away from its traditional locations around Fleet Street, and working practices in printing changed. Employers invested in machinery to undermine the control of workers and especially the craft trade unions that had maintained closed shop policies, restricting training and employment, since the beginning of the twentieth century. In the 1970s and 1980s, print and media industry corporations seized on the possibilities of offset lithographic printing as a means of attacking the power of those skilled craft trade unions, specifically typographical letterpress trades and skilled process workers represented by unions such as the National Graphical Association (NGA) or the Society of Lithographic Artists, Designers, Engravers and Process Workers (SLADE). In this period a few large groups, bent on consolidating power and in 'ruthless' competition, controlled the newspaper industry so that in 1974 just six companies controlled 80 per cent of production. These large corporations were also diversified, with interests in other businesses such as paper and packaging, property, travel, tourism, and other communications media such as television and financial activities (Marshall 1983: 54–59). Employers initially changed working practices in composition by moving from 'hot metal' letterpress composition to so-called 'cold composition', that is pasting-up and laying-out camera copy for offset lithographic printing in the 1970s. The men-only skilled workforce loathed these changes and felt their self-esteem to be threatened by working as 'glorified typists', for paste-up was seen as a clean and enfeebled activity in comparison with the dirty and clangorous work of hot metal (Cockburn 1983: 105–6). But machines for photosetting, use of typewriter composition, and then computerised 'direct inputting' also threatened male employment, not just their self-esteem. In the 1980s, computer inputting of text for print could be done by an employee with office typing skills, and employers recruited female office workers to try to replace male skilled print workers (Marshall 1983; Melvern 1986). Union action to try to combat these changes put skilled workers into conflict with the union for lower-skilled workers, SOGAT (Society of Graphical and Allied Trades). With computerised direct inputting, newspaper employers also began to work towards removing print trade involvement in composition entirely, and instead journalists were pressurised into taking on this role. Traditional typographical craft skills were now eclipsed by a battle for 'control of the keystroke' (Gennard 1987: 126–40). In 1986 there was a final and disastrous dispute between the print unions and News International, owned by Rupert Murdoch, publisher of the *Sun* newspaper. Murdoch intended to close the existing printing plant and move to new premises with computerized production. When the strike by over 5,000 workers failed, operations were transferred from Fleet Street to Wapping and 6,000 SOGAT and NGA members were dismissed (Melvern 1986; Gennard 1987: 126–40).

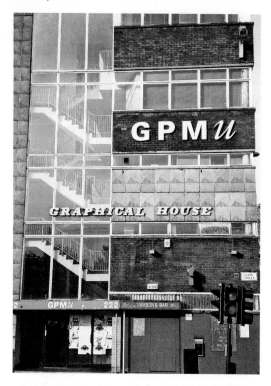

Figure 6.4 GPMU Graphical House, formerly Typographical House, 222 Clyde Street, Glasgow, now simply an item of architectural heritage, author photograph 2011.

Writing in 1983, Alan Marshall asked whether it was true to say that the printed word is dead. From the point of view of corporations, print was flourishing: 'in today's version of McLuhan's *global village*' he claimed, 'what we are witnessing is the promotion of a *global supermarket* in which half the world cannot afford to buy', for the UK printing industry had increased output by 6 per cent while cutting its workforce by 11 per cent (Marshall 1983: 2–5).

Marshall did, however, also acknowledge the 'double edge of technology' by stating that perversely, while ownership of equipment and technology had become more concentrated, unofficial printing activities had become cheaper, even if the self-publisher was only hiring the means of production, most notably in the use of photocopying for making short-run, self-published items from jumble-sale flyers to punk 'fanzines' (Marshall 1983: 63). In fact, in the 1980s, and despite the battles inside the specialist printing and publishing trades for control of computer inputting work, it is important to remember that for most people, access to computers or to the notion of computer-aided publishing was still remote. Apple Macintosh computers that offered (limited) choices of layout and typeface were only offered for sale in 1984. Before then,

computers created a distinct, machine-like style of office printouts for enthusiasts and users with technical expertise, and until at least the 1990s, home computers continued to be expensive and intimidating. For self-publishers, and for everyday printing commissions, there was still a range of print options available, from office duplicating of typed documents to local printers producing wedding invitations or dance tickets by letterpress. But even mainstream printed books often took on a more informal appearance, as seen for example in *The alternative printing handbook* (Treweek and Zeitlyn 1983). Photomechanical printing through offset litho or photocopying picked up any kind of mark and reproduced it in often emphatic gloss black. In comparison to the exactitude and formality of digital print, many printed texts through to the late 1980s maintained a more impromptu appearance, whether coming from a radical alternative group or a mainstream publisher. These typed-up-looking pages act to denote the sincerity and honest labour of the writer, clattering at the keys to craft an authentic, if necessarily imperfect, statement. Drawn marks, whether from Aubrey Beardsley, graphic novels, or 'counter-cultural' psychedelia, also use this emphatic direct style. Indeed, clear decorative graphic designs, using cheap black and white technologies of reproduction, were a mark of emancipatory and radical political movements since the late nineteenth century, when Socialist activists and educators such as Walter Crane took on the ideals of William Morris and spread the arts of graphic publicity to trade union and women's suffrage movement posters and banners (O'Neill 2008). But the direct impact of the images again often hide the exacting work of the printers behind the scenes, for example the skills needed in offset printing to keep the machines running with their 'thousands of moving parts functioning at extremely tight tolerances' (Drucker 1998c: 184–93), just as they hide the workings of the corporations behind the office technologies of copying machines. In many respects, numerous examples of printing in the late 1980s contrast in a more startling way with current digital norms than many earlier printed surfaces. Instead of the 'improper printing' ethos of photocopying and offset photolithography, the orderly templates and proliferating typographies in word processing applications appear to offer a certainty and perfection of expression that might fool even the writer into believing that her texts and arguments are equally orderly and controllable. As we see in the next and final chapter, even in the digital era print cultures continue to proliferate, and are evoking new arguments about the inscription and control of knowledge.

7 Conclusion

Post-print culture?

This book has addressed a plurality of print cultures, even while recognising that it would be impossible to embrace all the techniques or sites of printing in culture. Its approach has been synthetic and cross-disciplinary, developed from the author's own particular research and teaching interests in the social and cultural politics attaching to the production and reproduction of visual representations. The method of presentation, using specific, local examples of sometimes humble printed items is deliberate and informed by the belief, as Judy Attfield has it, that a 'self-aware, decentred standpoint' is a good way to encounter hidden histories (Attfield 2000: 53). In this approach, we see that print culture cannot be reduced to one narrative; for example the introduction of print culture in the Middle East or in India did not necessarily lead to the development of a Western humanist mindset, but was instead often adopted in order to attack colonial rule or secular values. In addition, as we have seen, 'print culture' (as a kind of slogan) has also often been espoused by particular groups within the business of print, whether by printing house workers, publishers or academics, leading to very different characterisations of what print culture might be; and in the process, these views have often been attached to different mediums and visual languages. But below these assured professional voices, many printed objects have been produced in more informal circumstances or in different working spheres. Against the more powerful expression of designers and associated discourses of exhibitions, academic monographs and critical commentaries, we have seen that discredited, outdated and 'merely decorative' items also have weight. The example of chromolithographs, whether in women's social exchanges in domestic spaces or in the development of 'photos of the gods' in India in the late nineteenth century (Pinney 2004), show that the worthy ideals of a single, progressive 'print culture' are simply the good taste of the ruling caste.

Breaking up print culture from any abstract overall meaning it may have, and looking at the particularities of printing techniques and mediums, also shows the social, political and economic costs and difficulties of change and innovation, combating more deterministic views of the march of print culture and indeed of visual culture in general. Looking at the materiality of specific mediums and examples shows those social negotiations in contact with the

worlds of production, and the meanings of making objects in multiples. Printing techniques have always been derived from other procedures for making objects in multiples, some very ancient, such as stamping, branding and stencilling, and, as we have seen, the development of printing reflects the state of surrounding technologies, whether these are expressed in steam and steel, chemistry, photographic imaging, or computing. Techniques for surface marking in print are at the very boundary of two- and three-dimensional making, and today some important applications of printing are sinking back into procedures for object crafting, and away from the production of textual content. For example, a Google search using the keyword 'photolithography' is now much more likely to throw up references to nanotechnology. Optical lithography is used for microfabrication of objects such as circuits (Sotomayor Torres 2003) in a continuation of the ways in which silk screen printing was also harnessed for fuse and circuit production earlier in the twentieth century (Kosloff 1958), while digital three-dimensional printing is now used increasingly for design prototyping or individual bespoke fabrication of material objects (Gerschenfeld 2007).

But against these new applications of print procedures, the advent of digital communication technology, whether as cyberspace (Benedikt 1992) or hypertext (Landow 2006) has been seen, often gleefully, as the end of print culture (Joyce 2001). Many rapid response books on the death of print appeared around the turn of the millennium with titles such as *The Gutenberg elegies: the fate of reading in an electronic age* (Birkerts 1994) or more bluntly (from the latecomer Jeff Gomez) *Print is dead: books in our digital age* (2008). Reviewers responded to this genre with their own crop of hackneyed jokes about the irony of this procedure, or the tonnage of dead trees. Sven Birkerts for example feared that the loss of printing would unweave the social fabric, erode language and destroy our sense of history (Birkerts 1994: 125–29) while more recent books such as *The shallows: how the internet is changing the way we think, read and remember* (Carr 2010) seemed to invite mockery by setting out to prove that we now lack the concentration to follow a sustained argument. These books do nevertheless all reflect serious anxieties; that digital communications appear to threaten those core values of print culture of clear authorship, of the perceived stability and fixity of texts, or that hyperlinks will encourage jumping and browsing so that we will lose interest in following the thread of sustained linear arguments or narratives that are carried in books. The short life of most websites and the open-access policies of most web servers, make digital content suspect to most academics. In short, digital communications threaten our social and consensual models of how information is to be made and agreed, and how knowledge is ordered. Other common fears about the death of print culture are more personal and subjective, usually focused directly on bookish pleasures that might be lost, such as the nostalgic atmosphere of old libraries, or the private pleasures of quiet reading in bed or the bath. Even before the development of commercially successful digital book readers, such as Sony's

digital ebook reader (2006) or Amazon's Kindle (2007), many commentators feared that young people, 'digital natives', were no longer accustomed to reading or handling information in books (Thompson 2010: 312–68). Why would a student bother to walk to the library or consult an index with Google or Wikipedia at hand? While book historians Finkelstein and McCleery note a 'natural closure' of the 'old print revolution' in the electronic era (Finkelstein and McCleery 2005: 26), Elizabeth Eisenstein has claimed more boldly that print's 'sense of an ending' began right from the start of the twentieth century due to incursions of previous new media, so that digital books are only a final confirmation of the end of print's domination (Eisenstein 2011: 215).

Nevertheless, we can see that many of these fears are exaggerated and misdirected, and some of the cult of the 'physical book' is misleadingly rose-tinted. Not all books are fun to handle. William Morris's complaint about unwieldy books in 1894 is still only too recognisable today: 'you want a book to turn over easily, and to lie quiet while you are reading it ... the fact is, a small book seldom does lie quiet, and you either have to cramp your hand by holding it, or else put it on the table with a paraphernalia of matters to keep it down, a tablespoon on one side, a knife on the other, and so on, which things always tumble off at a critical moment' (Morris 1999 [1893]; Peterson 1991). With e-readers, why go through this performance? Geoffrey Nunberg, like the harassed librarians in Chapter 6, suggests a massive but selective cull of printed material would not be a bad thing: 'books as such – that is, bound and printed documents – are not an interesting category. In modern industrial societies, the vast majority of books bear no cultural burden at all: they are parts catalogs, census reports ... repair manuals, telephone directories, airline schedules' (Nunberg 1993). But whatever one's stance, blanket statements such as 'print is dead' are still largely rhetorical and speculative. In relation to book use and production, print is still dominant. The volume of printed book sales has actually increased in the digital era, as communications and searching technologies support much more widespread browsing and buying, with online discussion groups and internet book sites such as Amazon. Used and out-of-print books are now much more easily available either through second-hand book sites such as Abebooks, or as facsimile copies through print-on-demand services. Even though ebook sales have increased significantly in the few years they have been available (for example, moving from around 3 per cent of total book sales in 2009 to around 8 per cent in 2010), those sales are only a small percentage of the total. Printed books and print culture are still central elements of cultural life, although patterns of use, marketing and consumption are changing (Nunberg 1996; Thompson 2010; Striphas 2011). In the late twentieth century publishing houses came together through merger and acquisition to form large transnational corporations, for example in the mass-market multi-media group News Corporation, owner of Harper-Collins (Greco 1996: 5–16). In these circumstances, John B. Thompson has argued that concentrating on the fate of the 'physical book' does not in fact offer the most important analysis of the effects of digital communications on

print culture. Instead, the real impact of digital technology is on the workflow and operating systems of print production (Thompson 2010: 321). Until the late 1990s, most publishers used offset lithographic printing that was expensive in terms of initial set-up costs to print large runs of books. Digital technologies such as Xerox DocuTech systems or scanned PDF facsimiles allow short-run print-on-demand strategies. Instead of selling large numbers of (it is hoped) startlingly new best-sellers, publishers can in theory maintain a large digital back catalogue of titles that would only be printed when desired (Thompson 2010: 324–27).

Nor is print culture just about book production. Ephemeral and everyday uses of print have increased in many domains in the digital era: in advertising, in commerce and packaging, and in the office. The printing industry is dominated by massive business corporations whose activities are rarely talked about outside the trade and financial press, but whose output spans a whole range of products such as security and banknote printing, mail order catalogues and packaging (Marshall 1983: 7, 54). If printers in craft unions have declined there is a still a vast workforce serving new species of printers (that is, machines), whether in large automated offset litho printing plants for newspapers and packaging, local copy shop equipment running both digital and offset operations or desktop printers. Workers in print culture include lower-skilled print workers, engineers, designers, marketing teams, and the buyers and users of printed products. The number of professional designers has increased enormously; creating a much more crowded labour market. In 1985 there were around 250,000 graphic design professionals in the US but the number increased by 1997 to 3 million (Cleveland 2004: 113–53). But as well as the expansion in numbers of professional designers, many other non-specialist and amateur people create design for print and graphic display with the aid of digital software packages. Conflict for control of the workplace still exists, but conducted in relation to a dispersed, atomised, non-unionised network of practices. In these conflicts professionals for example try to fend off incursions by amateur practitioners with claims about skill, taste and expertise.

The field of design and typography practices expanded and changed from the 1980s with increasing marketing of personal computers to ordinary buyers without technical expertise. Word processing and design software developed for these products, suitable for all computer users, meant that many non-specialists began to create graphic designs, or at the very least began to take an interest in typography and design to an unprecedented degree. Apple Macintosh computers, introduced in 1984, were equipped for the first time with word processing choices about fonts (such as Chicago and Geneva) and layout, prompting users to take account of their text's appearance. Such concentration on the visual, on appearance as a central factor in the writing process, marked a real change in the way that readers evaluated their texts (Staples 2000: 20). All home software providers developed word processing packages and the number of font choices and layout options continued

to increase. Some of the most popular fonts in use included Times New Roman, Arial, Lucida or Comic Sans, this latter offered as a supplementary typeface in Windows 95. Comic Sans rapidly developed an unexpected notoriety amongst non-specialists, far removed from professional graphic designers in new worldwide discourses about font choice that were conducted by web users. The font was first widely and indiscriminately adopted for would-be informal and friendly messages launched by home desktop publishers (from church magazines to local business fliers), then equally rapidly became the unlikely butt of worldwide online sniping from knowing people who attacked the uncool Comic Sans devotees. The designer, Vincent Connare, responded by trying to dismiss all these upstart amateurs, saying that anyone who took a stand on either side of the love/hate Comic Sans debate was just showing their ignorance of typography (Garfield 2010: 17–29). In similar vein to Connare, the graphic designer Paul Cleveland laments the baneful influence of non-specialist users on the 'inscription characteristics' of digital print production. By this he means that certain appearances and design decisions have already been built in to the functions of software programmes, foolproof 'default' decisions and style templates that allow anyone to create a design layout. This has come about because the sheer cost of developing the packages means they must be sold to the largest market, the lowest common denominator of specialists and non-specialists alike. Personally, this makes him feel cheated of his creative autonomy because the programmes give predetermined results. Aesthetically, he claims such rigid programmes have encouraged an unstoppable tide of the 'worst typography of the twentieth century' (Cleveland 2004: 113–53).

Default settings and 'style themes' impose structure and a somewhat bland uniformity. However, digital graphics and new methods of designing type also created unexpected appearances and layouts that formed a jarring contrast to established ideas of print layout and design. Programmes such as Fontographer in 1986 allowed experimentation in typeface design by anyone who could afford the software, while the relatively uncouth letterforms in early word processing programmes in turn prompted professional designers to experiment with many kinds of mashed-up or unorthodox typefaces (Lupton 1996: 32; Staples 2000: 25). Although Philip Meggs railed against amateur desktop 'morons' and their 'obscene typography' (Meggs 1994: 160), in fact many professional designers also revelled in endless possibilities for noise and distortion in digital typographic design, famously Zuzana Licko who developed three typefaces, Emperor, Oakland and Émigré in 1985 that deliberately exploited the pixellated appearance of the first Macintosh typefaces (Heller and Pomeroy 1997: 91–93; Staples 2000: 25). Licko was just one of many designers who responded to digital design possibilities and incongruities in this period, creating layered and often confusing effects. In part this was a response to the possibilities of digital design, but it was also in reaction to the clean certainties of previously dominant modernist design styles. These disorderly strategies marked a suspicion of the rationality of modernist design.

For while many designers have claimed that their professional expertise helps to order knowledge and make it accessible, nevertheless a display of order can give a false sense that the world is subject to rational control, or can be interpreted in just one particular way. In the 1990s, in accord with these critical revaluations of modernism in design, communications historians Nerone and Barnhurst looked at the introduction of the first modernist streamlined and hierarchical layouts into elite broadsheet newspaper design in the first half of the twentieth century. They argued that while this strategy of clean legible design claimed to support a democratic constituency of informed citizens, this very visual clarity masked a deceptive ideology, for 'news by definition is messy ... The news is weird, new, and dramatic; it is, in short, a jumble' (Nerone and Barnhurst 1995: 39). From this same account, we also see how modernist style bolstered up the professional authority of journalists and designers, asserting the claim that they alone could understand and explain the world (Nerone and Barnhurst 1995: 9–10).

Digital equipment allowed designers and writers to craft a postmodern form of expression that deliberately stressed the ambivalent quality of desta-bilised digital typography, demonstrating an indeterminacy of meaning to set against the fixity and trustworthiness of graphic design derived from traditional typesetting (Brannon 2007: 353–64), or to break with established norms of good practice in other ways. Well-known examples include April Greiman's 'Does it make sense?' contribution to the magazine *Design Quarterly* (issue 133: 1986). Here, an apparently normal issue of the magazine actually opened out to one single large poster, folded to the normal format size. When open, the poster presented unconventional graphic language laid out in unfamiliar style, designed and pasted-up entirely on computer. According to Heller and Pomeroy, this was completely new and astonishing. In 1986, most designers were accustomed to paste-up methods established in the era of photomechanical reproduction and felt that computers were 'arcane, expensive and unfriendly', producing uncongenial 'bit-mapped type and imagery'. Greiman's work asserted a 'new level of authorship for design-ers' using personal computers (Heller and Pomeroy 1997: 213–14). Such new graphic languages have quickly been assimilated into practice and into teaching, for example in the experimental and theoretical work of the gradu-ate school of graphic design at Cranbrook Academy of Art under Katherine McCoy. Through the 1980s and 1990s, the school developed graphic languages in print that reflected digital methods of working (and thinking), with layers of embedded information, non-linear progression of ideas, and an exploration of the decorative and expressive qualities of type (Heller and Pomeroy 1997: 147–50; Lupton and Miller 2010 [1994]: 192–99).

The opportunity to layer up many different images and styles in digital design was in accord with the eclectic historicism rife in commercial post-modern design in the 1980s. Many designers exploited the past in often deliberately ugly and retro styles. To many, this was an abomination, the developing study of design history, it was claimed, only led to 'really bad,

unhealthy design' (Kalman et al. 1994: 25–33). To others, these attacks on retro styles simply appeared to be an attempt to claim cultural capital and one-upmanship; to attempt to ban references to past styles is to forget that artists and designers have been appropriating form and style, and flouting established norms of good taste, since at least the nineteenth century (Heller 1994: 34–38). Wherever one stood on the use of historical styles, however, the study of history and theory at issue in these debates was becoming an important marker of professional expertise at this time. Currently design practitioners use history and theory in many ways in their working lives, perhaps reflecting on print history and print discourses through design, academic research, writing and teaching, but also increasingly in conceptual and hybrid forms of art. Johanna Drucker, for example, is an academic who is also a practitioner and has addressed questions to do with the practice and theory of print and its relation to our ordering of knowledge by focusing on experimental typography and artist book production. So in *The visible word: experimental typography and modern art, 1909–1923* (1994) Drucker makes an historical and theoretical examination of early avant-garde practices, while *Figuring the word: essays on books, writing, and visual poetics* (Drucker 1998a) presents examples of her own experimental writing and typography alongside essays on various other related contemporary practitioners. In these works there is an emphasis on the languages and legacy of letterpress production.

The conceptual artist and graphic designer Blair Robins also reflects on the multiple registers of print communication in his practice, but with reference to contemporary digital graphic styles of assembly. For example in the project *The money supply* Robins presented a critical analysis on the ways in which both art and money are accorded value through agreed systems for creating surface markings, while also thinking about the instant visual recognition aimed for in brand identity. Robins examined the processes and histories of banknote production originally developed through steel engraving in the nineteenth century, and reinvented these characteristic motifs through the glossy contemporary languages of digital drawing. Robins developed a series of digital prints covered with insistent and hypnotic patterning derived from the same geometric procedures that were used to make rose engine patterns on banknotes. Instead of the lathe-driven steel-engraved patterns in the original banknote designs, Robins used a computer drawing programme that he pushed to the limit, breaking the symmetries of the form and creating instead by random process images that resembled cloudy viscera built from multiplying fibres (Figure 7.1). This project deliberately invoked problematic aspects of digitised production in relation to the value given to artworks and money by manipulating the strategies of security printing. In fine art, printing in multiples threatens value based on notions of originality and authenticity. Digital imaging, severed from the baseline of observed reality that was so valued in photographic image capture, generates deceptive illusions. Banknote production depends on an artificial and mutual agreement to trust in the

Figure 7.1 Gorgon (2007) from *The money supply* (Robins 2008: 5). With the permission of the artist.

purchasing power of millions of identical scraps of paper. *The money supply* references the procedures of banknote design with their dense patterning of reiterative marks where every space is filled, and filled again, with abstract patterns and micro-lettering that compete in information overload, while the obsessive serial permutations of pattern also conjure the compulsive actions behaviour of repression and nightmare. Robins joined many references to moments of art and design history in this project, and combined them through contemporary languages of commercial display in print. Although the image shown in Figure 7.1 is in simple black and white, *The money supply* project also presented a suite of large colour poster-like prints in glossy high definition, invoking the appearance of corporate print campaigns in brochures, banners and advertising. By exploiting technologies of image reproduction and playing on the psychology of repetitive behaviour, Robins considered the continuing role of printed communications in providing an envelope for systems of value that are normally only discussed in the abstract.

In contrast to high-resolution prints in advertising and other commercial communications, digital design is also used to generate everyday and frequently low-resolution print outputs in domestic and office environments. In *The myth of the paperless office* Sellen and Harper (2002) describe the changing uses of paper and print in digital office environments. The idea of the paperless office was, as they show, a journalistic future-gazing invention; nevertheless it caught hold with many business thinkers because paper was a 'symbol of old-fashioned practices and old-fashioned technologies' placed in unflattering contrast to new digital regimes of office computing (Sellen and Harper 2002: 5). Office managers became sensitive to the sight of piles of paper that they associated with incompetence. Clear desks, to some bosses, signified their employees were clear thinkers and efficient workers. In reality, Sellen and Harper found that just as the volume of books on paper has increased in conjunction with digital technologies, so office paper use has also increased substantially in conjunction with digital office technologies.

The environmental writer Richard York links this phenomenon to the so-called 'Jevons paradox': the observation that increased efficiency in using a resource often leads to increased consumption. According to York, the 'paperless office paradox', by analogy shows that the development of an alleged substitute for a resource can also increase its use (York 2006: 143–47). The interaction between paper and digital ways of working has created new uses for an increased paper flow. According to Sellen and Harper, paper has certain 'affordances' (that is, possibilities for action) that are different from digital layouts of information. They found that paper is most useful for annotating, for shuffling around in a meeting, and for sharing and disseminating texts while working through a live project carried on by teams of people. In short, they asserted that printing on paper remains vital to 'knowledge work' but only for a very short period. It is a 'temporary medium' of creative development, whereas finished work tends to be stored digitally. Sellen and Harper predicted, correctly, that printers would increase in number, with smaller separate machines on individual desks in frequent use rather than there being one large communal printer. Equally they asserted, more playfully, the well-stuffed wastepaper basket ought to be recognised as the symbol of an effective and creative worker (Sellen and Harper 2002: 211–12). Their account of the print culture of the office challenges the idea that print leads to stability and fixity of texts, instead, in this usage, print becomes the forum for alteration, and digital storage is the medium of fixity. This description of paper use in Sellen and Harper was, however, focused on fairly private and hidden printing practices. Even though their findings may have been challenging to established managerial certainties, they were still interested in the same goal of efficient organisational function, and their account does not therefore address all the other more public and perhaps more frivolous uses of office printing technology that fill everyday environments. Ordinary home and office printers now churn out all kinds of posters and publicity materials (Figure 7.2). The same kinds of machines that are used to make powerpoint presentations, memos and e-mails are also used to craft unofficial flypostings, lost pet signs, or the daily menus of bars or restaurants. Most productions like this are printed out on the cheapest setting possible, for printer ink is expensive, deliberately so, as the companies who make cheap individual printers are in business to sell disposable ink cartridges designed to fit only into their machines. As a result, much of the ephemeral printed material we encounter today has a mushy, greyed-out quality (Figure 7.3), quite different from the sharp glossy blacks of cheap low-grade photocopies or offset lithography of previous eras.

Such examples of everyday printing, from print-on-demand book production, to commercial packaging or corporate communications, to office or home printing, show that digital graphic media are linked in various specific and localised ways to the material expressions of print and contradict a common assertion that we are now bombarded by texts and images that have somehow become dematerialised by new media developments.

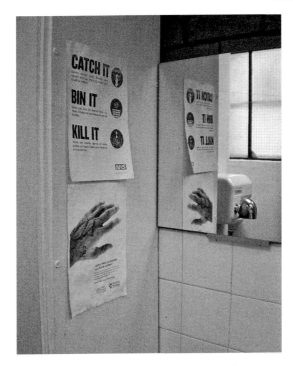

Figure 7.2 Health information poster in a college washroom, 2008–12, author photograph.

Figure 7.3 Detail of home-printed political action poster shown in Chapter 1, Figure 1.1.

Recently several digital media researchers such as Katherine Hayles (2002) and Matthew Kirschenbaum (2008) have begun to move away from 'virtuality' to the materiality of digital communications, looking at the 'actual "stuff" of media – the nuts, bolts, and silicon' (Kitzmann 2005: 681). Kirschenbaum, for example, has engaged with 'counterintuitive' evidence of textual stability and data recovery after traumatic damage, in order to challenge current assumptions of the ephemeral mutable nature of electronic textuality. He combats most writing on new media that remains focused on conceptual, textual layers of meaning imbued with a kind of 'screen essentialism', accepting current display technologies as an invisible window into virtuality. Instead Kirschenbaum investigates the material matrix governing electronic writing and inscription, examining physical processes of storage, inscription and processing (Kirschenbaum 2008: 1–35). Currently there has been less investigation of the complex and differentiated aspects of print and digital interaction in material production although the range of practices we see in this chapter shows that there is plenty of scope to ally these fields of inquiry.

To environmentalists and human rights activists, 'cyberspace' is a deceptive lie that obscures both 'ecology and labor' in the production and life cycle of digital equipment (Markley 1996: 77, cited in Kirschenbaum 2008: 35). Equally the 'myth of the paperless office' or the 'death of books' also obscure the environmental and human labour questions that are connected with the materiality of digital-print interactions in all their forms. Many different kinds of hybrid print/digital cultures coexist, and not always easily, from the corporate to the home-made. Currently, optimists and book-lovers look to the notion of an easy-going 'post-digital' print culture that will encourage a 'return to civility' (Jenkins 2011) and would exploit digital technology for its convivial sociable qualities. The term first appeared around 2000 in works such as *The postdigital membrane: imagination, technology and desire* (Pepperell and Punt 2000), which emphasised the values of live experience, asserting after the previous decade of techno-euphoria the virtues of being human rather than the dream of becoming a digital entity. In relation to books, 'post-digital' print culture attempts to be pragmatic, open and socially responsible, valuing some books, but trying to balance scarce resources. Publishers like OpenBook, for example, publish in a range of formats, as paper or ebooks, and as downloadable PDFs. In addition, all their books are available free to read online through Creative Commons licence arrangements. Adherents of 'creative commons', like this publisher, believe that open access is not just socially useful but also is good business, increasing sales.

Printing enthusiasts also sustain a similar ethos of creative commons, maintaining presses and techniques in part-time printing practices. In art schools, many graphic design students still study letterpress, composing text by hand setting, and printing on hand presses as a part of their training, building on the letterpress revival of the 1980s (Lupton 1996: 33; Jury 2006; Rivers 2010). The creative ferment of this part of their lives remains, and many graduates maintain a fluid identity, working as designers, teachers and

printers in turn, even though some parts of their work may not make much money. The community outreach, conference programme and evening classes at the St Bride Library show these printing practices in action, for example at the 'Vintage' events held as part of the South Bank Festival, July 2011, London. Print Workshop went out recruiting new students through a mobile exhibition, exhorting potential visitors to 'look for a pink milk float with cheery printers aboard' outside the Royal Festival Hall. In these active printer cultures, celebrating past glories, certain moments of printing history begin to stand out, notably avant-garde typographic experiments of the early twentieth century, or punk paste-ups, reinforcing a romantic outlaw image of past print cultures. Nevertheless, many current exhibitions and publications now take place with established artistic and academic sponsors somewhere in the background. For example, a recent publication *Splitting the atom on Dalston Lane: the birth of the do-it-yourself punk movement in March 1977* (Williamson 2009) presented an assembly of contributors that included printers, poets and artist collectives, and a text that gave testimony to the many stages on the way to publication. As a result, this very slim volume conjured two very distinct environments, both a psycho-geographical excursion around the shabby former stomping grounds of the band Desperate Bicycles, and a recent cultural event at the British Museum, celebrating these past exploits. In Glasgow we can see a similar diversity of working environments in the practice of one typographic artist, Edwin Pickstone, who is a letterpress specialist. Like Drucker, Pickstone reflects on the long history of his medium, on its many revivals, and on previous avant-garde critiques of the role of printing and typography in society in his work. To do this, he maintains multiple roles as a typographic craftsman, conceptual artist, academic tutor, graphic designer and jobbing printer. Currently he is Artist in Residence and Typography Technician in the Visual Communication Department of Glasgow School of Art, where he teaches and maintains the large caseroom facility where, as an undergraduate, he benefited from contact with the previous technician Fraser Ross, a former compositor who had many years of experience in the printing trade through apprenticeship and printing house work. As a printer with multiple roles, Pickstone adopts different letterpress styles according to the project. Earlier printers tried not to impress the page too deeply; in that respect the preface to *Jane Eyre* with its crinkled surface we saw in Figure 3.1 was badly printed by the standard of the rest of the book. Today, more recent clichés and expectations are in force; many clients now prefer deeply impressed work into soft cotton stock paper (Rivers 2010: 11). By maintaining a flexible range of roles, and a critical stance, Pickstone can develop a fuller range of creative printing techniques and display much of the tacit knowledges of the past that would otherwise be difficult to access. As well as teaching and printing in Glasgow, Pickstone also exhibits and demonstrates his work in galleries and in workshops across Britain and abroad. As a graphic designer he produced the typographic cover of Christian Bök's *Eunoia* (2008 [2001]), an experimental text composed in homage to the Oulipo group, a 'univocal

lipogram' in which each chapter restricts itself to the use of a single vowel. As a conceptual artist Pickstone creates works such as *One gram of black ink squared* (2011) or *The ashes of one copy of William Blades's The enemies of books, first published 1881* (2011); for this latter work the ink was ground from the cremated remains of the unfortunate book (a print-on-demand copy!). Pickstone also works as a jobbing printer, composing and printing up letterpress ephemera such as flyers, club night posters, corporate invitations, or commemorative cards (Figure 7.4).

Copyright laws and agreements began with printing. Copyright issues, and battles for control of intellectual property continue but are changing in the digital era. To the opponents of tighter copyright legislation, the battle is still framed in the terms described by William St Clair, that is as a price-fixing and monopoly agreement in the merchant's favour (St Clair 2004: 43–45). The author and publisher copyright system established in the nineteenth

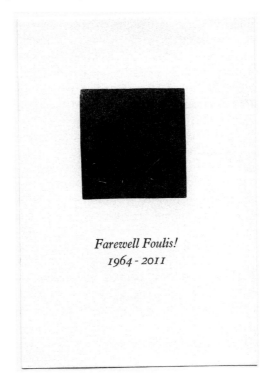

Figure 7.4 Edwin Pickstone, letterpress commemorative card *Farewell Foulis!* (2010) marking the closure for demolition of the old Foulis Building on Glasgow School of Art Campus, and former home of the Department of Visual Communications Caseroom. Currently the rebuilding work has reached the stage of a large rectangular hole in the ground, while letterpress teaching continues in temporary studios. This card was given away at the 'wake' (the funeral party) held with bars, bands and plenty of students on the day before the demolition closure. With the permission of the artist.

century has now grown and ramified with new forms of mechanical reproduction such as photography, music, film and digital communications. Different national legal systems, and the values they uphold do not mesh together. New technologies do not fit easily into existing legal frameworks, giving enterprising poachers and pirates the chance to grab or share other people's work. In the digital era many artists and publishing corporations feel particularly endangered by the spectre of free copying and sharing on the internet because it allows instant worldwide communications and datacopying (Goldstein 2003; Lessig 2008; Johns 2009). Against these anxieties, general internet users value that 'free' content. In addition, many people value the empowerment of rapid and free exchange of information and debate. Currently, in the first decades of the twenty-first century, arguments about control versus freedom in the digital realm are complex and increasingly embittered. Potentially corporations and internet providers are in a position to exert much more copyright control over consumers than in recent print periods. For example, with the 'celestial jukebox' system, providers are in a position to limit the number of times that even a legitimate subscriber can access their downloaded content, in contrast to the amount of use that can be wrung from a book, LP record or videotape (Goldstein 2003: 25; Lessig 2004; 2008). In early 2012, while the United States legislature was considering two controversial bills, SOPA (Stop Online Piracy Act) and PIPA (Protect IP Act), the online encyclopaedia Wikipedia imposed a 24-hour protest blackout of service in opposition ('English Wikipedia anti-SOPA blackout' 2012), prompting vociferous counter-accusations from powerful corporation bosses against the 'political' involvement of this content provider.

More insidiously, the new litigious atmosphere of digital 'zero-tolerance' against piracy by large media corporations, defending their publishing and archive holdings, threatens 'fair use' conventions. 'Fair use' is the established legal convention that copying or quoting parts of works without copyright charges or penalties is legitimate for academic purposes. Without this neutral territory for operation, say defenders of fair use, no one could possibly operate in the vaunted knowledge economy that is supposed to replace man-ufacturing in the West. Increasingly, if there is any doubt about whether an image or quotation might annoy a copyright holder, it is now much more likely for publishers to self-police and censor themselves and their authors rather than risk a legal battle. Ted Striphas and Kembrew McLeod have argued that in current circumstances 'fair use' is a right that must be defen-ded, not simply because of its importance in the academic sphere, but as a civic duty. Aggressive control of intellectual property by corporate interests now extends deeply into many aspects of everyday life. For example battles about GM crops that are deemed to be eligible for copyright protection are important because at base this is a battle for control of food production and access to daily nourishment. The science of copyright protection now gives much more power to copyright holders, from 'terminator crops' to the coded working of digital information that limits the amount of access

to material. With this in mind, say Striphas and McLeod, everyone should be alert to defend the principle of 'fair-use' in their own patch wherever possible (Striphas and McLeod 2006).

As well as the idea of copyright and the development of social systems for the defence of intellectual property, other concepts from print culture have been transported into the digital realm, notably the kind of technological determinism that claimed the development of printing formed a new kind of consciousness for humans. Adherents of 'visual culture' for example often dismiss the importance of print communications in our lives today because at some level they believe that non-linear digital thinking is now dominant (Mirzoeff 1999; Coupland 2010). This way of thinking rejects the idea of print culture not because it is technologically determined, but because it is an outmoded deterministic regime. Instead of fearing the death of print, many ecstatic visions of digital culture welcomed it, for example when *The alphabet versus the goddess* (Shlain 1998) conjured the destruction of the patriarchy that would surely follow from new visual and non-linear communication on the web (Crow 2006).

With the numbers of practitioners, students, interested spectators, academic historians, and other contributors noted in this chapter, print culture as both practice, production and discourse about print is evidently not at all dead. Ordinary people now take an interest in design and the previously arcane topic of typography through exhibitions, books (Loxley 2004; Garfield 2010), television programmes and films, for example Gary Hustvit's *Helvetica* (2007). The approach of popularising texts often emphasises personal stories and anecdotes, as for example in Simon Loxley's narrative of 'Frederic Goudy, type star' (Loxley 2004: 93), in contrast to new approaches to print culture by scholars and academics who investigate wider systems and networks of practice in social and economic contexts. Johanna Drucker has argued that the expansion of resources for study is encouraging this change in method: 'as networked (and print) resources grow, the artefacts available for study expand ... as the available inventory of materials expands, this history will not be limited to an inventory of artefacts to be thought about, but will include a lively critical discourse about ways of thinking' (Drucker 2009: 72). Indeed, in relation to 'ways of thinking' it is important to assert cultures of print as a contemporary, and not simply a historical phenomenon. In contrast to the triumphalist celebration of print in the nineteenth century, the vast range of contemporary print activity is hidden by the deliberate anonymity of large corporations, and eclipsed by the excitement of digital culture to the extent that the older words for the workings of the mind, such as 'impress' and 'imprint' have been displaced by newer metaphors as we talk about 'hard-wiring' or 'programming' the brain. Currently digital and print mediums are mixed up in many ways, are expressed in many kinds of action, and invoke many different struggles for cultural and economic power, so that future print cultures remain to be made, and remade, neither 'impressed' nor 'hard-wired' into our brains.

Bibliographic notes and further sources

This section supplements the full Bibliography with additional commentary, directions to further reading not covered in the text, and other information such as web links.

Chapter 1

For general texts on the notion of 'print culture' and its ongoing debates, see the writings of Eisenstein (1979; 1983; 2011), McLuhan (1962; 2001 [1964]) and Ivins (1992 [1953]) whose ideas are cited and discussed throughout this book. For further reading, and for reappraisals and revisions of this concept see *The coming of the book: the impact of printing, 1450–1800* (Chartier et al. 1997 [1976]), *Orality and literacy: technologizing the word* (Ong 1982), *The book history reader* (Finkelstein and McCleery 2002), *An introduction to book history* (Finkelstein and McCleery 2005), *Old books & new histories: an orientation to studies in book & print culture* (Howsam 2006), *The nature of the book: print and knowledge in the making* (Johns 1998) and *Agent of change: print culture studies after Elizabeth L. Eisenstein* (Baron et al. 2007). In addition see also the Program in the History of the Book in American Culture, initiated by the American Antiquarian Society, with annual conferences and regular seminars since 1983 and marked by the recent five-volume collaborative publication *A history of the book in America* (2007–10), University of North Carolina Press, that runs from Volume 1, *The colonial book in the Atlantic world* (Amory and Hall 2010) to Volume 5, *The enduring book* (Volume 5, 2009), see www.americanantiquarian.org/hob.htm for further information. Other useful organisations include the Centre for the History of the Book at the University of Edinburgh (www.hss.ed.ac.uk/chb/), and the Society for the History of Authorship, Reading, and Publishing (SHARP), an international society with annual conferences and strong page of weblinks (www.sharpweb.org/). Joseph A. Dane, whose opposition to the whole notion of 'print culture' is already cited in the Introduction (Dane 2003) returns to the attack with *Out of sorts: on typography and print culture* (2011) in which he expands his view that material books are each so singular that to create an

overarching discussion of 'print' from individual encounters is abstract and misleading.

For general guides to the history of print, either for text or image production, see *A chronology of printing* (Clair 1969), *Printing presses: history and development from the fifteenth century until modern times* (Moran 1973), *Nineteenth-century printing practices and the iron handpress* (Rummonds 2004), *Prints and printmaking: an introduction to the history and techniques* (Griffiths 1996), *Printmaking and picture printing: a bibliographical guide to artistic and industrial techniques in Britain, 1750–1900* (Bridson and Wakeman 1984) and *Printing 1770–1970: an illustrated history of its development and uses in England* (Twyman 1970a). For print research, weblinks and conferences, see the St Bride Library, Bride Lane, Fleet Street, London EC4Y 8EE (www.stbride.org/), their journal *ULTRABOLD* and bulletin *Printing History News* produced in association with the National Printing Heritage Trust, and the Printing Historical Society. For a brief introduction to the collection see 'Typographic treasures at St. Bride's' (Mosley 1978–79).

For guides to graphic design history and typography see *Type and typography* (Baines and Haslam 2005), *Design literacy: understanding graphic design* (Heller and Pomeroy 1997) or *A history of graphic design*, third edition (Meggs 1998). For a consideration of print in relation to recent developments in design history as a discipline see 'A decade of design history in the United States, 1977–87' (Margolin 1988) and *The design history reader* (Lees-Maffei and Houze 2010). For introductions to cultural and media history, see *What is cultural history?* (Burke 2004), or *A social history of the media from Gutenberg to the internet* (Briggs and Burke 2009). For various approaches to ideas of everyday life and material culture in relation to cultural and social history, some texts that make little if any explicit reference to print, but are full of valuable and relevant ideas, include *Material powers: cultural studies, history and the material turn* (Bennett and Joyce 2010), *Everyday life and cultural theory: an introduction* (Highmore 2002) and *Wild things: the material culture of everyday life* (Attfield 2000). For a sustained discussion on the working of 'popular memory' in the period covered by this book, and the ways in which narratives of the past infuse everyday life in and amongst print mediums integrated with other social channels, see *Theatres of memory: past and present in contemporary culture* (Samuel 1996). Finally, for discussions of copyright and intellectual property in relation to print history, see *Authorship and copyright* (Saunders 1992) or *Piracy: the intellectual property wars from Gutenberg to Gates* (Johns 2009).

Chapter 2

For a discussion of the cultural and spiritual significance that has been accorded to the characters of the Roman alphabet and their antecedents, see *The alphabetic labyrinth: the letters in history and imagination* (Drucker 1995). Johanna Drucker has also, in *The visible word* (Drucker 1994), examined the

development of semiotically based critical practices in the course of the twentieth century in relation to typographic thinking, responding for example to Derrida's critique of 'logocentrism', and the 'metaphysics of phonetic writing'; that is, Derrida attacks attempts to dominate or master the whole field of meaning within a narrow field of logic, deriving in his view from our classical alphabetic systems of writing and, thence, reasoning. Drucker's work in part sets out to explain why such linguistic and philosophical approaches might appear in writings on print and the culture of print from the last decades of the twentieth century (to examine the ideas of Derrida directly, see *Of grammatology* 1976). For a spread of writing on graphic design and the role of graphic designers and typographers coming mainly from within the profession, see *Typographers on type* (McLean 1995), *Texts on type: critical writings on typography* (Heller and Meggs 2001) or the *Looking closer* series (for example Bierut et al. 1994; 1999) from Allworth Press, New York. The exhibition catalogue *Printing and the mind of man*, exhibition publication 1963 London: Messrs R.W. Bridges & Sons Ltd and the Association of British Manufacturers of Printers' Machinery (Proprietary) Ltd, compiled by Stanley Morison, on the other hand manifests the self-presentation of a separate but related area of 'printer culture' from the mid-twentieth century. For a discussion of the development of graphs and tables in visual communications since around 1800, see 'The evolution of graphics in scientific articles' (Meadows 1991) and *The visual display of quantitative information* (Tufte 1993); and for an interim report from the ongoing University of Reading research project *Designing information in everyday life 1815–1914* see 'Information design for Victorian London's cab passengers' (Dobraszczyk 2009). For the development of 'industrial taste' in art and techniques of reproduction in the nineteenth century, see *Art and the industrial revolution*, second edition (Klingender 1972), *The industrialisation of taste: Victorian art and the Art Union of London* (King 1985) or *The arts of industry in the age of enlightenment* (Fox 2009). For discussion of the engraving trade in the nineteenth century, see *Steel-engraved book illustration in England* (Hunnisett 1980), *Pictures to print: the nineteenth-century engraving trade* (Dyson 1984) and finally *The Heath family engravers 1779–1878*, Volume 2 (Heath 1993) that expands on some of the connections between illustrative and fine art printing and the development of security printing industries in this period. Finally, on the topic of paper currency and the fraught business of 'printing money', see 'What one man can make another can copy' (Bower 1988), *A nation of counterfeiters: capitalists, con men, and the making of the United States* (Mihm 2007) and 'The aesthetics of authenticity: banknotes as industrial currency' (Robertson 2005). To view some of the infinite permutations of the spirograph-like forms so particular to security printing, created in the nineteenth century by the rose engine and now generated by digital geometries, see the 'Guilloche pattern generator' in the web pages run by designer and web developer Tom Beddard on www.subblue.com/projects/guilloche.

Chapter 3

For further discussions on popular literacy in relation to formal education and industrial methods of working in the nineteenth century see *The English common reader, a social history of the mass reading public, 1800–1900* (Altick 1957), 'Literacy and social mobility in the industrial revolution in England' (Laqueur 1974), *Literacy and popular culture: England 1750–1914* (Vincent 1989), and *The social construction of literacy* (Cook-Gumpertz 2006). For adult education, 'steam intellects' and self-improvement, see *The steam intellect societies* (Inkster 1985) or *The rise of respectable society: a social history of Victorian Britain, 1830–1900* (Thomson 1988). For the development of illustrated periodicals and the expansion of visual cultural resources in print see *Victorian print media, 1820–1900* (King and Plunkett 2004), *Graphic journalism in England during the 1830s and 1840s* (Fox 1988), *Graphic design: reproduction and representation since 1800* (Jobling and Crowley 1996), *The lure of illustration in the nineteenth century press* (Brake and Demoor 2009), *The printed image and the transformation of popular culture 1790–1860* (Anderson 1991), *Science in the nineteenth-century periodical: reading the magazine of nature* (Cantor et al. 2004) or *Victorian popularizers of science: designing nature for new audiences* (Lightman 2007). For engaging and detailed accounts of the machinery and machinations of the publishing and printing industries in the nineteenth century see *Literature in the marketplace* (Jordan and Patten 1995) or *Victorian sensation* (Secord 2000). For information on 'William Blades, St Bride's posthumous benefactor' see Jeffries (2009), and Mosley (1978–79). For the history and involvement of skilled print trades in printing history and print culture through to the late twentieth century see *The Typographical Association: origins and history up to 1949* (Musson 1954), *Brothers: male dominance and technological change* (Cockburn 1983), *The skilled compositor, 1850–1914* (Duffy 2000). For broadsides and chapbooks, see *Folk in print: Scotland's chapbook heritage 1750–1850* (Cowan and Paterson 2007) or Glasgow University Library Special Collections chapbooks site at http://special.lib.gla.ac.uk/chapbooks/search. For all things Gutenberg and a distinguished body of exhibitions and publications to do with many other aspects of worldwide printing history see the Gutenberg Museum in Mainz: www.gutenberg-museum.de. For first-hand contact with the subject, start reading newspapers and journals of the period such as the *Illustrated London News*, preferably in your local academic library, although many publications are also available in online databases such as *19th century periodicals online*. Digital periodical archives of many kinds are mainly available through academic or large public-access libraries such as the British Museum. For information about Gale Digital Collections, a major provider in this area, see http://gdc.gale.com. Printing trade union and mechanics' journals to consult include: the *Compositors' Chronicle: an epitome of events interesting to printers* numbers 1–37 (1840–43), the *Printers' Register* and the *Mechanics' Magazine* (1823–), and find working-class autobiographies

in *The autobiography of the working class: an annotated critical bibliography Volume I: 1790–1900* (Burnett, Vincent and Mayall 1984). For ephemera, see *Victorian things*, in which Briggs (1990) discusses the Johnson Collection of Ephemera, Oxford and attempts to provide context for the multitude of material objects that ultimately defy categorisation. Print and paper here feature very much as material production, notably in the chapter 'Carboniferous capitalism: coal, iron and paper'.

Chapter 4

The history of lithography in Britain is indebted to Michael Twyman's many investigations. All are worth reading, but his introduction to 'improper printing' *Early lithographed books* (Twyman 1990) makes a good starting point. Further confirmation of the reach of pragmatic and non-specialist exploitation of lithographic applications in the nineteenth century can be found in *Aspects of Victorian lithography: anastatic printing and photo-zincography* (Wakeman 1970). The expansion of printing production to practitioners from outside the sphere of craft training by means of lithography was due in part to the fact that Senefelder's methods were deliberately disseminated early, appearing in English translation as *A complete course of lithography* (Senefelder 1977 [1819]) now still available in facsimile. For comics and graphic novels, see also *Reading comics* (Wolk 2008) and *Comic book culture* (Pustz 1999). For the influential example of lithography and political caricature in France in the period of Daumier, see *The charged image: French lithographic caricature 1816–1848* (Farwell 1989), and see also *Realism* (Nochlin 1971) for further context. Interactions of art, print and business are addressed in *Lemercier et Compagnie: photo-lithography and the industrialization of print production in France, 1837–1859* (Rosen 1988), while in *Parallel lines* (2001), Stephen Bann presents a consideration of the status of reproductive printmaking in the context of nineteenth-century visual culture, in which both lithography and photography (another innovation, forty years later), feature as similarly disruptive elements, calling into question established ideas of value.

In relation to questions about the reception of Western techniques of printing in other cultures around the world, it is evident that lithography was not the only print medium that was at issue. Non-Latin type foundries for traditional letterpress, hot metal, office typing equipment and now digital foundries have existed to serve printing and publishing ventures beyond the West, as we see for example in such diverse works as *Middle Eastern languages and the print revolution: a cross-cultural encounter* (Hanebutt-Benz et al. 2002), *Indian ink: script and print in the making of the English East India Company* (Ogborn 2007) or the *History of printing and publishing in India: a story of cultural re-awakening* (Kesavan 1997) amongst others. But what is apparent from all these works is first that all print mediums gained new kinds of significance in the context of different cultural and political

circumstances outside the Western comfort zone of 'print culture', and second that lithography is more prominent in these discourses than in the West because it offered opportunities for 'improper printing', fostering the emergence of local political movements. In relation to image production in colonial and post-colonial India, Christopher Pinney's *'Photos of the gods': the printed image and political struggle in India* (2004) is a major recent work that addresses the Indian-run chromolithographic presses that developed from the 1870s onwards. Pinney describes this genre of popular visual culture, derived from the work of traditional painting castes and from self-taught sign painters, in order to show how this apparently kitschy touristic 'local colour' carried and promoted various kinds of political contests in the struggle for self-determination in India. Behind these discussions of specific print mediums and of print more generally lie further debates on the construction of knowledge and the ordering of society through writing, inscription and the workings of bureaucracy. For further consideration of these issues see for example *Colonising Egypt* (Mitchell 1991), a study of power manifested in the deployment of cultural and political mechanisms for ordering and framing space, knowledge and people in new ways through regulation and education. Mitchell examines various 'disciplinary techniques' in examples that range from international trade exhibitions to printing and publishing to the design of worker housing in order to question the workings of power in the colonial era. Other useful texts include *Imagined communities: reflections on the origin and spread of nationalism* (Anderson 2006 [1983]) and 'Filing the Raj' (Joyce 2011), in *Material powers: cultural studies, history and the material turn* (Bennett and Joyce 2010).

Chapter 5

For the development and many permutations of photomechanical reproduction with printing technologies see the work of Tom Gretton on various entanglements of industrial printing, art and graphic illustration throughout the nineteenth century (for example 2005; 2010), also *The mass image: a social history of photomechanical reproduction in Victorian London* (Beegan 2008) and *Visual communication and the graphic arts: photographic technologies in the nineteenth century* (Jussim 1974) and for a comprehensive treatment of processes both on paper and in other applications such as ceramics or textile printing, see the *Encyclopaedia of printing, photographic, and photomechanical processes* (Nadeau 1994). For approaches to avant-garde typographic and graphic experimentation and its continuing reception and interpretation throughout the twentieth century see *The visible word: experimental typography and modern art, 1909–1923* (Drucker 1994), *Clean new world: culture, politics, and graphic design* (Lavin 2001), *Breaking the rules: the printed face of the European avant garde 1900–1937* (Bury 2007) or *Russian constructivism* (Lodder 1983). For commentaries on the reception and afterlife of the writings of Walter Benjamin and other cultural theorists,

see *Visual studies: a skeptical introduction* (Elkins 2003) and *The work of art in the age of its technological reproducibility and other writings on media* (Jennings et al. 2008). For discussions of the promotion of fashion through printed images, including photography, and through visual journalism, see *Cut with the kitchen knife: the Weimar photographs of Hannah Höch* (Lavin 1993), *Fashion spreads: word and image in fashion photography since 1980* (Jobling 1999), 'Virility in design: advertising Austin Reed and the "New tailoring" during the interwar period in Britain' (Jobling 2005), 'Depicting gentlemen's fashions in the *Tailor and Cutter*, 1866–1900' (Kent 2009) and 'Fashion journals and the education of enlightened consumers' (Purdy 2010). For discussions of stock photography and the various uses of image banks, see *Image worlds: corporate identities at General Electric, 1890–1930* (Nye 1985), '"The new heraldry": stock photography, visual literacy, and advertising in 1930s Britain' (Wilkinson 1997), 'Spectacles and illusions: photography and commodity culture' (Ramamurthy 1996) and 'Building the world's visual language: the increasing global importance of image banks in corporate media' (Machin 2004). To view the spread and methods of categorising and selling stock images today, see Getty Images (www.gettyimages.com). Getty Images is now one of the most extensive image banks in the world, and controls historically important holdings such as the Hulton Picture Archive (from *Picture Post*) as well as more bland, concept-based corporate marketing stocks of contemporary images. Finally, the Mass Observation Archive is currently held by the University of Sussex Library and can be accessed online through www.massobs.org.uk.

Chapter 6

For the development of office technologies and changes in working practices in relation to the development of 'business thinking', see *The visible hand: the managerial revolution in American business* (Chandler 1977), *Women in the administrative revolution: the feminisation of clerical work* (Lowe 1987), *The white blouse revolution: female office workers since 1870* (Anderson 1988), *The souls of the skyscraper: female clerical workers in Chicago, 1870– 1930* (Fine 1990) or *Mechanical brides: women and machines from home to office* (Lupton 1993), *Scripts, grooves, and writing machines: representing technology in the Edison era* (Gitelman 1999) and *Always already new: media, history, and the data of culture* (Gitelman 2006). For alternative and underground techniques and printing movements, see *Underground: the London alternative press 1966–74* (Fountain 1988), *Notes from Underground: Zines and the politics of alternative culture* (Duncombe 1997) and *DiY culture: party and protest in nineties Britain* (McKay 1998). For an online source on Fluxus see the George Maciunas Foundation Inc. (http://georgemaciunas.com/?page_id=1470) a contemporary history and evaluation of situationist procedures, see *The beach beneath the street: the everyday life and glorious times of the Situationist International* 2011) and finally *Urgent images: the graphic*

language of the fax (Booth-Clibborn 1994). For attitudes to self-publishing, and guides on how to do it, see *Publishing and printing at home* (Lewis and Eason 1984) or *The alternative printing handbook* (Treweek and Zeitlyn 1983). Treweek and Zietlyn introduce and evaluate a wide range of methods in a 'consumer guide' style, weighing up the relative merits of cost, simplicity, speed and other factors.

This book (*Print culture*) does not address every type of printing technique in the periods under discussion. Although silk screen printing features briefly in this chapter in connection with pop artists who relished the bold graphic effects of silk screen, and its industrial connotations, the development and reception of this technique can be examined further for example in *Screen process printing* (Kosloff 1958). The process, characterised by Kosloff as 'an American technique', was initially an industrial method for stencilling bold markings and first developed at the start of the twentieth century, to apply brand names and motifs such as 'Brillo' onto cardboard boxes, or to create strongly patterned textile designs. One important development, less well known, was in electronic circuit printing for industrial and military uses, and in other similar applications, as for example in the use of screen process printing of proximity fuses for artillery shells (Kosloff 1958: 196–205).

Chapter 7

For a clear commentary on changes in the conception of typographic design see, 'Typography and the screen: a technical chronology of digital typology' (Staples 2000). For ideas of print/digital interaction see *Remediation: understanding new media* (Bolter and Grusin 1999), *Writing space: computers, hypertext, and the remediation of print* (Bolter 2001), *Beyond the book: theory, culture and the politics of cyberspace* (Plant 1996), *The postdigital membrane: imagination, technology and desire* (Pepperell and Punt 2000) and *Text and genre in reconstruction: effects of digitalisation on ideas, behaviours, products and institutions* (McCarty 2010; this is published by OpenBook Publishers who offer a range of print and digital options to readers, their texts freely available to view online under Creative Commons licence, and they also sell print-on-demand or downloadable versions of their books. See www.openbookpublishers.com). Finally, see 'Book 2.0' (Striphas 2003) in Culture Machine 5: the E-Issue. *Culture machine* is an international peer-reviewed open-access journal of culture and theory, available at www.culturemachine.net. Striphas's article 'Book 2.0' has an ironic title that comments on the ways in which ebooks have been theorised and discussed. Striphas takes exception to the notion that ebooks build on or poorly imitate print-on-paper books, citing for example Jay David Bolter's concept of 'remediation' as an example of this thinking. But instead, argues Striphas, we should look to the technological forms, socioeconomic relations, and historical processes that ebooks really come from. Ebooks have more to do with the development of film and photography in the nineteenth

century, with television in the twentieth, with microphotography, and with videotext or teletext services on broadcasting channels.

For consideration of the changes in publishing and printing in relation to digital media, see 'Shaping the future: mergers, acquisitions and the US publishing, communications and mass media industries, 1990–95' (Greco 1996), *Merchants of culture: the publishing business in the twenty-first century* (Thompson 2010), and *The late age of print: everyday book culture from consumerism to control* (Striphas 2011).

Creative Commons Licensing is explained at http://creativecommons.org.

For self-publishing through print-on-demand services see sites such as Blurb (www.blurb.com), Lulu (www.lulu.com), Booksurge (www.booksurge.com) and Xlibris (www2.xlibris.com).

For a discussion of the materiality of digital communications, and for the links with earlier office information processing technologies and cultures, see *Mechanisms: new media and the forensic imagination* (Kirschenbaum 2008).

For questions and arguments about copyright and control of information, see *Copyright's highway: from Gutenberg to the celestial jukebox* (Goldstein 2003), *Remix: making art and commerce thrive in the hybrid economy* (Lessig 2008; also available to read online under Creative Commons licence) and 'Strategic improprieties: cultural studies, the everyday, and the politics of intellectual properties' (Striphas and McLeod 2006, available in *Cultural Studies* Special issue: the politics of intellectual properties 20 (2/3) available online at www.indiana.edu/~bookworm/ip-toc.html). Finally, for the 'English Wikipedia anti-SOPA blackout' on 16 January 2012, see http://wikimedia-foundation.org/wiki/English_Wikipedia_anti-SOPA_blackout.

This chapter also features the work of various artists and designers as examples of new hybrid methods of making a living in contemporary 'printer cultures'. For example, I show the guilloche-generated pattern 'Gorgon' from *The money supply: printing & engraving by Blair Robins* (Robins 2008). This is an artist book first produced in association with Robins's residency at *Banknote 2008*, a conference devoted to issues specific to the banknote industry and attended by representatives of national central banks, law enforcement agencies and security printing companies, 6–9 April 2008, Washington DC. See the 'Special exhibit' section in the Bank Note 2008 website at www.banknoteconference.com/banknote2008/banknote_highlights.html.

I discussed *Splitting the atom on Dalston Lane: the birth of the Do-it-yourself Punk movement in March 1977* (Williamson 2009), a book made by the printer Stephen Fowler (sngfowler@yahoo.co.uk) and purchased at the Glasgow International Artists Bookfair 2010: www.giab.org.uk.

Edwin Pickstone's work can be seen at his website, www.edwinpickstone.co.uk, and also in an online celebration of his exhibition *O! and other letters* that was staged as part of the Merchant City Festival in July 2011, Glasgow at http://wearepanel.co.uk/index.php?page=o-and-other-letters.

Bibliography

Alfrey, N. and S. Daniels, eds (1990) *Mapping the landscape* Nottingham: University Art Gallery

Altick, Richard D. (1957) *The English common reader, a social history of the mass reading public, 1800–1900* Chicago: University of Chicago Press

—— (1978) *The shows of London* Cambridge, Mass.: The Belknap Press of Harvard University

Anderson, Benedict (2006 [1983]) *Imagined communities: reflections on the origin and spread of nationalism* London: Verso

Anderson, Gregory (1988) *The white blouse revolution: female office workers since 1870* Manchester: Manchester University Press

Anderson, Patricia (1991) *The printed image and the transformation of popular culture 1790–1860* Oxford: Clarendon Press

Annandale, Charles, ed. (1890–93) 'Printing' in *The popular encyclopaedia: a general dictionary of arts, sciences, literature, biography, and history*, new issue, Volume XI London and Glasgow: Blackie & Son: 286–97

Art-Journal, 1849–1912

Ashbrook, Susan Margaret (1991) *The private press movement in Britain, 1890–1914*, Volumes I and II. Unpublished PhD Dissertation, Boston University

Ashwin, Clive (1978) 'Graphic imagery 1837–1901: a Victorian revolution' *Art History* 1 (3): 360–70

Attfield, Judy (2000) *Wild things: the material culture of everyday life* Oxford: Berg

Aubenas, Sylvie (1998) 'The photograph in print: multiplication and stability of the image' in Frizot, Michel (1998) *A new history of photography* Köln: Könemann: 225–31

Avery, Gillian (1995) 'The beginnings of children's literature to c. 1700' in Peter Hunt, ed. (1995) *Children's literature: an illustrated history* Oxford: Oxford University Press: 1–25

Babbage, Charles (1835 [1832]) *On the economy of machinery and manufactures* London: Charles Knight

Badaracco, Claire (1996) 'Rational language and print design in communication management' *Design Issues* 12 (1): 26–37

Baines, Phil and Andrew Haslam (2005) *Type and typography* London: Laurence King Publishing

Baker, Nicholson (2001) *Double fold: libraries and the assault on paper* New York: Random House

Bann, Stephen (2001) *Parallel lines* New Haven and London: Yale University Press

Barnhurst, Kevin G., Michael Vari and Igor Rodriguez (2004) 'Mapping visual studies in communication' *Journal of Communication* 54 (4): 616–44

Baron, Sabrina Alcorn, Eric N. Lindqvist and Eleanor F. Shevlin, eds (2007) *Agent of change: print culture studies after Elizabeth L. Eisenstein* Amherst, Boston and Washington DC: University of Massachusetts Press and the Center for the Book, Library of Congress

Barthes, Roland (1980) *Camera lucida* London: Vintage

Batchen, Geoffrey (1999) *Burning with desire: the conception of photography* Cambridge, Mass.: MIT Press

Baudelaire, Charles (1998 [1859–63]): 'The painter of modern life' in Harrison, C., P. Wood and J. Gaiger, eds *Art in theory, 1815–1900* Oxford: Blackwell: 497

Beeching, Wilfred A. (1990) *Century of the typewriter* Bournemouth: British Typewriter Museum Publishing

Beegan, Gerry (1995) 'The mechanization of the image: facsimile, photography, and fragmentation in nineteenth-century wood engraving' *Journal of Design History* (1995) 8 (4): 257–74

—— (2007) '*The Studio*: photomechanical reproduction and the changing status of design' *Design Issues* 23 (4): 46–61

—— (2008) *The mass image: a social history of photomechanical reproduction in Victorian London* London: Palgrave Macmillan

Belchem, John (1996) *Popular radicalism in nineteenth-century Britain* London: Macmillan

Bell, Quentin (1963) *The schools of design* London: Routledge and Kegan Paul

Benedikt, Michael, ed. (1992) *Cyberspace: first steps* Cambridge, Mass.: MIT Press

Benjamin, Walter (2008 [1936]) 'The work of art in the age of its technological reproducibility' (second version) in Walter Benjamin *The work of art in the age of its technological reproducibility and other writings on media*, edited by Michael W. Jennings, Brigid Doherty and Thomas Y. Levin, Cambridge, Mass.: The Belknap Press of Harvard University Press: 19–55

Bennett, Arnold (1970 [1910]) *Clayhanger* Harmondsworth: Penguin

Bennett, Tony and Patrick Joyce, eds (2010) *Material powers: cultural studies, history and the material turn* London: Routledge

Berman, Marshall (2010 [1982]) *All that is solid melts into air: the experience of modernity* London: Verso

Bermingham, A. (2000) *Learning to draw: studies in the cultural history of a polite and useful art* New Haven and London: published for the Paul Mellon Centre for Studies in British Art by Yale University Press

Bhandari, Vivek (2002) 'Print and the emergence of multiple publics in nineteenth-century Punjab' in Baron, Sabrina Alcorn, Eric N. Lindqvist and Eleanor F. Shevlin (2007) *Agent of change: print culture studies after Elizabeth L. Eisenstein* Amherst, Boston and Washington DC: University of Massachusetts Press and the Center for the Book: 268–86

Bierut, Michael, William Drenttel, Steven Heller and D.K. Holland, eds (1994) *Looking closer: critical writings of graphic design* New York: Allworth Press

Bierut, Michael, Jessica Helfand, Steven Heller and Rick Poynor, eds (1999) *Looking closer 3: classic writings of graphic design* New York: Allworth Press

Bijker, Weibe E., Thomas P. Hughes and Trevor Pinch, eds (1987) *The social construction of technological systems* Cambridge, Mass.: MIT Press

Binckley, Robert C. (1936) *Manual on methods of reproducing research materials* Ann Arbor, Michigan: Edwards Brothers, Inc

Birkerts, Sven (1994) *The Gutenberg elegies: the fate of reading in an electronic age* London: Faber and Faber

Blades, William (1891) *The Pentateuch of printing*, with a memoir of the author, and a list of his works by Talbot B. Reed, London: Elliot Stock

Blair-Fish, J. (1949) *Better parish magazines and how to produce them* London: The press and publications board of the church assembly

Blaszczyk, Regina Lee (2000) *Imagining consumers: design and innovation from Wedgwood to Corning* Baltimore and London: John Hopkins University Press

Bogart, Michele (1995) *Artists, advertising, and the borders of art* Chicago: University of Chicago Press

Boime, Albert (1971) *The academy and French painting in the nineteenth century* New Haven and London: Yale University Press

Bök, Christian (2008 [2001]) *Eunoia* Edinburgh: Canongate Books

Bolter, J.D. (2001) *Writing space: computers, hypertext, and the remediation of print*, second edition, Mahwah, New Jersey and London: Lawrence Erlbaum Associates

Bolter, J.D. and D. Grusin (1999) *Remediation: understanding new media.* Cambridge, Mass.: MIT Press

Boone, Troy (2005) *Youth of darkest England: working-class children at the heart of Victorian empire* New York and London: Routledge

Booth-Clibborn, Edward (1994) *Urgent images: the graphic language of the fax* London: Booth-Clibborn Editions

Bouchot, Henri (1895) *La lithographie* Paris: Ancienne Maison Quantin

Bower, Peter (1988) 'What one man can make another can copy' *Bond and Banknote News* October–November: 19–20

Brake, Laurel and Marysa Demoor, eds (2009) *The lure of illustration in the nineteenth century press* London: Palgrave Macmillan

Brannon, Barbara A. (2007) 'The laser printer as an agent of change: fixity and fluxion in the digital age' in Baron, Sabrina Alcorn, Eric N. Lindqvist and Eleanor F. Shevlin, eds (2007) *Agent of change: print culture studies after Elizabeth L. Eisenstein* Amherst, Boston and Washington DC: University of Massachusetts Press and the Center for the Book: 353–64

Bratton, J.S. (1981) *The impact of Victorian children's fiction* London and New York: Routledge

Brett, David (1992) *On decoration* Cambridge: Lutterworth Press

Bridson, G. and Wakeman, G. (1984) *Printmaking and picture printing: a bibliographical guide to artistic and industrial techniques in Britain, 1750–1900* Oxford: Plough Press; Williamsburg: Bookpress Ltd.

Briggs, Asa, ed. (1962) *William Morris: selected writings and designs* Harmondsworth: Penguin

Briggs, Asa (1979) *Iron Bridge to Crystal Palace* London: Thames & Hudson

—— (1990) *Victorian things* Harmondsworth: Penguin

Briggs, Asa and Peter Burke (2009) *A social history of the media from Gutenberg to the internet* Cambridge: Polity Press

Brothers, Caroline (1997) *War and photography: a cultural history* London: Routledge

Brown, Bill (2001) 'Thing theory' *Critical Inquiry* 28 (1): 1–22

Bryans, Dennis (2000) 'The double invention of printing' *Journal of Design History* 13 (4): 287–300

Bullen, George (1877) *Caxton celebration, 1877: catalogue of the loan collection of antiquities, curiosities, and appliances connected with the art of printing, South Kensington* London: N. Trübner & Co.

Bülow, Anna E. and Jess Ahmon (2001) *Preparing collections for digitization* London: Facet Publishing

Burke, Peter (2004) *What is cultural history?* Cambridge: Polity Press

Burnett, John, David Vincent and David Mayall, eds (1984) *The autobiography of the working class: an annotated critical bibliography Volume I: 1790–1900* Brighton: The Harvester Press

Burrard, Colonel S.G. (1914) *The reproduction of maps, plans, photographs, diagrams and line illustrations by the Survey of India for other departments* Calcutta: The Photo and Litho Office, Survey of India

Bury, Stephen, ed. (2007) *Breaking the rules: the printed face of the European avant garde 1900–1937* London: the British Library

Cadman, Eileen, Gail Chester and Agnes Pivot (1981) *Rolling our own: women as printers, publishers and distributors* London: Minority Press Group

Callen, Anthea (1979) *Women artists of the arts and crafts movement 1870–1914* New York: Pantheon Books

Cantor, Geoffrey, Gowan Dawson, Graeme Gooday, Richard Noakes, Sally Shuttle-worth and Jonathan R. Topham (2004) *Science in the nineteenth-century periodical: reading the magazine of nature* Cambridge: Cambridge University Press

Carpo, Mario (2001) *Architecture in the age of printing* Cambridge, Mass.: MIT Press

Carr, Nicholas (2010) *The shallows: how the internet is changing the way we read, think and remember* London: Atlantic

Carter, Matthew (1995) 'Now we have mutable type' in Ruari McLean *Typographers on type* London: Lund Humphries Publishers

Casper, Scott E., Jeffrey D. Gorves, Steven W. Nissenbaum and Michael Winship (2007) *A history of the book in America Volume 3: the industrial book 1840–1880* Chapel Hill, The American Antiquarian Society and the University of North Carolina Press

Cave, Roderick (1971) *The private press* London: Faber and Faber

Chandler, Alfred D. (1977) *The visible hand: the managerial revolution in American business* Cambridge, Mass.: Harvard University Press

Chappell, Warren and Robert Bringhurst (1990) *A short history of the printed word* New York: Hartley & Marks

Chartier, Roger, Lucien Febvre and Henri-Jean Martin (1997 [1976]) *The coming of the book: the impact of printing, 1450–1800* London: Verso

Clair, C. (1969) *A chronology of printing* London: Cassell

Cleveland, Paul (2004) 'Bound to technology: the telltale signs in print' *Design Studies* 25: 113–53

Cobbing, Bob, ed. (1974) *Concrete poetry: gloup and woup* Gillingham Kent: Arc Publications

Cockburn, Cynthia (1983) *Brothers: male dominance and technological change* London: Pluto Press

Colley, Linda (1992) *Britons: forging the nation 1707–1837* New Haven: Yale University Press

Collins, Bradford R. (1985) 'The poster as art: Jules Chéret and the struggle for the quality of the arts in late nineteenth-century France' *Design Issues* 2 (1): 41–50

Connelly, Mark (1999) *Christmas: a social history* London: I.B. Tauris

Cook-Gumpertz, Jenny (2006) *The social construction of literacy* Cambridge: Cambridge University Press

Cost, Patricia A. (2011) *The Bentons: how an American father and son changed the printing industry* Rochester, NY: RIT Cary Graphic Arts Press

Coupland, Douglas (2010) *Marshall McLuhan: You know nothing of my work!* New York: Atlas & Co

Cowan, Edward J. and Mike Paterson (2007) *Folk in print: Scotland's chapbook heritage 1750–1850* Edinburgh: John Donald

Crain, Patricia (2000) *The story of A: the alphabetization of America from the New England Primer to the Scarlet Letter* Stanford, Cal.: Stanford University Press

Crary, Jonathan (1999) *Suspensions of perception: attention, spectacle and modern culture* Cambridge, Mass.: MIT Press

Crawford, William (1979) *The keepers of light: a history and guide to early photographic processes* Dobbs Ferry, NY: Morgan and Morgan

Crimp, Douglas, with photographs by Louise Lawler (1993) *On the museum's ruins* Cambridge, Mass.: MIT Press

Crow, David (2006) *Left to right: the cultural shift from words to pictures* Lausanne: AVA Publishing

Cunningham, Hugh (2005) *Children and childhood in Western society since 1500* London: Pearson Longman

Curtis, Gerard (2002) *Art and the material book in England* Aldershot: Ashgate

Dane, Joseph A. (2003) *The myth of print culture: essays on evidence, textuality, and bibliographical method* Toronto: The University of Toronto Press

—— (2011) *Out of sorts: on typography and print culture* Philadelphia: University of Pennsylvania Press

Darnton, Robert (1995) 'Censorship, a comparative view, France 1789–Germany 1989' *Representations* 49: 40–60

Daston, L. and P. Galison (1992) 'The image of objectivity' *Representations* Fall: 40–86

—— (2007) *Objectivity* New York: Zone Books

De Maré, Eric (1980) *The Victorian woodblock illustrators* London: Gordon Fraser

Denis, Rafael Cardoso (1995) *The educated eye and the industrial hand: art and design instruction for the working classes in mid-Victorian Britain* Unpublished PhD Dissertation, London: Courtauld Institute of Art

Derrida, Jacques (1976) *Of grammatology* Baltimore: John Hopkins University Press

Design Quarterly, issue 133, 1986

Desmond, Adrian (1987) 'Artisan resistance and evolution in Britain, 1819–48' *Osiris* 2nd series 3: 77–110

Dickens, Charles (1900 [1850]) *David Copperfield* London: Thomas Nelson New Century Library Edition

Dobraszczyk, Paul (2009) 'Information design for Victorian London's cab passengers' *ULTRABOLD 7*

Döring, Jürgen (2011) *Power to the imagination: artists, posters and politics* Munich: Hirmer Verlag and Museum fur Kunst und Gewerben, Hamburg

Dorlay, J.S. (1978) *The Roneo story* Croydon: Roneo Vickers Ltd

Driskel, Michael Paul (1991) '"Et la lumiere fut": the meanings of David d'Angers's monument to Gutenberg' *The Art Bulletin* 73 (3): 359–80

Drucker, Johanna (1994) *The visible word: experimental typography and modern art, 1909–1923* Chicago: University of Chicago Press

—— (1995) *The alphabetic labyrinth: the letters in history and imagination* London: Thames & Hudson

—— (1998a) *Figuring the word: essays on books, writing, and visual poetics* New York: Granary Books

—— (1998b) 'Experimental/visual/concrete' in *Figuring the word: essays on books, writing, and visual poetics* New York: Granary Books: 110–36

—— (1998c) 'Offset: the work of mechanical art in the age of electronic (re)production' in *Figuring the word: essays on books, writing, and visual poetics* New York: Granary Books: 184–93

—— (1999) 'Who's afraid of visual culture?' *Art Journal* 58 (4): 36–47

—— (2009) 'Philip Meggs and Richard Hollis: models of graphic design history' *Design and culture* 1 (1): 51–78

Duffy, Patrick (2000) *The skilled compositor, 1850–1914* Aldershot: Ashgate

Duncan, Carol (1995) *Civilizing rituals: inside public art museums* London: Routledge

Duncombe, Steven (1997) *Notes from underground: zines and the politics of alternative culture* London: Verso

Dyson, Anthony (1984) *Pictures to print: the nineteenth-century engraving trade* London: Farrand Press

Easton, John (1958) *The De La Rue history of British and foreign postage stamps, 1855 to 1901* London: The Royal Philatelic Society in association with Faber

Eaves, M. (1992) *The counter-arts conspiracy: art and industry in the age of Blake* Ithaca and London: Cornell University Press

Edwards, Steve (2004) '"Profane illumination": photography and photomontage in the USSR and Germany' in Steve Edwards and Paul Wood, eds *Art of the avant-gardes* New Haven and London: Yale University Press in association with the Open University

Eisenstein, Elizabeth L. (1979) *The printing press as an agent of change: communications and cultural transformations in early modern Europe* (2 vols) Cambridge: Cambridge University Press

—— (1983) *The printing revolution in early modern Europe* Cambridge: Cambridge University Press

—— (2011) *Divine art, infernal machine: the reception of printing in the West from first impressions to the sense of an ending* Philadelphia: University of Pennsylvania Press

Eliot, Simon (1995) 'Some trends in British book production, 1800–1919' in Jordan, John O. and Robert L. Patten, eds *Literature in the marketplace* Cambridge: Cambridge University Press: 19–43

Elkins, James (2003) *Visual studies: a skeptical introduction* New York and London: Routledge

Esbester, Mike (2009) 'Designing time: the design and use of nineteenth-century transport timetables' *Journal of Design History* 22 (2): 91–113

Fairfull-Smith, George (1999) 'Art and design education in Glasgow in the 18th and 19th centuries' *Journal of the Scottish Society for Art History* 4: 9–16

Farwell, Beatrice (1977) *The cult of images: Baudelaire and the 19th-century media explosion* Santa Barbara, Calif.: UCSB Art Museum

—— (1989) *The charged image: French lithographic caricature 1816–1848* Santa Barbara: Museum of Art

Fawcett, Trevor (1983) 'Visual facts and the 19th century art lecture' *Art History* 6: 442–60

Ferry, Kathryn (2003) 'Printing the Alhambra: Owen Jones and chromolithography' *Architectural History* 46: 175–88

Fielding, T.H. (1841) *The art of engraving* London: Ackermann

Fine, Lisa M. (1990) *The souls of the skyscraper: female clerical workers in Chicago, 1870–1930* Philadelphia: Temple University Press

Finkelstein, David and Alistair McCleery, eds (2002) *The book history reader* London: Routledge

—— (2005) *An introduction to book history* London: Routledge

Flood, John L. (2000) 'On Gutenberg's 600th anniversary: towards a history of jubilees of printing' *Journal of the Print Historical Society* new series, volume 1: 5–36

Fountain, Nigel (1988) *Underground: the London alternative press 1966–74* London: Comedia/Routledge

Fowler, Harold N. (1925) *Plato: Plato in twelve volumes* London: William Heinemann

Forty, Adrian (1986) *Objects of desire: design and society since 1750* London: Thames & Hudson

Fox, Celina (1980) 'Wood engravers and the city' in Nadel, I.B. and F.S. Schwarzbach, eds *Victorian artists and the city* Oxford: Pergamon Press: 1–12

—— (1988) *Graphic journalism in England during the 1830s and 1840s* New York & London: Garland Publishing, Inc.

—— (2009) *The arts of industry in the age of enlightenment* New Haven and London: Yale University Press

Frasca-Spada, Marina and Nick Jardine, eds (2000) *Books and the sciences in history* Cambridge: Cambridge University Press

Freeman, Michael (1999) *Railways and the Victorian imagination* New Haven and London: Yale University Press

Frow, John (2010) 'Matter and materialism: a brief pre-history of the present' in Bennett, Tony and Patrick Joyce, eds *Material powers: cultural studies, history and the material turn* London: Routledge: 25–37

Fyfe, Gordon J. (1996) 'Art and reproduction: some aspects of the relations between painters and engravers in London 1760–1850' in J. Palmer and M. Dodson, eds *Design and aesthetics: a reader* Routledge: London and New York

Galey, Alan (2010) 'The human presence in digital artefacts' in McCarty, Willard, ed. *Text and genre in reconstruction: effects of digitalisation on ideas, behaviours, products and institutions* Cambridge: OpenBook Publishers (also available to read online under Creative Commons licence)

Garfield, Simon (2010) *Just my type: a book about fonts* London: Profile Books

Garland, Ken (1999 [1964]) 'First things first' manifesto in Bierut, Michael, Jessica Helfand, Steven Heller and Rick Poynor, eds (1999) *Looking closer 3: classic writings of graphic design* New York: Allworth Press: 154–55

Garvey, Ellen Gruber (1996) *The adman in the parlor: magazines and the gendering of consumer culture, 1880s to 1910s* New York: Oxford University Press

Gaskell, Philip (1974) *A new introduction to bibliography* Oxford: Oxford University Press

Gennard, John (1987) 'The NGA and the impact of new technology' *New Technology, Work and Employment* 2 (2): 126–40

George, M. Dorothy (1967) *Hogarth to Cruikshank: social change in graphic satire* London: Penguin

Gernsheim, Helmut and Alison Gernsheim (1968) *L.J.M. Daguerre* New York: Dover publications

Gerschenfeld, Neil (2007) *FAB: The coming revolution on your desktop: from personal computers to personal fabrication* New York: Basic Books

Gilmartin, Kevin (1996) *Print politics: the press and radical opposition in early nineteenth-century England* Cambridge: Cambridge University Press

Gitelman, Lisa (1999) *Scripts, grooves, and writing machines: representing technology in the Edison era* Stanford, Calif.: Stanford University Press

—— (2006) *Always already new: media, history, and the data of culture* Cambridge, Mass.: MIT Press

Glasgow Mechanics' Magazine, and Annals of Philosophy, 1824–1826

Glass, Dagmar and Geoffrey Roper (2002) 'Early Arabic printing in Europe' and 'The printing of Arabic books in the Arab world' in Hanebutt-Benz, Eva, Dagmar Glass and Geoffrey Roper *Middle Eastern languages and the print revolution: a cross-cultural encounter*, exhibition catalogue Westhofen: WVA-Verlag Skulima and the Gutenberg Museum Mainz: 129–150, 177–205

Goldstein, Paul (2003) *Copyright's highway: from Gutenberg to the celestial jukebox* Stanford Calif.: Stanford University Press

Gomez, Jeff (2008) *Print is dead: books in our digital age* London: Palgrave Macmillan

Goodman, Paul (1994) *Victorian illustrated books 1850–1870: the heyday of wood engraving* London: British Museum Press

Gray, Nicolete (1960) *Lettering on buildings* London: The Architectural Press

Gray, Robert (1981) *The aristocracy of labour in nineteenth-century Britain, c.1850–1900* London: Macmillan

Greco, Albert (1996) 'Shaping the future: mergers, acquisitions and the US publishing, communications and mass media industries, 1990–95' *Publishing Research Quarterly* 12 (3): 5–16

Greenberg, Clement (2003 [1939]) 'Avant-garde and kitsch' in C. Harrison and P. Wood, eds *Art in theory 1900–2000: an anthology of changing ideas* Oxford: Blackwell: 539–49

Green-Lewis, Jennifer (1996) *Framing the Victorians: photography and the culture of realism* Ithaca and London: Cornell University Press

Gretton, Tom (2005) 'Signs for labour-value in printed pictures after the photomechanical revolution: mainstream changes and extreme cases around 1900' *Oxford Art Journal* 28 (3): 371–90

—— (2010) 'The pragmatics of page design in nineteenth-century general-interest weekly illustrated news magazines in London and Paris' *Art History* 33 (4): 680–709

Griffiths, Antony (1996) *Prints and printmaking: an introduction to the history and techniques* London: British Museum Press

Grint, Keith and Steve Woolgar (1997) *The machine at work: technology, work and organisation* Cambridge: Polity Press

Groensteen, Thierry and Benoît Peeters (1994) *Töpffer: l'invention de la bande dessinee* Paris: Hermann

Guffey, Elizabeth E. (2006) *Retro: the culture of revival* Oxford: Reaktion Books

Guise, Hilary (1980) *Great Victorian engravings: a collector's guide* London: Astragal Books

Habermas, Jürgen (1989 [1960]) *The structural transformation of the public sphere: an inquiry into a category of bourgeois society* Cambridge, Mass.: MIT Press

Hall, Stuart (1980) 'Cultural studies: two paradigms' *Media, Culture and Society* 2: 57–72

Hallett, Mark (1999) *The spectacle of difference: graphic satire in the age of Hogarth* New Haven: Yale University Press

Hanebutt-Benz, Eva (2002) 'Type specimens of oriental scripts' in Hanebutt-Benz, Eva, Dagmar Glass and Geoffrey Roper (2002) *Middle Eastern languages and the print revolution: a cross-cultural encounter*, exhibition catalogue Westhofen: WVA-Verlag Skulima and the Gutenberg Museum Mainz: 13–32

Hanebutt-Benz, Eva, Dagmar Glass and Geoffrey Roper (2002) *Middle Eastern languages and the print revolution: a cross-cultural encounter*, exhibition catalogue Westhofen: WVA-Verlag Skulima and the Gutenberg Museum Mainz

Harris, Elizabeth M. (1983) *The fat and the lean: American wood type in the 19th century* Washington DC: Smithsonian Institution

Harrison, Frederic (1892) *The new calendar of great men: biographies of the 558 worthies of all ages and nations in the Positivist calendar of Auguste Comte* London: Macmillan & Co

Harvey, Michael (2009) 'Down with Times New Roman: lettering on buildings, memorials and coins' *Sculpture Journal* 18 (2): 223–58

Haslam, Ray (1988) 'Looking, drawing and learning with John Ruskin and the Working Men's College' *Journal of Art and Design Education* 7 (1): 65–80

Hawker, William R. (1966) *Copying methods manual* Chicago: Library Technology Program Association

Hayles, N. Katherine (2002) *Writing machines* Cambridge, Mass.: MIT Press

Haywood, Ian (2004) *The revolution in popular literature: print, politics and the people, 1790–1860* Cambridge, Cambridge University Press

Heath, John (1993) *The Heath family engravers 1779–1878*, Volume 2, Aldershot: Scolar Press

Heller, Steven (1994) 'The time machine' in Bierut, Michael, William Drenttel, Steven Heller and D.K. Holland, eds *Looking closer: critical writings of graphic design* New York: Allworth Press: 34–38

—— (2001) 'Advertising: the mother of graphic design' in Steven Heller and Georgette Balance, eds *Graphic design history* New York: Allworth Press: 295–302

Heller, Steven and Georgette Ballance, eds (2001) *Graphic design history* New York: Allworth Press

Heller, Steven and Philip Meggs (2001) *Texts on type: critical writings on typography* New York: Allworth Press

Heller, Steven and Karen Pomeroy (1997) *Design literacy: understanding graphic design* New York: Allworth Press

Hendricks, Jon (1983) Fluxus/Addenda 1: The Gilbert and Lila Silverman Collection New York: INK &

Herrada, Julie (1995) 'Zines in libraries: a culture preserved' *Serials Review* 21 (2): 79–88

Herzka, Dorothy (1965) *Pop Art One* New York: Publishing Institute of America

Highmore, Ben (2000) 'Awkward moments: avant-gardism and the dialectics of everyday life' in Schneuemann, Dietrich, ed. *European avant-garde: new perspectives* Amsterdam and Atlanta: Rodopi

—— (2002) *Everyday life and cultural theory: an introduction* London: Routledge

Hobsbawm, Eric and Terence Ranger, eds (1983) *The invention of tradition* Cambridge: Cambridge University Press

Höch, Hannah (2003 [1934]) 'A few words on photomontage' in Jason Gaiger and Paul Wood, eds *Art of the twentieth century: a reader* New Haven and London: Yale University Press in association with the Open University: 112–14

Hoole, Elijah (1829) *Personal narrative of a mission to the south of India from 1820 to 1829* London: Longman, Rees, Orme, Brown and Green

Hopkins, David (2000) *Weegee re-viewed*, exhibition catalogue, Edinburgh: Stills Gallery

Hopkinson, Tom (1970) *Picture Post 1938–50* Harmondsworth: Penguin Books

Howsam, Leslie (2002) *Cheap bibles: nineteenth-century publishing and the British and Foreign Bible Society* Cambridge: Cambridge University Press

—— (2006) *Old books & new histories: an orientation to studies in book & print culture* Toronto: University of Toronto Press

Howsam, L., C. Stray, A. Jenkins, J.A. Secord and A. Vaninskaya (2007) 'What the Victorians learned: perspectives on nineteenth century school books' *The Journal of Victorian Culture* 12 (2): 262–85

Hunnisett, Basil (1980) *Steel-engraved book illustration in England* London: Scolar Press

Illustrated London News (1851) 'Speaking to the eye'

Inkster, Ian, ed. (1985) *The steam intellect societies* University of Nottingham, Department of Adult Education

Isaac, Peter (1990) *William Davison's new specimen of cast-metal ornaments and wood-types introduced with an account of his activities as pharmacist and printer in Alnwick, 1780–1858* London: Printing Historical Society

Ivins, W.M., Jr (1992 [1953]) *Prints and visual communication* Cambridge, Mass.: MIT Press

Jammes, Isabelle (1981) *Blanquart-Evrard et les origines de l'édition photographique francaise* Genève-Paris: Librairie Droz

Jeffery, Tom (1998 [1978]) *Mass Observation: a short history* Brighton: Mass Observation Archive, University of Sussex Library

Jeffries, Ursula (2009) 'William Blades, St Bride's posthumous benefactor' *ULTRA-BOLD 7*

Jenkins, Simon (2011) 'Welcome to the post-digital world, an exhilarating return to civility via Facebook and Lady Gaga' *The Guardian* online, 1 December 2011 [www.guardian.co.uk/commentisfree/2011/dec/01/post-digital-world-web accessed 17 January 2012]

Jennings, Michael W., Brigid Doherty and Thomas Y. Levin, eds (2008) *The work of art in the age of its technological reproducibility and other writings on media* Cambridge, Mass.: The Belknap Press of Harvard University Press

Jervis, S. (1974) *High Victorian design* Ottawa: National Gallery of Canada

Jobling, Paul (1999) *Fashion spreads: word and image in fashion photography since 1980* Oxford: Berg

—— (2005) 'Virility in design: advertising Austin Reed and the "New tailoring" during the interwar period in Britain' *Fashion Theory* 9 (1): 57–84

Jobling, Paul and David Crowley (1996) *Graphic design: reproduction and representation since 1800* Manchester: Manchester University Press

Johns, Adrian (1998) *The nature of the book: print and knowledge in the making* Chicago: University of Chicago Press

—— (2009) *Piracy: the intellectual property wars from Gutenberg to Gates* Chicago: University of Chicago Press

Johnston, Gordon (1999) 'What is the history of samizdat?' *Social History* 24 (2): 115–33

Jones, Owen (1836–45) *Plans, sections, elevations and details of the Alhambra* London: Owen Jones

—— (1856) *The grammar of ornament* London: Day & Sons

Jones, W. & Company (c. 1868) *William Jones & Company, Army, Navy and Volunteer Contractors Catalogue*, 236 Regent Street, London

Jones, Yolande (1974) 'Aspects of relief portrayal on 19th-century British military maps' *Cartographic Journal* 11: 19–33

Jordan, John O. and Robert L. Patten (1995) *Literature in the marketplace* Cambridge: Cambridge University Press

Joyce, Michael (2001) 'Notes toward an unwritten non-linear electronic text, "The ends of print culture" (a work in progress)' *Postmodern Culture* 2 (1) September

Joyce, Patrick (2011) 'Filing the Raj' in Tony Bennett and Patrick Joyce, eds (2010) *Material powers: cultural studies, history and the material turn* London: Routledge: 102–23

Jury, David (2006) *Letterpress: new applications for traditional skills* Hove: RotoVision

Jussim, Estelle (1974) *Visual communication and the graphic arts: photographic technologies in the nineteenth century* New York and London: R.R. Bowker Company

Kalman, Tibor, J. Abbott Miller and Karrie Jacobs (1994) 'Good history/ bad history' in Bierut, Michael, William Drentell, Steven Heller and D.K. Holland, eds *Looking closer: critical writings of graphic design* New York: Allworth Press: 25–33

Kent, Christopher (2009) 'Depicting gentlemen's fashions in the *Tailor and Cutter*, 1866–1900' in Brake, Laurel and Marysa Demoor, eds (2009) *The lure of illustration in the nineteenth century press* London: Palgrave Macmillan

Kesavan, B.S. (1997) *History of printing and publishing in India: a story of cultural re-awakening* Volume III, origins of printing and publishing in the Hindi Heartland, New Delhi: National Book Trust, India

King, Andrew and John Plunkett, eds (2004) *Victorian print media, 1820–1900*, Volumes I–III London: Routledge

King, Lyndel Saunders (1985) *The industrialisation of taste: Victorian art and the Art Union of London* Ann Arbor, Michigan: UMI Research Press

Kirschenbaum, Matthew G. (2008) *Mechanisms: new media and the forensic imagination* Cambridge, Mass.: MIT Press

Kittler, Friedrich A. (1999) *Gramophone, film, typewriter*, Geoffrey Wintrop-Young and Michael Wutz, trans. Stanford: Stanford University Press

Kitzmann, Andreas (2005) 'Review essay: the material turn: making digital media real (again)' *Canadian Journal of Communication* 30: 681–86

Klingender, Francis D., revised and ed. Arthur Elton (1972) *Art and the industrial revolution*, second edition, London: Paladin

Knight, Charles (1864) *Passages from a working life* London: Bradbury & Evans

Komaroni, Ann (2008) 'Samizdat as an extra-Gutenberg phenomenon' *Poetics Today* 29 (4): 629–67

Kooistra, Lorraine Janzen (1995) *The artist as critic: bitextuality in fin-de-siecle illustrated books* Aldershot: Scolar Press

Kosloff, Albert (1958) *Screen process printing* Cincinnati, Ohio: The Signs of the Times Publishing Company

Kwint, Marius (1999) 'Introduction: the physical past' in Kwint, Marius, Christopher Breward and Jeremy Aynsley, eds (1999) *Material memories* Oxford: Berg: 1–16

Lambert, Susan (1987) *The image multiplied: five centuries of printed reproductions and painting* London: Trefoil

Landow, George P. (2006) *Hypertext 3.0: critical theory and new media in an era of globalization* Baltimore: John Hopkins University Press

Langenfeld, Robert (1989) *Reconsidering Aubrey Beardsley* Ann Arbor, Michigan: UMI Research Press

Laqueur, T.W. (1974) 'Literacy and social mobility in the industrial revolution in England' *Past and Present* 64 (1): 96–107

Latour, Bruno (1987) *Science in action* Cambridge, Mass.: Harvard University Press

Lavin, Maud (1993) *Cut with the kitchen knife: the Weimar photographs of Hannah Höch* New Haven and London: Yale University Press

—— (2001) *Clean new world: culture, politics, and graphic design* Cambridge, Mass.: MIT Press

Layard, Austen Henry, Sir (1849) *Nineveh and its remains* London: John Murray

Lees-Maffei and Rebecca Houze, eds (2010) *The design history reader* Oxford: Berg

Lenman, Bruce P. (2009) *Enlightenment and change: Scotland 1746–1832*, second edition, Edinburgh: Edinburgh University Press

Lessig, Lawrence (2004) *Free culture: how big media uses technology and the law to lock down culture and control creativity* London and New York: Penguin

—— (2008) *Remix: making art and commerce thrive in the hybrid economy* London: Bloomsbury Academic (also available to read online under Creative Commons licence)

Levin, Miriam R. (1993) 'Democratic vistas – democratic media: defining a role for printed images in industrializing France' *French Historical Studies* 18 (1): 82–108

Lewis, Roy and John B. Eason (1984) *Publishing and printing at home* Newton Abbott: David & Charles

Life, 8 August 1938

Lightman, Bernard (2007) *Victorian popularizers of science: designing nature for new audiences* Chicago: University of Chicago Press

L'Imprimerie, 15 January 1900

Linton, W.J. (1895) *Memories* London: Lawrence and Bullen

Lodder, Christine (1983) *Russian constructivism* New Haven and London: Yale University Press

Lowe, Graham S. (1987) *Women in the administrative revolution: the feminisation of clerical work* Cambridge: Polity Press

Loxley, Simon (2004) *Type: the secret history of letters* London: I.B. Tauris

Lupton, Ellen (1993) *Mechanical brides: women and machines from home to office* New York: Cooper-Hewitt National Museum of Design, Smithsonian Institution and Princeton Architectural Press

—— (1994) 'Low and high: design in everyday life' in Bierut, Michael, William Drenttel, Steven Heller and D.K. Holland, eds *Looking closer: critical writings of graphic design* New York: Allworth Press: 104–8

—— (1996) *Mixing messages: contemporary graphic design in America* London: Thames and Hudson

Lupton, Ellen and J. Abbott Miller (2010 [1994]) 'Deconstruction and graphic design: history meets theory' in Grace Lees-Maffei and Rebecca Houze, eds *The design history reader* Oxford: Berg: 192–99

Maas, Jeremy (1975) *Gambart: Prince of the Victorian art world* London: Barrie & Jenkins

Macdonald, S. (1970) *The history and philosophy of art education* London: University of London Press

Machin, David (2004) 'Building the world's visual language: the increasing global importance of image banks in corporate media' *Visual Communication* 3 (3): 316–36

MacLeod, Christine (2007) *Heroes of invention: technology, liberalism and British identity, 1750–1914* Cambridge: Cambridge University Press

MacGregor, William (1999) 'The authority of prints: an early modern perspective' *Art History* 22 (3): 389–421

MacKenzie, John M. (1995) *Orientalism: History, theory and the arts* Manchester: Manchester University Press

Malley, Shawn (1996) 'Austen Henry Layard and the periodical press: Middle Eastern archaeology and the excavation of mid-nineteenth century Britain' *Victorian Review* 22 (2): 152–70

Malraux, Andre 1954 [1951]) *The voices of silence* London: Secker & Warburg

Mandler, Peter (1999) '"The Wand of Fancy": the historical imagination of the Victorian tourist' in Marius Kwint, Christopher Breward and Jeremy Aynsley, eds *Material memories* Oxford: Berg: 125–42

Margolin, Victor (1988) 'A decade of design history in the United States, 1977–87' *Journal of Design History* 1: 51–72

—— (2009) 'Design in history' *Design Issues* 25 (2): 94–105

Markley, Robert, ed. (1996) *Virtual realities and their discontents* Baltimore: John Hopkins University Press

Marsden, Ben and Crosbie Smith (2005) *Engineering empires: a cultural history of technology in nineteenth-century Britain* Basingstoke: Palgrave Macmillan

Marshall, Alan (1983) *Changing the word: the printing industry in transition* London: Comedia

Martin, Paul (1939) *Victorian snapshots* London: Country Life

Marx, Karl and Frederick Engels (2008 [1848]) *The communist manifesto*, with an introduction by David Harvey, London: Pluto Press

Marzio, Peter C. (1980) *The democratic art: chromolithography 1840–1900: pictures for a 19th century America* London: Scolar Press

Marzolph, Ulrich (2002) 'Printed manuscript (c.1817–1900)' in Hanebutt-Benz, Eva, Dagmar Glass and Geoffrey Roper *Middle Eastern languages and the print revolution: a cross-cultural encounter*, exhibition catalogue, Westhofen: WVA-Verlag Skulima and the Gutenberg Museum Mainz

Mass Observation (1947) *Puzzled people, a study in popular attitudes to religion, ethics, progress and politics in a London borough* London: Victor Gollancz Ltd

Maynard, Patrick (1997) *The engine of visualization; thinking through photography* Ithaca and London: Cornell University Press

McCarty, Willard, ed. (2010) *Text and genre in reconstruction: effects of digitalisation on ideas, behaviours, products and institutions* Cambridge: OpenBook Publishers

McDannell, Colleen (1995) *Material Christianity: religion and popular culture in America* New Haven: Yale University Press

McGrady, Patrick, director (2008) *Stephen Fry & the Gutenberg Press* television documentary, BBC TV Four

McKay, George (1998) *DiY culture: party and protest in nineties Britain* London: Verso

McKenzie, D.F. (1986) *Bibliography and the sociology of texts: the Panizzi Lectures 1985* London: The British Library

McKitterick, David (2003) *Print, manuscript and the search for order, 1450–1830* Cambridge: Cambridge University Press

McLean, Ruari (1972) *Victorian book design and colour printing*, second edition, London: Faber

—— (1995) *Typographers on type* London: Lund Humphries

McLuhan, Marshall (1962) *The Gutenberg galaxy: the making of typographic man* London: Routledge & Kegan Paul

—— (2001 [1964]) *Understanding media* London: Routledge

Meadows, A.J. (1991) 'The evolution of graphics in scientific articles' *Publishing Research Quarterly* 7 (1): 23–32

Mechanics' Magazine, Museum, Register, Journal and Gazette, 1823–1871

Meggs, Philip B. (1992) *A history of graphic design*, second edition, New York: Van Nostrand Reinhold

—— (1994) 'The obscene typography machine' in Bierut, Michael, William Drenttel, Steven Heller and D.K. Holland, eds *Looking closer: critical writings on graphic design* New York: Allworth Press: 160–62

—— (1998) *A history of graphic design*, third edition, New York: John Wiley & Sons, Inc.

Melvern, Linda (1986) *The end of the street* London: Methuen

Mihm, Stephen (2007) *A nation of counterfeiters: capitalists, con men, and the making of the United States* Cambridge, Mass.: Harvard University Press

Miller, J. Abbott and Ellen Lupton (1994) 'A natural history of typography' in Bierut, Michael, William Drenttel, Steven Heller and D.K. Holland, eds *Looking closer: critical writings of graphic design* New York: Allworth Press: 19–25

Miller, J. Hillis (1992) *Illustration: Essays in Art and Culture* Cambridge, Mass.: Harvard University Press

Mitchell, Timothy (1991) *Colonising Egypt* Berkeley and Los Angeles: University of California Press

Mirzoeff, Nicholas (1999) *An introduction to visual culture* London: Routledge

Moore, Barbara (2011) 'George Maciunas: a finger in fluxus' George Maciunas Foundation Inc. [http://georgemaciunas.com/?page_id=1470 accessed 29 September 2011]

Moran, J. (1963) *The composition of reading matter: a history from case to computer* London: Wace

—— (1971) *Stanley Morison: his typographic achievement* London: Lund Humphries

—— (1973) *Printing presses: history and development from the fifteenth century until modern times* London: Faber

Morison, Stanley (1972) *Politics and script: aspects of authority and freedom in the development of Graeco-Roman script from the sixth century BC to the twentieth century AD* Oxford: Clarendon Press

Morris, William (1999 [1893]) 'The ideal book' in Bierut, Michael, Jessica Helfand, Steven Heller and Rick Poynor, eds. (1999) *Looking closer 3: classic writings of graphic design* New York: Allworth Press: 1–5

Mosley, James (1978–79) 'Typographic treasures at St. Bride's' *Penrose: the international review of the graphic arts 1978/1979* London: Northwood Publications Ltd.: 85–98

Mumby, F.A. (1934) *The house of Routledge 1834–1934* London: George Routledge & Sons, Ltd

Musson, A.E. (1954) *The Typographical Association: origins and history up to 1949* London: Oxford University Press

Nadeau, Luis (1994) *Encyclopaedia of printing, photographic, and photomechanical processes* Fredericton, New Brunswick: Atelier Luis Nadeau

Nash, Paul W. (2007) 'The distaff side: a short history of women printers: part II, 1838 to 2006' *ULTRABOLD, the journal of the St. Bride Library* 2: 26–33

Naylor, Gillian (1971) *The arts and crafts movement* London: Studio Vista

Nelson, Robert S. (2000) 'The slide lecture, or the work of art history in the age of mechanical reproduction' *Critical Inquiry* 26: 414–34

Nerone, John and Kevin G. Barnhurst (1995) 'Visual mapping and cultural authority: design changes in U.S. newspapers, 1920–40' *Journal of Communication* 45 (2): 9–43

Nochlin, Linda (1971) *Realism* Penguin: Harmondsworth

Noever, Peter (1991) *The future is our only goal: Aleksandr M. Rodchenko; Varvara F. Stepanova* Munich: Prestel-Verlag

Nunberg, Geoffrey (1993) 'The place of books in the age of electronic reproduction' *Representations* 42 Special issue: Future libraries: 13–37

Nunberg, Geoffrey, ed. (1996) *The future of the book* BREPOLS Papers from Conference at Centre for Semiotic and Cognitive studies at University of San Marino 1994

Nye, David E. (1985) *Image worlds: corporate identities at General Electric, 1890–1930* Cambridge, Mass.: MIT Press

——(2006) *Technology matters* Cambridge, Mass.: MIT Press

Ogborn, Miles (2007) *Indian ink: script and print in the making of the English East India Company* Chicago: University of Chicago Press

O'Gorman, Francis (2010) *The Cambridge companion to Victorian culture* Cambridge: Cambridge University Press

O'Neill, Morna (2008) *'Art and Labour's cause is one': Walter Crane and Manchester, 1880–1915* Manchester: Whitworth Art Gallery

Ong, Walter (1982) *Orality and literacy: technologizing the word* London: Routledge

Oppler, E.C., ed. (1988) *Picasso's Guernica* New York: Norton

Orwell, George (1949) *Nineteen eighty-four* London: Secker & Warburg

Parker, Rozsika (1984) *The subversive stitch: embroidery and the making of the feminine* London: Women's Press

Penny Magazine (1833) 'Monthly Supplement'

Pepperell, R. and M. Punt (2000) *The postdigital membrane: imagination, technology and desire* Bristol: Intellect Books

Peterson, William (1991) *The Kelmscott Press: a history of William Morris's typographical adventure* Oxford: Clarendon Press

Petroski, Henry (1999) *The book on the bookshelf* New York: Alfred A. Knopf

Pevsner, Nikolaus (1960) *Pioneers of modern design* Harmondsworth: Penguin

Piepmeier, Alison (2008) 'Why zines matter: materiality and the creation of embodied community' *American Periodicals: A Journal of History, Criticism and Bibliography* 18 (2): 213–38

Pinney, Christopher (2004) *'Photos of the gods': the printed image and political struggle in India* London: Reaktion

Plant, S. (1996) *Beyond the book: theory, culture and the politics of cyberspace* London: University of London Press

Poster, Mark, ed. (1988) *Jean Baudrillard: selected writings* Cambridge and Stanford: Polity and Stanford University Press

Poynor, Rick (1999a) 'Introduction' in Bierut, Michael, Jessica Helfand, Steven Heller and Rick Poynor, eds (1999) *Looking closer 3: classic writings of graphic design* New York: Allworth Press

—— (1999b) 'First things first revisited' *Émigré* 51: 9

Printing and publishing, Manpower studies No. 9 (1970) London: Her Majesty's Stationery Office

Printing and the mind of man, exhibition publication 1963 London: Messrs R. W. Bridges & Sons Ltd and the Association of British Manufacturers of Printers' Machinery (Proprietary) Ltd

Prothero, I.J. (1979) *Artisans and politics in early 19th century* London and Baton Rouge: Louisiana State University Press

Proudfoot, W.B. (1972) *The origin of stencil duplicating* London: Hutchinson

Purdy, Daniel L. (2010) 'Fashion journals and the education of enlightened consumers' in Giorgio Riello and Peter McNeil, eds *The fashion history reader: global perspectives* London and New York: Routledge: 238–56

Pustz, Matthew (1999) *Comic book culture: fanboys and true believers* Jackson: University Press of Mississippi

Ramamurthy, Anandi (1996) 'Spectacles and illusions: photography and commodity culture' in Liz Wells, ed. *Photography: a critical introduction*, third edition, London: Routledge: 193–244

Rawson, George (1999) 'The Glasgow Government School of Design, 1845–53' *Journal of the Scottish Society for Art History* 4: 18–25

Reed, Talbot Baines (2001 [1920]) 'Old and new fashions in typography' in Heller, Steven and Philip B. Meggs (2001) *Texts on type: critical writings on typography* New York: Allworth Press: 6–15

Renny-Tailyour, Colonel T.F.B (1913) *Notes on the 'Vandyke' or direct zinc printing process* Calcutta: The Photo and Litho Office, Survey of India

Reynolds, Sian (1989) *Britannica's typesetters: women compositors in Edwardian Edinburgh* Edinburgh: Edinburgh University Press

Rhodes, Barbara and William Wells Streeter (1999) *Before photocopying: the art and history of mechanical copying 1780–1938* Delaware and Massachusetts: Oak Knoll Press and Heraldry Bindery

Rickards, M. and Michael Twyman (2001) *The encyclopaedia of ephemera* New York: Routledge

Rider, Robin (1998) 'Shaping information: mathematics, computing, and typography' in Timothy Lenoir, ed. *Inscribing science: scientific texts and the materiality of communications* Stanford, Calif.: Stanford University Press

Riley, Bridget (1999) *The eye's mind: Bridget Riley collected writings 1965–1999*, edited by Robert Kudielka, London: Thames & Hudson

Ritchin, Fred (2000) 'Close witnesses: the involvement of photojournalists' in Frizot, Michel, ed. (1998) *A new history of photography* Cologne: Konemann

Rivers, Charlotte (2010) *Reinventing letterpress: inspirational pieces by contemporary practitioners* Hove: RotoVision

Roberts, F. David (2002) *The social conscience of the early Victorians* Stanford, Cal.: Stanford University Press

Roberts, John (2006) *Philosophizing the everyday: revolutionary praxis and the fate of cultural theory* London: Pluto Press

Robertson, Frances (2005) 'The aesthetics of authenticity: banknotes as industrial currency' *Technology and Culture* 46 (1): 31–50

—— (2012) 'The geometric poetry of graphic art' *The Drouth: 'graphic' special issue* 41: 33–39

Robins, Blair David (2008) *The money supply: printing & engraving by Blair Robins* Artist book

Robinson, Francis (1993) 'Technology and religious change: Islam and the effect of print' *Modern Asian Studies* 27 (1): 229–51

Rodchenko, Alexander (2003 [1920–21]) 'Slogans' in Charles Harrison and Paul Wood, eds. *Art in theory 1900–2000* Oxford: Blackwell: 339–40

Rogers, Pat (1972) *Grub Street; studies in a sub-culture* London: Methuen & Co.

Rolt, L.T.C. (1986) *Tools for the job* London: HMSO

Roper, Geoffrey (2007) 'The printing press and change in the Arab World' in Baron, Sabrina Alcorn, Eric N. Lindqvist and Eleanor F. Shevlin *Agent of change: print culture studies after Elizabeth L. Eisenstein* Amherst, Boston and Washington DC: University of Massachusetts Press and the Center for the Book: 250–67

Rosen, Charles and Henri Zerner (1984) *Romanticism and realism: the mythology of nineteenth century art* London: Faber and Faber

Rosen, Jeffrey Howard (1988) *Lemercier et Compagnie: photolithography and the industrialization of print production in France, 1837–1859* PhD Facsimile Copy, Evanston Illinois: Northwestern University

Rowe, Eleanor (1889) *Studies from the museums: wood carvings from the South Kensington Museum* London: R. Sutton & Co

Royle, E. (1980) *Radicals, secularists and republicans: popular freethought in Britain, 1866–1915* Manchester: Manchester University Press

Rubinstein, W.D. (1998) *Britain's century: a social and political history, 1815–1905* London: Arnold

Rudwick, Martin J.S. (1992) *Scenes from deep time* Chicago: University of Chicago Press

Rummonds, Richard-Gabriel (2004) *Nineteenth-century printing practices and the iron handpress* New castle, Delaware and London: Oak Knoll Press and the British Library in association with Five Roses Press

Sabin, Roger and Teal Triggs, eds (2000) *Below critical radar: fanzines and alternative comics from 1976 until now* Hove: Slab-O-Concrete

Said, Edward W. (1978) *Orientalism* New York: Vintage

Samuel, Raphael (1996) *Theatres of memory: past and present in contemporary culture* London: Verso

Sardar, Ziauddin (1993) 'Paper, print and compact disks: the making and unmaking of Islamic culture' *Media, Culture and Society* 15: 43–59

Sarton, George (1952) 'Auguste Comte, historian of science' *Osiris* 10: 328–57

Saunders, David (1992) *Authorship and copyright* London: Routledge

Savage, William (1841) *A dictionary of the art of printing* London: Longman, Brown, Green, and Longmans

Schaaf, Larry (1992) *Out of the shadows: Herschel, Talbot and the invention of photography* New Haven: Yale University Press

Scharf, Aaron (1974) *Art and photography* Harmondsworth: Penguin Books

Schivelbusch, Wolfgang (1986) *The railway journey: the industrialization of time and space in the 19th century* Berkeley and Los Angeles: University of California Press

Schmeichen, James A. (1995) 'Reconsidering the factory, art-labor, and the schools of design in nineteenth-century Britain' in Denis P. Doordan *Design history: an anthology* Cambridge, Mass.: MIT Press: 167–77

Schwartz, Hillel (1996) *The culture of the copy: striking likenesses, unreasonable facsimiles* New York: Zone Books

Scott, Derek B. (2001) *The singing bourgeois: songs of the Victorian drawing room and parlour* Aldershot: Ashgate

Secord, James A. (2000) *Victorian sensation: the extraordinary publication, reception, and secret authorship of Vestiges of the Natural History of Creation* Chicago: University of Chicago Press

Sedlmaier, Alexander and Stephan Malinowski (2011) ' "1968"—a catalyst of consumer society' *Cultural and Social History* 8 (2): 255–74

Selby, Aimee, ed. (2009) *Art and text* London: Black Dog

Sellen, Abigail J. and Richard H.R. Harper (2002) *The myth of the paperless office* Cambridge, Mass.: MIT Press

Senefelder, Alois (1977 [1819]) *A complete course of lithography* London: Ackermann's English Editions, reprinted in New York: Da Capo Press

Shapin, Steven and Barry Barnes (1977) 'Science, nature and control: interpreting mechanics' institutes' *Social Studies of Science* 7: 31–74

Shapin, Steven and Simon Schaffer (1985) *Leviathan and the air pump: Hobbes, Boyle and the experimental life* Princeton: Princeton University Press

Sharkey, John J. (1971) *Mindplay: an anthology of British concrete poetry* London: Lorrimer Publishing

Shlain, L. (1998) *The alphabet versus the goddess: the conflict between word and image* New York: Penguin and Arkana

Simmel, Georg (2003 [1902–3]) 'The metropolis and mental life' in Charles Harrison and Paul Wood, eds *Art in theory 1900–2000* Oxford: Blackwell: 132–36

Smith, Charles Manby (1967 [1857]) *The working man's way in the world* London: Printing Historical Society, reprinted with notes by Ellic Howe

Snyder, Joel (1980) 'Picturing vision' in W.J.T. Mitchell ed. *The language of images* Chicago and London: University of Chicago Press

Sontag, Susan (1978) *On photography* London: Allen Lane

Sotomayor Torres, Clivia M. (2003) *Alternative lithography: unleashing the potentials of nanotechnology* London: Kluwer Academic/Plenum

Sparke, Penny (2010 [1995]) *As long as it's pink: the sexual politics of taste* Halifax: Press of the Nova Scotia College of Art and Design

Spencer, Herbert (1969) *The visible word* London: Lund Humphries in association with the Royal College of Art

Stalleybrass, Peter (2007) '"Little jobs": broadsides and the printing revolution' in Sabrina Alcorn Baron, Eric N. Lindqvist and Eleanor F. Shevlin, eds (2007) *Agent of change: print culture studies after Elizabeth L. Eisenstein* Amherst, Boston and Washington DC: University of Massachusetts Press and the Center for the Book: 315–40

Stankiewicz, Mary Ann (1984) 'A picture age: reproductions in picture study' *Studies in Art and Education* 26 (2): 86–92

Staples, Loretta (2000) 'Typography and the screen: a technical chronology of digital typology' *Design Issues* 16 (3): 19–34

Stark, Ulrike (2003) 'Politics, public issues and the promotion of Urdu literature: *Avadh Akhtar*, the first Urdu daily in northern India' *The Annual of Urdu Studies*: 66–94

St Clair, William (2004) *The reading nation in the Romantic period* Cambridge: Cambridge University Press

Steinberg, Leo (2003 [1968–72]) 'from *Other criteria*' in Harrison, C. and P. Wood, eds *Art in theory 1900–2000* Oxford: Blackwell: 971–76

Striphas, Ted (2003) 'Book 2.0' *Culture Machine* 5: the E-Issue [www.culturemachine. net/index.php/cm accessed 18 December 2011]

—— (2011) *The late age of print: everyday book culture from consumerism to control* Columbia: Columbia University Press

Striphas, Ted and Kembrew McLeod (2006) 'Strategic improprieties: cultural studies, the everyday, and the politics of intellectual properties' *Cultural Studies*

Special issue: the politics of intellectual properties 20 (2/3) [www.indiana.edu/ ~bookworm/ ip-toc.html accessed 17 January 2012]

Sussmann, Herbert (2000) 'Machine dreams: the culture of technology' *Victorian Literature and Culture* 28 (1): 197–204

The Studio: an illustrated magazine of fine and applied art Volume 1, 1893

—— Special autumn number, art and publicity, 1925

Talbot, William Henry Fox (1844) *The pencil of nature* London: Longman, Brown, Green and Longmans

Thomas, Julian (2004) *Archaeology and modernity* London and New York: Routledge

Thompson, John B. (2010) *Merchants of culture: the publishing business in the twenty-first century* Cambridge: Polity Press

Thomson, F.M.L. (1988) *The rise of respectable society: a social history of Victorian Britain, 1830–1900* Cambridge, Mass.: Harvard University Press

Timperley, C.H. (1839) *A dictionary of printers and printing* London: H. Johnson

Tracy, Walter (1986) *Letters of credit: a view of type design* London: Gordon Fraser

Transactions of the Society for the encouragement of arts, manufactures and commerce, 1789–1845 (Society of Arts)

Treweek, Chris and Jonathan Zeitlyn with the Islington Bus Company (1983) *The alternative printing handbook* Harmondsworth: Penguin

Triggs, Teal (2001) 'Liberated spaces: identity politics and anti-consumerism' in Sabin, Roger and Teal Triggs, eds *Below critical radar: fanzines and alternative comics from 1976 until now* Hove: Slab-O-Concrete: 33–48

Trodd, Colin (1994) 'Culture, class, city: the National Gallery, London and the spread of education, 1822–57' in Marcia Pointon, ed. *Art apart: art institutions and ideology across England and North America* Manchester: Manchester University Press

Tsivian, Yuri (1996) 'Media fantasies and penetrating vision: some links between X-rays, the microscope, and film' in Bowlt, John E. and Olga Matich (1996) *Laboratory of dreams* Stanford, Calif.: Stanford University Press: 81–99

Tucker, Jennifer (2005) *Nature exposed: photography as eyewitness in Victorian science* Baltimore: John Hopkins University Press

Tufte, E.R. (1993) *The visual display of quantitative information* Cheshire Conn.: Graphics Press

Turner, Graeme (2003) *British cultural studies: an introduction*, third edition, London: Routledge

Twyman, Michael (1970a) *Printing 1770–1970: an illustrated history of its development and uses in England* London: Eyre & Spottiswoode

—— (1970b) *Lithography 1800–1850: the techniques of drawing on stone in England and France and their application in works of topography* London: Oxford University Press

—— (1976) *A directory of London lithographic printers 1800–1850* London: Printing Historical Society

—— (1990) *Early lithographed books: a study of the design and production of improper books in the age of the hand press* Williamsburg, Virginia and London: The Book Press Ltd. and Farrand Press & Private Libraries Association

—— (1992) 'Asymmetric book design in lithographed books of the nineteenth century: the convergence of manuscript and printing' *Journal of Design History* 5 (1): 5–17

—— (1996) *Early lithographed music* London: Farrand Press

Tylecote, Mabel (1957) *The mechanics' institutes of Lancashire and Yorkshire before 1851* Manchester: Manchester University Press

Updike, Daniel Berkeley (1980 [1937]) *Printing types: their history, forms and use*, Volumes I–II, New York: Dover Publications, Inc.

Vetch, R.H. (2004) 'Pasley, Sir Charles William (1780–1861)' in *Oxford dictionary of national biography*, Oxford University Press, Sept 2004; online edn, May 2007 [www.oxforddnb.com/view/article/21500, accessed 15 April 2010]

Vincent, David (1989) *Literacy and popular culture: England 1750–1914* Cambridge: Cambridge University Press

Wakeman, Geoffrey (1970) *Aspects of Victorian lithography: anastatic printing and photozincography* Wymondham: Brewhouse Press

Wark, McKenzie (2011) *The beach beneath the street: the everyday life and glorious times of the Situationist International* London: Verso

Watson, Thomas J. (1999 [1975]) 'Good design is good business' in Bierut, Michael, Jessica Helfand, Steven Heller and Rick Poynor, eds (1999) *Looking closer 3: classic writings of graphic design* New York: Allworth Press: 246–51

Weintraub, Stanley (1976) *Aubrey Beardsley: imp of the perverse* University Park, Pennsylvania and London: The Pennsylvania State University Press

Wilkinson, Helen (1997) '"The new heraldry": stock photography, visual literacy, and advertising in 1930s Britain' *Journal of Design History* 10 (1): 23–38

Williams, Emmett, ed. (1967) *An anthology of concrete poetry* New York: Something Else Press

Williams, Raymond (1980) 'A hundred years of culture and anarchy' in *Culture and materialism* London: Verso: 3–8

Williamson, Aaron (2009) *Splitting the atom on Dalston Lane: the birth of the Do-it-yourself Punk movement in March 1977* London: The Eel

Wilson, Gurriero R. (2001) 'Women's work in offices and the preservation of men's "breadwinning" jobs in early twentieth-century Glasgow' *Women's History Review* 10 (3): 463–82

Wolk, Douglas (2008) *Reading comics: how graphic novels work and what they mean* New York: Da Capo Press

Wood, Rev. J.G. (1857) *Common objects of the seashore* London: Routledge

Wood, Marcus (1994) *Radical satire and print culture, 1790–1822* Oxford: Clarendon Press

Wood, Paul (2004) 'The neo-avant-garde' in Paul Wood, ed. *Varieties of modernism* New Haven and London: Yale University Press and the Open University: 271–313

Woodham, Jonathan M. (1997) *Twentieth-century design* Oxford: Oxford University Press

Wright, Alex (2007) *Glut: mastering information through the ages* Washington, DC Joseph Henry Press

Wright, T.R. (1986) *The religion of humanity: the impact of Comtean Positivism on Victorian Britain* Cambridge: Cambridge University Press

Yeo, Richard (2001) *Encyclopaedic visions* Cambridge: Cambridge University Press

York, Richard (2006) 'Ecological paradoxes: William Stanley Jevons and the paperless office' *Human Ecology Review* 13 (2): 143–47

Zeitlin, Jonathan (1979) 'Craft control and the division of labour: engineers and compositors in Britain 1890–1930' *Cambridge Journal of Economics*: 263–74

Index

The Book History Reader
2nd Edition

Edited by **David Finkelstein**,
University of Dundee, UK and
Alistair McCleery,
Edinburgh Napier University, UK

Following on from the widely successful first volume, this second
edition has been updated and expanded to create an essential
collection of writings examining different aspects of the history of
books and print culture.

Arranged in thematic sections, bringing together a wide range of
contributors, and featuring introductions to each section, this new
edition:

- contains more extracts covering issues of gender,
 material culture and bibliographical matters
- has a brand new section on the future of the book in the
 electronic age
- examines different aspects of book history including: the
 development of the book, spoken words to written texts,
 the commodifcation of books, and the power and profile
 of readers.

This pioneering book is a vital resource for all those involved in
publishing studies, library studies, book history and also those
studying English literature, cultural studies, sociology and history.

October 2006: 246 x 174: 576pp
HB: 978-0-415-35947-4
Pb: 978-0-415-35948-1

For more information and to order a copy visit
www.routledge.com/9780415359481

Available from all good bookshops